PAINTING and DRAWING

PAINTING

and DRAWING

Discovering Your Own Visual Language

ANTHONY TONEY

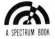

A SPECTRUM BOOK

Prentice-Hall Inc., Englewood Cliffs, New Jersey 07632

Library of Congress Cataloging in Publication Data

TONEY, ANTHONY.
 Painting and drawing.

 (A Spectrum book)
 Includes index.
 1. Art—Technique. 2. Composition (Art) I. Title.
N7430.T66 1978 702'.8 77–11873
ISBN 0–13–648113–2
ISBN 0–13–648105–1 pbk.

PAINTING AND DRAWING by Anthony Toney
© 1978 by Prentice-Hall, Inc., Englewood Cliffs, N.J. 07632

A SPECTRUM BOOK

Printed in the United States of America

10 9 8 7 6 5 4 3 2 1

Cover illustration:
ANTHONY TONEY, "Fifth Avenue"; oil on canvas

PRENTICE-HALL INTERNATIONAL, INC., *London*
PRENTICE-HALL OF AUSTRALIA PTY. LIMITED, *Sydney*
PRENTICE-HALL OF CANADA, LTD., *Toronto*
PRENTICE-HALL OF INDIA PRIVATE LIMITED, *New Delhi*
PRENTICE-HALL OF JAPAN, INC., *Tokyo*
PRENTICE-HALL OF SOUTHEAST ASIA PTE. LTD., *Singapore*
WHITEHALL BOOKS LIMITED, *Wellington, New Zealand*

ANTHONY TONEY
is an award-winning artist whose works
have been shown throughout the United States.
A member of the National Academy of Design and
the National Society of Mural Painters, he has served
on the board of directors of Audubon Artists and
Artists Equity Association. Currently he is teaching
art at the New School for Social Research.

To Edna, Anita, and Adele

I wish to acknowledge the editing assistance of my wife Edna;
the encouragement and friendly assistance of
Michael Hunter and Marjorie Streeter of Spectrum Books;
the editorial and typographic work of Hilda Tauber,
Production Editor; the photographic tutoring of Russell
Buckingham; the cooperation of Hayward Cirker of Dover
Publications, Inc. and Tschacbasov of the American Library
Color Slide Co. I am grateful to Sidney Bergen of the
ACA Galleries for supplying many of the photographs.
I also wish to thank the artists and collectors whose
works serve to illustrate this book.

Contents

2 ADDITION APPROACH VERSUS WHOLE APPROACH 21

3 DIRECT AND INDIRECT PAINTING 45

4 THE LANGUAGE OF VISUAL CONTRASTS 59

5 STRUCTURING VISUAL DISCOVERIES 89

6 IDENTIFYING YOUR AESTHETIC VIEWPOINT 113

7 EXPLORING THE CREATIVE PROCESS 127

8 PRACTICAL ADVICE FOR THE DEVELOPING ARTIST 149

Preface

The crisis that existed a decade ago in art and its environment has intensified. The contradictions in the world of art become more severe as our plenty of yesterday becomes plagued by scarcity and unemployment, poisoned by industrial and nuclear waste and haunted by threatening accumulative disaster even as the promise and the possible solutions remain.

As part of that promise, there have never been more who seek fulfillment in some form of creative art. Since the publication of my book, *Creative Painting and Drawing*, (Dover Publications, Inc., New York, 1966), there has not only been a continuing development of multimedia, minimal, conceptual, pop, op, and environmental works but also an avant garde resurgence of dramatic forms of realism and naturalism. We are less dominated by any single tendency, although the world of art continues to reflect the commercialism, faddism, and fanaticism of contemporary society.

Experience as art educator and reactions to my previous book have confirmed my awareness of the difficulty of clear communication. Verbal language has its own internal and external ambiguities, with the possibility of unintended meanings as well as distortions projected by the interests and attitudes of the reader. In this book I hope to have found ways of being clearer both verbally and in visual illustration. To this end I have relied to a great extent upon my own work and also upon the work of others who may more directly dramatize the meanings intended.

My goal is to more effectively aid you as an artist or developing artist to discover yourself in the maze of conflicting artistic assertions and actions. The character of the opposing doctrines and practices is identified in order to sharpen, through that counterpoint, the possibilities open to you.

The book is divided into three sections. The first three chapters are devoted to practical problems of materials, methods, and skills. Chapters 6 and 7 explore the framework in creative art and thought within which you may be able to identify your particular goals and practices. The final chapter takes a look at artists' economic problems and opportunities.

Read this book critically. It serves best as it stimulates your own thinking and practice. Real understanding will come as you draw and paint.

ANTHONY TONEY

CHAPTER
1

Choosing Media And Materials

Your outlook affects your technique. Many students come to a class or to a book expecting to be taught a specific technique. But technique is inseparable from the personality that uses it. Skills grow as practice and theory interact—not one skill at a time, each perfected, but rather as a group of skills developing as the resolution of one level of problem makes possible a more complex level. Development does not occur in an even progression; it stays on a plateau for varying periods while imperceptible changes accumulate, and then there is a jump in ability, a shift to a new level. Each aspect develops throughout life, not separately but as part of a whole.

Have patience. Waiting will allow the paint to dry enough to permit the application of succeeding layers. Waiting will also allow time for ideas to come, for the creative process to work.

Many of you study art in the hope of rapidly acquiring a skill that can be turned into money. Money is necessary of course,

1

and a professional goal is fine, but it all takes time.

You are often overconcerned about your basic ability. For that reason I avoid using the term "talent" because it implies a static capacity about which nothing can be done. Students who are already insecure are only too willing to blame lack of talent when difficulties pile up. Those difficulties may be the very signs of growth. More important than ability is that you maintain interest and persist.

Many art students tend to be individualistic and find theory dull. Some wish to learn to copy well. Perhaps some of you will seek an ideal order in your art or a profound realism. Confusion often results when you simultaneously pursue opposing goals, not only in work but also in relation to your teacher. You insist on independence, freedom from interference, yet at the same time you want more and more direction. Success and failure are intertwined as the instructor attempts to provide meaningful support within these contradictions.

Often a gap between your readiness and your goal creates difficulties, especially if your development is one-sided. Students with developed taste and excellent backgrounds in art history are often beginners in workshop practice; they become destructively impatient with their fumblings and demand immediate solutions.

The creative process, subject to every kind of external and internal pressure, requires time, and unfortunately the classroom is hardly set up to accord with its needs. We cannot imprison the creative process into so many weeks or hours, nor can we compel it to function; our living situations are not so ordered.

Each of you brings to the classroom a distinctive body–mind complex and a unique situation in life, and these circumstances influence your creative possibilities. You must be aware of these challenges and try to meet them constructively. Often the contradictions within us will be revealed not only in our work but also in discussion. Our ideas, when echoed back, will sometimes seem unrecognizable. Yet it is precisely this distortion that must be seized upon if we are to be able to

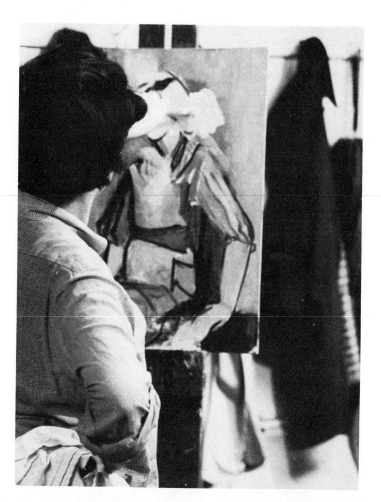

1.1 Art student at the New School for Social Research.

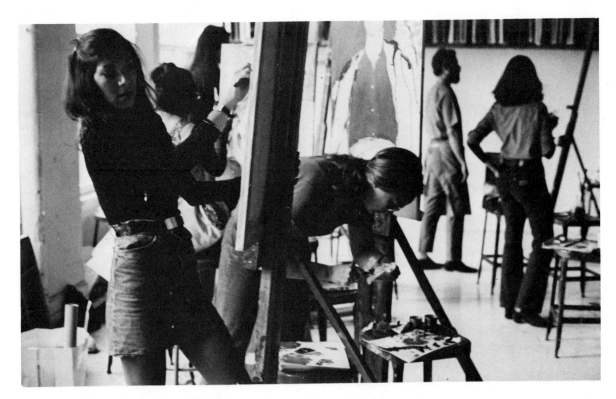

1.2 Students in the New School art workshop.

understand and help each other. We must go behind the masks of understanding to the underlying reality.

Within this counterpoint it is useful to have a base—a set of defined concepts against which differences can be tested. This can give direction and prevent destructive fragmentation. The concepts must be able to withstand assault without becoming rigid or dogmatic.

In a class that is homogeneous there is a tendency to adopt a stereotyped approach. Where development is diverse, the melange of cross-purposes demands a more individual and creative interaction.

Inevitably, vague longings, tenacious hopes, determination, tentative trial, fascination, romantic illusions, compulsions, and the search for fulfillment are pitted against boredom, frustration, confusion, fatigue, pressures, conflicting interests, variable weather, illness, unsympathetic criticism, slowness in development, creative anguish, contrary standards, and the many tensions in today's world.

Despite these conflicting forces, or perhaps *out of* all these contradictions, careers in art begin and develop, whether early or late in life. Many take up painting and drawing as a hobby, just for relaxation and personal satisfaction. Teachers often attend shows by former students or receive announcements about them.

For those of you who are new to painting and drawing, some consideration must be given to the materials you might use. This chapter will describe the various media and how they perform, so that you may decide what suits your visual goals best.

CHOOSING YOUR MEDIA

Today we tend to think in terms of *now* rather than *always*. A building may no sooner be built when it is found more profitable to replace it. Lost along with it are its sculpture and decorations.

This stress on the present and the beguilement of novelty have also influenced many artists to sacrifice permanence through

3

the use of perishable materials and unstable mixtures. Some artists have found advantages in house paint, sprays, fluorescent color, and montages of chance substances.

Action painting took on the character of a performance as artists tried to burst the limits of the canvas plane and involve the spectator in the creative effort.

As the value of the work of many of these artists rose, more interest was shown in its preservation, and today art restoration flourishes. Although a full explanation of material interactions is beyond the scope of this book it will be helpful to suggest ways of working that can prolong the life of your work.

For the painter, material can mean paint, paper, or canvas. But it also means the material of life, of nature and society, its culture and technology. The work becomes a synthesis of all of these.

Artists also need to have rapport with the materials they use. There is immense satisfaction to be derived in the feel of the qualities of paint, its smell and sight, whether thin, thick, runny, flat, or raised. Paint must be respected not only for what it can do but for itself. The contrastive possibilities of paint have great power when controlled by an artist.

To determine the media that are best for you will require some experimentation. You may have to try them all before you find the material that gives you satisfaction in its feel, its smell, and its sight.

DRAWING MATERIALS—CHARCOAL

When we paint directly, we paint and draw simultaneously. But there are times when we simply draw with charcoal, crayons, pen or brush and ink, pencil, etc. We may sketch, make visual notes, do studies, or full-scale drawings that have everything except color.

Charcoal is black and generally comes in compressed form in boxes containing a number of sticks, rectangular or pointed tubular in shape, of varying hardness and softness. Charcoal also comes in pencil form. The various compressed forms are most consistent in hardness or softness and they adhere to the paper more. Ordinarily, charcoal can be dusted off easily. It smudges readily but has the advantage of being very flexible once you become accustomed to drawing with it. Charcoal sticks can be used in many ways, varying, for example, from making the paper black with charcoal and pulling out the lights with a kneaded rubber eraser to building first with light lines and gradually getting darker as you become more certain where you want darker tones. The tones can be built with line, (Figure 1.4) or the charcoal can be rubbed into the paper with a stomp, which is a compressed tube of cardboard that comes to a point (Figure 1.5).

I prefer to build my drawing with line because I find it more controllable. I also tend to prefer charcoal pencils since they offer clear

1.3 Drawing and Painting Materials. Left to right: pastels and pastel pencils, brushes, watercolor pad, crayons, tubes of tempera, watercolor tubes, chamois for charcoal drawing, pencils, charcoal, pens, and clips.

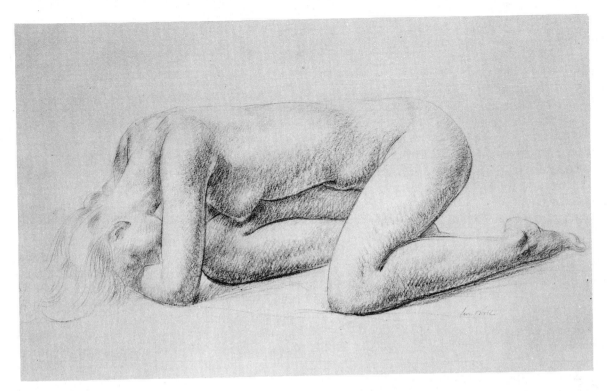

1.4 LEON KROLL, "Nude"; Charcoal.
(Courtesy ACA Galleries)

Tones can be built with line moving with the volumes.

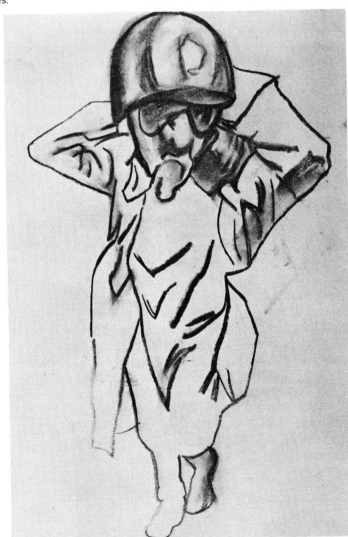

1.5 ANTHONY TONEY, "Soldier Surrendering";
Charcoal on rag paper.

Charcoal smudges easily and can be rubbed
into the paper with a stomp.

grades of hardness to softness. As with pencils in general, the harder the grade, the lighter the line and the softer the grade, the darker the line.

Compressed charcoals are useful for working very large formats and for sensitive, consistent drawings. Large areas of dark and black tones can be readily achieved with this kind of charcoal, but erasures are more difficult.

PAPERS FOR CHARCOAL

When working with charcoal, it is advisable to use charcoal papers, because they have the kind of grain or "tooth" that holds the drawing better (Figure 1.6). Of course, if you are beginning to learn to draw, you can use

1.6 ALLEN HERMES, "Male Nude"; Charcoal with white on grey charcoal paper. (Courtesy of artist)

Line can be superimposed over tones to accent the movement of planes.

newsprint pads, which are more economical. Unfortunately, newsprint rapidly self-destructs, so as soon as you begin to get results that you wish to retain, change to a more permanent paper. Although bond paper—also relatively cheap—has little tooth, it can be used for charcoal drawing as well as for other media. Better papers contain varying amounts of rag; the best paper is 100 percent rag. It is preferable for beginners to work on a large pad, the largest available, because you need to learn to draw from an arm's distance, moving from the shoulder rather than with the fingers. At a distance you can see the whole drawing and better judge directions, proportions, and values. Of course you should also have a small pad that you can carry around with you for taking visual notes and general sketching when you are away from your studio.

FIXATIVE

Charcoal drawings need to be fixed to the paper. Fixatives are available for this purpose. Although most of them now come with built-in sprayers, I prefer to use the metal mouth sprayer.

In any case, hold the can of fixative about one foot from your drawing, and spray gradually, letting the first layer settle and dry before spraying again. Keep the spray moving or else the fixative will run. Do not spray in a room with other people because the fumes pose some danger. Spray for a brief period in a well-ventilated room.

CRAYON AND PENCIL

Conte crayon, in black or sepia, adheres to the surface well but does not erase easily. Keep your line light if you wish control. You can always get darker. Conte crayon allows a rich range of values (Figure 1.7). It can be fixed to the paper but requires only little fixing (Figure 1.8). Conte can be used on any firm pa-

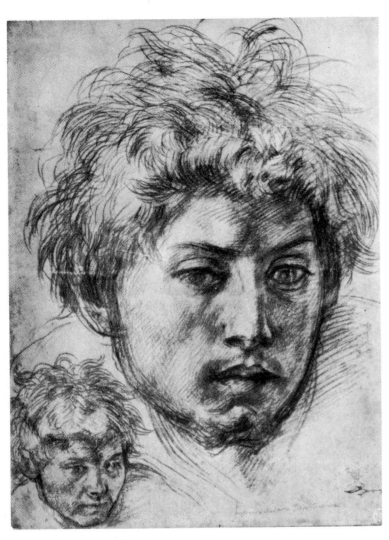

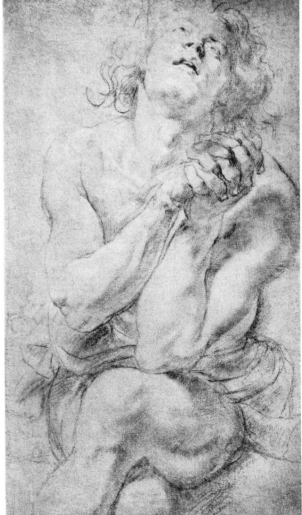

1.7 ANDREA DEL SARTO, "Heads"; Crayon.
(Courtesy Dover Publications, Inc.)

Gesture line caressing the volumes through lightness and heaviness of touch can control the values of tones in most drawing media.

1.8 PETER PAUL RUBENS, "Figure"; Crayon and chalk.
(Courtesy Dover Publications, Inc.)

Crayon erases less readily than charcoal and need not be fixed.

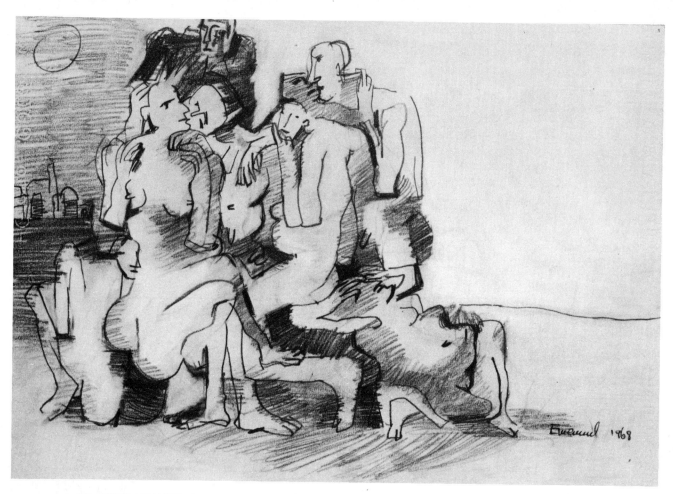

1.9 HERZL EMANUEL, Study for a sculpture; Pencil. (Courtesy of the artist)

Pencil is flexible and has a broad range of values.

per; it does not need a paper with tooth. Beginners can well use it on newsprint or bond paper.

A lithographer's crayon is useful for general drawing as well as for lithography. It is capable of a sensitive range of greys to black and goes well on any paper. It resists erasures and does not require fixing, although it can be fixed. Again, when you wish control, begin lightly and make your darks gradually as you begin to know where you want them.

Ebony pencil also provides a wide range of values (Figure 1.9). Like charcoal, most pencils come in varying degrees of hardness or softness. Since hard pencils can bite into the paper, they should be used gently. Ebony pencil is easily and best erased with kneaded rubber since the paper is protected by its unabrasiveness. In general ebony pencil does not provide the rich blacks of the crayons or charcoal. It is extremely flexible and has a range of definite strokes and soft tones.

Although pencil works on all papers, it is best on smoother surfaces.

PEN AND INK

Black inks should be richly opaque as, for example, India ink. Your pen can be almost anything from one of the great variety of dip pens to fountain pens that use drawing inks (Figures 1.10 and 1.11). Ball point pens can also be used, preferably one with non-water soluble ink. Ball points have an ease and flexibility that is enticing, but the line produced is often not dark or opaque enough.

Bristol paper has a hard, smooth surface and works well with pen and ink. Any smooth paper is usable; those with rag content are preferable when permanence is desired.

8

You can also draw beautifully with matchsticks, which are absorbent, hold ink well, and make a bold, sensitive, soft line. Various markers are also possible as drawing tools. Their wide range of sizes creates opportunity for diverse kinds of line. Choose markers that are non-soluble and as opaque as possible.

Brush and ink is an old traditional medium that allows areas of black or grey as well as variation of line (Figure 1.12). Not only can you draw a contour line with a brush, you can also make calligraphic strokes of sensitive variation. Dry-brush is another way of drawing with a brush and it provides a large measure of flexibity. In this technique you dry out the brush on a blotter or similar substance and with a chisel edge you turn each stroke into a series of tiny parallel lines. Thus you can control the value differences and, through lightness and heaviness of touch, obtain the whole range of light to dark values.

Try to obtain a red sable brush, preferably a round, that is, a brush with a round fer-

1.11 ANITA KAREN TONEY, "Self-portrait"; Pen and ink.
Tonal values are built here with pen line.

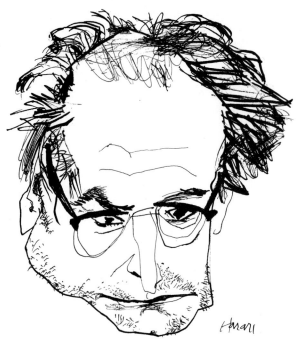
1.10 HANANIAH HARARI, "Portrait"; Pen, brush and ink.
(Courtesy of the artist)
Notice the variations of calligraphic line.

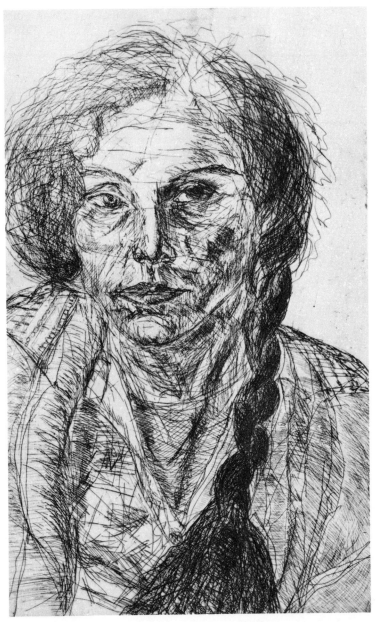

rule, which allows the brush to come to a point. A medium-size brush might be best because it can be used with a point or chisel edge adequate for most purposes. Since sable brushes are rather expensive, you might consider an imitation called *sabeline* as an economical substitute.

Drawing and painting merge whenever color becomes a factor. There is a wide range of choice in drawing-color media. You can choose color in the forms of ink, pencils, wax crayons, oil pastel, craypas, markers, and ball points, as well as pastel itself. One of the advantages of these media is the possibility of readily superimposing color upon color until the desired hue is obtained. When we keep the linear quality, the counterpoint of colored lines retains the vibration of opposing color, even as the synthesis of a particular hue is achieved (see Plate 1).

1.12 REMBRANDT VAN RIJN, Drawing; Pen, brush and ink. (Courtesy Dover Publications, Inc.)

Example of inventively varied pen, line, and brush stroke.

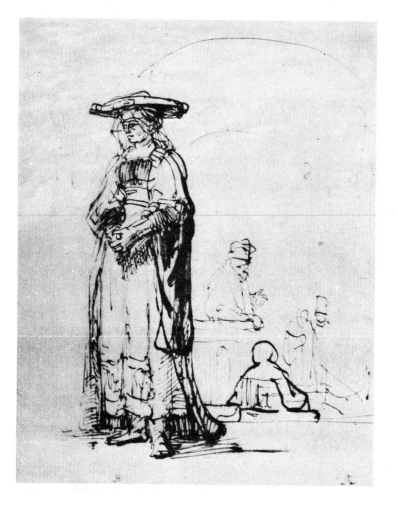

Working with colored inks takes on some of the characterstics of watercolor, particularly if you use the ink with various dilutions of water. Both inks and watercolors can be used as lines of color as well as tones. Working with colored line takes patience, and the size of the drawing may have to be limited. The general procedure is to establish a gesture drawing in a light color throughout the paper, then superimpose another gesture drawing in an opposing color and when that is dry, superimpose still another. Generally a yellow may be followed by a red and finally by a blue. Then, whatever finishing variations prove necessary can be introduced.

With pastel-like pencils, crayons, and the like, the colored line, though blunter, can be even more readily controlled. The layers of color can be more gentle, the touch more sensitive, the synthesis more subtle. You can learn much about color as you watch the components of each tone or hue visibly vying with each other. But all of these media will also merge if you should prefer to use them to form more flat contending shape relationships. Inks, pastel pencils, crayons, markers, and the like may also be used together in combinations that fit your purpose. Many artists prefer to combine media (Figures 1.13 and 1.14). Combinations of these media are particularly useful in situations that allow for only limited equipment. With these media you can sketch, make value and color notations, or develop fully some idea that catches your attention, without the problem of their drying or rubbing off.

PASTEL

One of the most flexible media is pastel. We can blend with it or use it to form tones composed of layers of lines of color, as previously described. Pastel is softer than the combination media, although it is available in harder varieties and in pencil form, useful in smaller works. Sometimes in portraiture you may wish to begin with softer pastels and finish with pastel pencils. Unless you become very involved with pastel, a medium size or even small set should be sufficient for your pur-

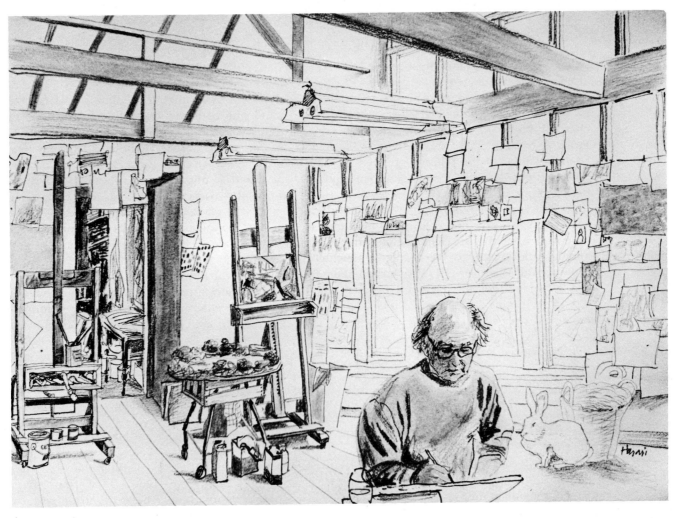

1.13 HANANIAH HARARI, "Toney's Studio"; Pencil, pen and ink, crayon. (Courtesy of the artist)

With multi-media we can draw, make color notations, combine
varied textures, and develop quite fully whatever interests us.

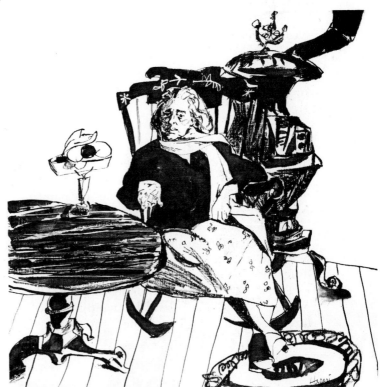

1.14 HANANIAH HARARI, "Homebody";
Ink, pen and wash, litho crayon.
(Courtesy of the artist)

poses, since you can mix most of the hues desired

Pastel painting requires a special toothed paper. It ranges from varieties resembling charcoal paper to velvet or sandpaper surfaces. A medium light grey paper provides a context similar to the relative greyness of nature, and enables you to judge your color mixtures against it.

Pastel works must be handled carefully; any roughness can disturb or even lose layers of pastel from the surface. Pastel can easily smudge and be ruined by accidental touches. But carefully handled or undisturbed, pastel can last indefinitely. I have some unfixed pastels in portfolios and on my walls, and they have held up well.

Fixing pastel paintings has been a negative experience for me. I have found that fixing results in a loss of lightness and brilliance. Some manufacturers claim to have a fixative that works well. If pastel becomes an important medium for you, you will have to experiment with fixatives and their use. As described above under Fixatives, spray approximately one foot away from the drawing or painting, and move gently over the surface. Avoid pausing at any one spot because it will get too wet and start to run. When the work is dry, you can spray again and again until it seems enough. Some artists spray lightly as they go along. Try it. Perhaps that may be a way of keeping brilliance. Generally it is better is underspray than overspray.

PIGMENTS

Pigment is the chemical substance that gives the specific hue. The binder of the pigment may vary, as we shall discuss next, and produce the various media such as oil paint, watercolor, acrylic, casein, egg tempera, etc. (see Plates 2 and 3). Chemical combinations affect the stability of the color. I use and recommend a simple combination; other artists differ.

Andre L'Hote suggests using as many colors as possible in a pure state, avoiding mixtures. If each chemical is isolated, there is less chance of changes occurring due to unfortunate combinations.

I consider mixing inevitable and recommend one of many possible combinations of pigment. The combination based on the cadmiums seems to me to be the simplest and most stable. Also desirable is to stress the primary and secondary colors. Recommended are warm and cold yellows, and reds and blues buttressed by secondary and earth colors. The yellows, oranges, and reds (except alizarin crimson) are cadmium; the blues and greens are phthalocyanine and ultramarine; the purples are quinacridone. These chemicals, except for phthalocyanine and quinacridone, have a history of reliability; the others have been recommended as being compatible chemically but they have not met the test of time. Alizarin dries more rapidly than the cadmiums, and therefore it cannot be placed over them or even any other pigment that dries more slowly, because there is danger of cracking.

Colors are warmer as they tend toward red-orange and cooler as they approach blue-green. Yellow light is cooler than yellow medium, and red light is warmer than red medium. Ultramarine blue is warmer than phthalocyanine blue. Alizarin crimson is quite cold as a red, almost purplish. (See palette, Plate 24.)

Ostensibly, the mixture of primaries should produce brilliant secondary colors but, because of their chemistry, they may not. Cadmium yellow light with phthalocyanine blue will give a brilliant green. If ultramarine blue, cadmium yellow, or yellow medium is substituted, it will add a reddish element that makes the green more grey.

Cadmium red light with cadmium yellow or medium will give a bright orange, but red medium or red or alizarin crimson replacing red light will not.

Ultramarine blue mixed with alizarin crimson will give an almost adequate purple, but another red and phthalocyanine blue will give a greyish purple. This is why we need warm and cool primary colors. The various nuances we may seek depend upon what we mix together.

Earth colors, while consistent with cadmiums, dry more rapidly. They are therefore most useful for underpainting, since they en-

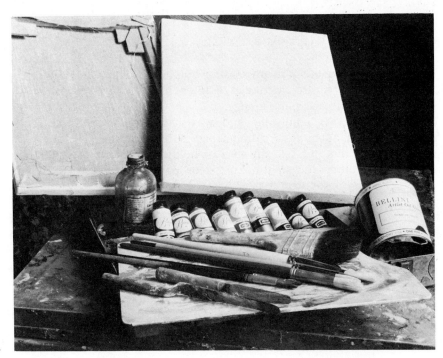

1.15 Oil painting materials: linseed oil, studio size tubes of oil colors, pint of titanium white, palette knives, sable and bristle round brushes, various flat bristle and other brushes. In background, canvas surface and back of canvas showing stretcher.

sure that the areas closest to the canvas dry more rapidly. Earth colors are also used in tonal painting, which stresses an orchestration of greys against which brighter hues provide contrast and enrichment.

The siennas are lighter and warmer browns than the umbers. In both, the burnt form is warmer than the raw. Venetian red is a redish-brown, lighter than the similar Indian red. Yellow ochre is grey-yellow and viridian green is grey-green.

Since earth colors are already quite grey, they can become an obstacle to the less experienced when it comes to understanding and control of color relationships. Otherwise, earth colors can play a rich and valid role, particularly in tonal painting and underpainting. This is discussed further in Chapter 3.

Titanium white is opaque and flexible, and retains its whiteness. Zinc white is transparent and useful for semi-transparent glazes. Lead white is faster drying and therefore has often been used in underpainting. However, it tends to yellow with drying and it contains lead. At present many painters avoid using lead white, although it has been traditionally used for priming canvas. All of these whites are chemically sound when combined with cadmium and the aforementioned pigments.

Mars black and ivory black are also compatible with the pigments mentioned above. Again, I suggest that the less experienced avoid them until they are very familiar with

the role of primary colors in mixing greys. Without white, phthalocyanine green and blue and alizarin crimson will give a very dense black. Certainly any grey desired may be obtained by mixing various reds, yellows, and blues with white to get the desired value.

BINDERS

Binders are not to be confused with mediums, although they sometimes are the same. The binder holds the powdered pigment together. It may be linseed oil, polymer, gum arabic, or other substance.

There was a period during which I painted with water, egg, and dry powder. The mixture of raw egg (either yellow or white or both) with water became at once binder and medium. This form of egg tempera combines qualities of oil and watercolor—richness of body, flexibility, and quick drying.

In the various media, the pigments remain or can remain the same; the binder differs. Gum arabic can be used for both transparent watercolor and opaque temperas. Casein can be used as the binder to obtain casein tempera. There are also egg emulsions that create an opaque watercolor. For some time now we have had a variety of pigments that use polymer emulsions as a binder. These

13

promise much in possessing qualities of flexibility, control, richness of intensity, mixture, texture, and permanency.

Wax emulsions and wax itself are also used as binders. Almost any substance that has the glue-like capacity of holding pigment together and to the canvas or paper can be used, provided that it has the required permanence.

Oil paint has used various oils such as poppy seed and linseed as its binder. Today most paint is made with linseed oil. For me, oil paint remains the most flexible and the richest vehicle for both direct and indirect painting. My techniques do not demand the quick drying that comes with water-soluble acrylic or acrylics bound with a synthetic resin that is mixable with oil and turpentine.

Each of the media we have mentioned—and the range of possibilities has not been exhausted—offers particular advantages. For example, transparent watercolor is inevitably somewhat more spontaneous and fresh, using as it does the white of the paper for variable lightness of value.

The various temperas offer subtle control combining transparent and opaque qualities. Acrylics compete with oil for richness and flexibility, and may be more permanent. You will want to try out all of the media, as the opportunity and need arise. Each will require time and persistent experimentation to master. The main thrust of this discussion applies to all.

MEDIUMS

A medium is a liquid that may be mixed with a pigment to make the pigment less thick or even transparent. A wash or glaze becomes mostly medium.

Watercolors use water as the medium for thinning or painting. Acrylics use water or turpentine and oil, depending upon the kind of acrylic. Acrylics soluble in water also may be used with a polymer medium, matte or glossy, as well as modeling paste and extenders to produce impasto qualities.

Oil painting uses a combination of gum turpentine and linseed oil as its main me-

dium. Some painters prefer a medium that will dry more rapidly. One of the formulas that has served me well for many years is as follows: One part each of venice turpentine, stand oil, and damar varnish are combined with gum turpentine in variations of from four or five to nine parts turpentine. Other combinations use cobalt varnish instead of damar. Some leave out venice turpentine, which is a thick oily substance. Some artists paint mostly with turpentine and others mostly with varnish. A brief look into reference works on materials, such as those by Ralph Mayer, will reveal the range of possible mediums.

I recommend simply using stand oil and gum turpentine as a medium. Stand oil is a heavy, thick version of linseed oil. In this and all such combinations, gum turpentine is the variable. More turpentine is used in the layers of paint closest to the canvas surface, less as one reaches the final layers. I use a combination of one part stand oil with nine parts gum turpentine, gradually ending with five parts turpentine. At this point I tend to try to keep the chemistry of mixtures as few and as simple as possible. I simply wait instead of using the quick drying method, whether in direct or indirect painting.

The purpose of the variable amounts of turpentine is to try to prevent surfaces from cracking as the layers of paint dry. You must make sure that the paint dries more rapidly the closer it is to the canvas surface; for this reason more turpentine is used in the initial layers of painting. As a general rule, mix paint only with turpentine the first day. Once your first relatively thin layer is established, you may mix the leanest combination that you have, that is, with the most turpentine.

The same principle holds for any opaque media in which there is a variable. In acrylic, water is the variable with polymer mediums. Of course the danger of cracking increases with the relative thickness of the pigment. There is no such problem with transparent watercolor or any technique relying primarily on thin layers, transparencies, or stains.

However, it must be remembered that turpentine and water have no adhesive qualities. Turpentine used excessively simply reduces the pigment toward its powdered form.

Where a relatively pure, fast-drying pig-

ment is desired in an area, make sure that a slower drying color is not underneath. Time itself can be a factor. The more time allowed between layers, the greater the possibility that lower layers are sufficiently dry.

It is easier to control these relationships if your canvas proceeds through a series of planned stages. If the entire erratic creative process occurs directly on the canvas, control can become more difficult, if not impossible. Do not become so involved with getting the best or only necessary relationship that you lose concern for permanence.

Those of you who can complete a painting in a day or two will have fewer problems, because painting will be all of one piece, one general layer more or less drying at one rate. Be aware of the problem and, through experimentation, work out the solution that applies to you.

PAINTING SURFACES

Paint can be applied to a variety of surfaces such as canvas, wood, composition panels, canvas boards, paper, plaster, etc. Permanence and praticality are both factors that determine our choices.

I prefer linen canvas, although a good grade of cotton is better than poor linen. I also paint occasionally on composition panels and paper. If properly mounted or protected, rag paper can be as permanent a surface as any. Of course a 100 percent rag paper, mounted, may cost as much as canvas anyway. Paper absorbs readily and paint on paper dries fairly quickly, which might be good in some sketching situations.

Linen canvas, the choice of many painters, combines the advantages of strength, relative permanence, and flexibility. Its weaves are varied. For most purposes I prefer a close weave of medium texture. A fine weave may be desirable for certain kinds of portraiture, especially if the weave might intrude in unwanted ways.

Off and on through the years I have used already prepared canvas and also sized and primed raw linen. My earlier practice was to first stretch the raw canvas on a

stretcher. After having cooked and dissolved rabbit skin glue in water so that it was well mixed, I would apply a layer of this glue to the canvas surface to isolate it from paint. This is called *sizing*. Once this layer was dry, I primed the canvas with a coat or two of white pigment. At that time I used lead white because of its quick drying quality and flexibility. However, other whites may be substituted, especially since we have become concerned about lead poisoning.

For some time painters have also prepared canvases with acrylic gesso, because the procedure is direct and simple. Acrylic gesso is a mixture of ground titanium dioxide and carbonate of calcium in a pure acrylic polymer base. Manufacturers feel that this gesso is an adequate safeguard against embrittlement and deterioration caused by the absorption of oil.

But this safeguard is considered unnecessary for acrylic paints, which may be used directly on raw canvas. Acrylic painters who prime their canvases may do so because they prefer a less absorbent canvas. Although some artists prefer to prime with several thin coats, sanding at least the first, others prefer to use one or two full-bodied coats. The sanding helps to eliminate roughness.

The surface you choose to paint on will depend upon your experience and attitude. You need to get as much experience as possible if you are a beginner. That is why it might be wise to do many paintings and exercises on paper until you get the feel of mixing and controlling paint. Generally, you will find it easier to work on large surfaces. Later, it will be important to do smaller as well as larger things. You will gradually find the kind of surface that you prefer.

STRETCHING A CANVAS

Canvas is generally stretched on wooden frames formed of wood strips. These strips are sold in many sizes. Narrow strips are suitable for frames under 40 inches in length. Wider strips become necessary for frames over that size. The strips are slotted so that they easily fit together. For very large sizes you will also need cross pieces (see Figure 1.15).

Watch for warping and out-of-line strips when making your purchases. Although you can buy canvases that have already been stretched, you should gain this fundamental experience, and it can save you money.

Some painters paint on unstretched canvas, particularly when it is so large that it must be rolled for transportation. When the canvas reaches its destination, it may then be stretched or hung some other way.

To begin, put your strips together. Tap them firmly square and then check the corner angles with a metal square. Make sure that the raised sides of the stretchers coincide with each other. When they are square, you may help hold the squareness by stapling the corners on the back side.

Cut your canvas large enough so that you may staple the canvas to the back side rather than the edge. There are cutting knives or one-sided razor blades for this purpose. The canvas should then be placed over the front stretcher side—the side with the raised edge. When the canvas is taut, it touches only that edge.

Since stretched pressure must be even, start with the center of one side and then go to the opposite side. First it might be helpful to center your canvas on the frame with temporary staples at the corners. Use a metal canvas stretcher because your finger strength will be insufficient to get the canvas tight enough. As indicated above, move from one center to the opposite, stapling the canvas at the back rather than at the edge. Keep centering each subsequent distance between staples, moving from one side to the other until the canvas is taut and free of wrinkles.

The corners will have to be folded back neatly and stapled as well. Since stapling is so easy a process, keep stapling until the canvas is firmly attached. If your pressure has been even, the canvas should still be square. Test it with your metal square. If you are stretching an unprimed canvas, you need not stretch the canvas as tightly as a primed one. The canvas will shrink somewhat as the primer dries.

Creases in a canvas may be removed by wetting the back. As the canvas dries, the crease is pulled flat. Holes may be patched by attaching a piece of canvas to the back with a coat of paint on the patch and on the back of the canvas. This makes for a firm bond. Of course, the painting side must be evened out with some thick paint and a palette knife.

Since canvas expands and contracts with humidity changes, corner wedges are useful for tightening or relaxing tension. The canvas fares best in moderate dryness and temperature.

BRUSHES

Brushes should be chosen according to their varied purposes. For painting in wide broad strokes, you will discover that the ordinary house painter's brush is very useful. When establishing a ground, a transparent coat of warm grey (umber or sienna), a lint-free rag may suffice. Much of the time you will use a flat bristle brush, $1\frac{1}{2} \times 1\frac{1}{2}$ inches, or one a bit longer than its width. Bristle flat brushes allow the use of broad and narrow edges, giving a range of calligraphic strokes. A flat ferrule produces a flat brush; a round ferrule produces a round brush that comes to a point.

Flat or round, the brush should be firmly anchored in the ferrule and should snap back to center after pressure. If the brush is round, it should also snap to a point.

You don't really need many brushes. Several large flat and round bristle brushes and one or two large red sable (or the more economical imitation sabeline) round brushes can suffice. But you will find your own needs dictating your choices. The sabeline rounds allow for a wide variety of stroke by using the point or chisel edge that the brush can also form. Being softer, the sabeline brush is more important for thin or transparent color, for smaller planes, and for dry-brush technique.

Although optimum life of a brush is short, still it will serve for some time. To extend that life it is necessary to store brushes end up, because pressure can distort them. Brushes must be washed well, first in turpentine or similar solvent if you are working with oils, then with mildly warm water and soap. Hot water will soften the glue holding the hairs, and they will loosen and fall out. Although paint may be applied in a multitude

of ways that you may wish to try, the brush remains basic and so deserves care.

PALETTE AND PALETTE KNIFE

You must have a surface on which to mix the paint. Palettes may be of any substance, and traditionally they were formed of wood. The surface should be non-absorbent; but any surface can be made so by simply rubbing the leftover paint over the surface. A few such applications will give a hard, resistant surface that will also be somewhat grey, a good base to mix against in most circumstances. Since I urge my students to have large palettes, I suggest that they use large pieces of cardboard treated in this manner.

When I work transparently or relatively so with egg tempera or watercolor of various sorts, I use a large piece of glass with white paper underneath. Since the white of the paper functions as part of the color value, I must also mix against a similar white.

Paint is put in gobs of related hues around the edge of the palette (Figure 1.16). Mixtures are made in the center. Putting the color in a prismatic order will simplify your mixing. Yellow light is followed by yellow medium, then orange, red light, red medium, alizarin crimson, violet or purple, ultramarine

blue, phthalocyanine blue, and phthalocyanine green. White would be separate and in greater quantity. To control this mixing even though you will use a brush to mix your color, you need a palette knife.

The palette knife is a long, somewhat elliptical blade with a recessed handle. It is used for picking up and mixing various hues that have been previously used, and putting them aside at the edge of the palette so that the center remains free for further mixing. Those various greys are often useful in other areas of the canvas, either as they are or modified (see Figure 1.16).

The palette knife is often confused with a painting knife. A painting knife has a shorter, more triangular blade. Of course either knife can be used for painting. The result can be very definite areas of color or more complex ones as color is put on top of color.

The palette knife is also used for controlling the surface of the canvas. If the paint becomes too thick for the purpose, it is removed with a palette knife. It can be removed and still leave the color area intact. We can also control the painting texture with the knife by making the texture thinner or thicker. Sometimes after knifing out an area we can remove even more by wiping with a lint-free rag. Artists also use a scraping knife, but I have not found such a knife necessary.

Rags are of great importance in the painting act. They serve to wipe the palette

1.16 Palette with easels in background. (Hananiah Harari photo)

clean and to clean brushes. To clean a brush, dip the brush in the cleaner (turpentine, varnoline, etc.) and wipe it with a rag. This should be done before mixing each decisive variation.

To hold your cleaning vehicle, use a medium large can, preferably one with a top and with a folded over piece of screen in its bottom. The turpentine, varnoline, or whatever can be used for some time for cleaning, but it is preferable to cover the container when it is not in use.

Old newspapers are useful for protecting areas of your studio, and also for blotting your canvas to control the amount of medium or to even the thickness of paint. One can blot a canvas without altering its areas but simply drying it some; or one can blot to create accidents that may suggest visual ideas.

Sponges are particularly useful in any form of watercolor including acrylic. If you

have to work in areas that need protection you will find that plastic sheets make good drop cloths. Of course it would be better to be able to work in an area that will only be used as a studio.

EASELS AND STUDIO

A large, strong, flexible easel will eventually be needed for your studio. You will need the kind that adjusts with a crank and tilts as desired. It should also be able to hold both very large and fairly small canvases. Until you get such an easel any of the cheapest kinds will do. If you have a wall to which you can tack a canvas, you can paint without an easel. You can also paint flat on the floor (Figure 1.17) or on a table. Small table easels are also avail-

1.17 Painting on the floor. (Mimi Forsyth photo)

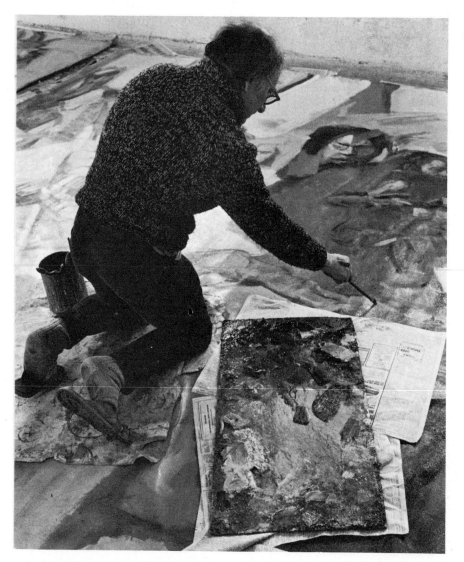

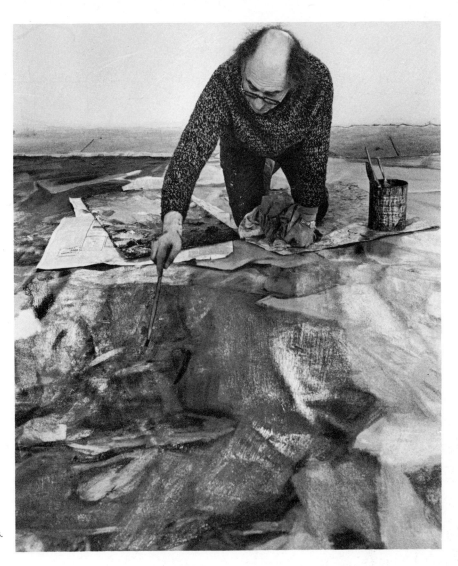

1.18 Most artists prefer large work areas.
(Mimi Forsyth photo)

able. Watercolor painting is generally done most easily on a table, but much depends on the size of the paper used.

Unless for physical reasons you need to sit, you should stand while painting so that you can walk away from your work to see it as a whole. Most artists prefer large work areas (Figure 1.18), but I've known some who appear very satisfied with a small room. Much depends upon your approach. Those who work by adding one small detail to another can more easily function close to their work. Those who progressively modify the whole image of the painting may require more distance. Mirrors can extend visual distances in a small studio. Also reducing glasses can help show how your work carries from a distance.

If you start using a model regularly, you may want to get a model stand. A model stand measures approximately 1 to 1½ feet high, 5 feet wide, and 10 feet long. The stand allows the seated model's eyes to be on a level with your own.

Whatever else you may need will accumulate as your interests develop. Screens, drapery, still-life objects of various sorts, and so on are traditionally found in some studios. More recently artists seem to prefer large bare spaces in which they may work freely on large canvases.

Use the media that attract your interest. Stay with them for some time; give them a chance. You need to become accustomed to their characteristics. In both painting and drawing, development is a continuous, life-time proposition. Don't think in terms of mastering one thing before proceeding to another. As you experiment you will acquire more and more information and become more skilled in the use of various materials and techniques.

CHAPTER

2

Addition Approach Versus Whole Approach

You may already work in one or both of the methods that will be discussed in this chapter. We can call one the *addition approach* and the other the *whole approach*. In the addition or part-by-part approach you add one finished part to another, each determined by what is already there. In the whole approach you begin at once to consider the entire canvas or paper, its main divisions, masses, etc., and progressively modify them until you reach final details.

In the addition approach you stress line as detailed contour, and shapes are rather flat. In the whole approach you are more general, more fluid, and spatial.

THE ADDITION APPROACH

Because the addition approach at once establishes detail upon detail, you must be able to work with boldness and sensitivity. The accu-

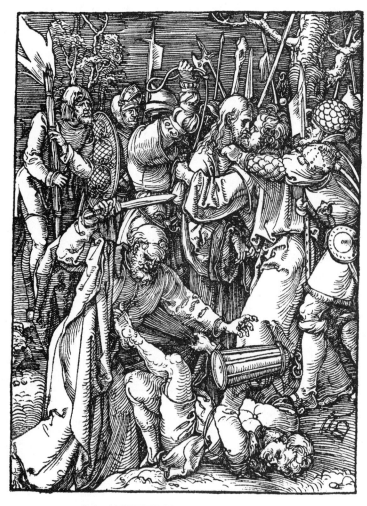

2.1 ALBRECHT DÜRER, "The Small Passion"; Engraving. (Courtesy Dover Publications, Inc.)

Each part has a definiteness and a separateness even as it is part of a whole.

mulation of detail, determined by will and chance, ultimately achieves a wholeness—a point when nothing more seems needed. The method reminds one of the intuitive improvisation of jazz musicians. Each part has a definiteness and a separateness even as it is part of a whole (Figure 2.1). The emphasis on shape tends to flatten the space and the dark and light color pattern. Such emphasis can easily become decorative.

Theoretically, a mistake is impossible. Anything added can be so psychologically and structurally compensated by other additions that eventually we reach an acceptable conclusion (Figure 2.2). Chance happenings become automatically absorbed.

Historically, the addition method has persisted from the contour drawings of prehistoric times through the Egyptian, Byzantine, and Gothic periods to the present. This method is congenial to the closed form of classicism and also adaptable to the needs of such romantics as Modigliani and Van Gogh. The approach is used by both sophisticated and naive painters. Art students who are beginners automatically tend to draw in the part-by-part approach, whereas the whole approach—blocking in or constructing a drawing—has to be learned.

Whether one is drawing or painting directly from visual material or from symbolic or imaginary ideas, the addition method may

2.2 ANTHONY TONEY, "Kahn Summer Home"; Pen and ink.

We keep adding until we reach an acceptable conclusion.

begin with a line drawing of some sort—sure, bold, and continuous, or halting, tentative, etc. Some of us may create shapes directly as silhouettes or masses stated calligraphically. The drawing may proceed slowly, with deliberateness and sensitive awareness, or it may emerge quite rapidly.

CONTOUR DRAWING

In contour drawing the contour is the surface of whatever you draw. Some of you may use more or fewer lines to describe that contour.

Those of you who wish to be purer or simpler will choose a few calculated lines. Others will be concerned only with the outer edges. Or you may find interest in selecting lines describing movements revealed by the way light hits the volumes. Some of you will exaggerate, cross-fertilize, or otherwise transform the contour.

To draw the surface sensitively, you must identify with it. Draw your line as a sequence of positions in space (Figure 2.3). It is helpful if you can feel that you are tracing whatever you are drawing, or better, that you are drawing on its very surface. This feeling is what I call *identification*. It transforms your paper into space.

2.3 LEONARDO DA VINCI, "Study of Hands" (Courtesy Dover Publications, Inc.)

Draw your line as a sequence of positions in space.

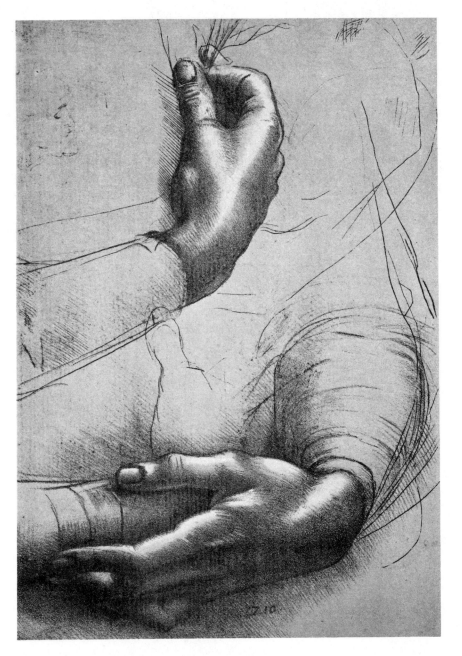

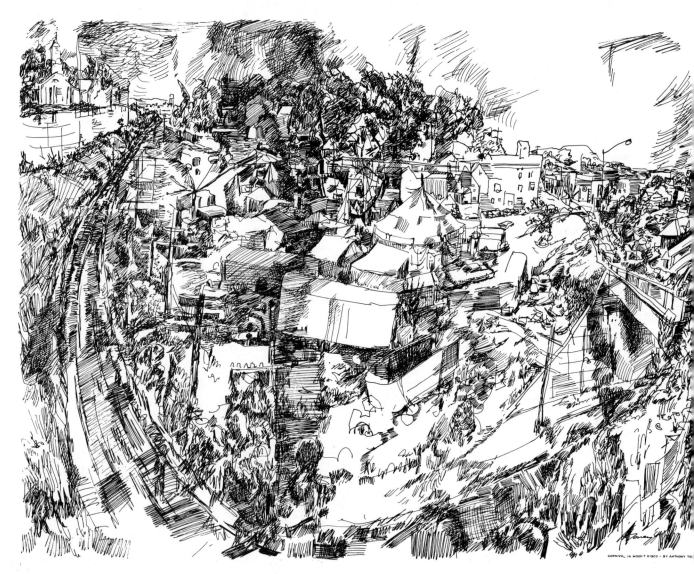

2.4 ANTHONY TONEY, "Carnival in Mount Kisco"; Pen and ink.
You will have the feeling of accuracy but the result is less so.

As you move your line simultaneously over the surface of the paper and the model, you will have the feeling of accuracy. But the result is quite different. Fixing one's eyes on the part rather than on the whole tends to distort the relationship of that part to others (Figure 2.4). Inevitably, the distortions accumulate and the drawing becomes a synthesis of errors in judgment and coordination. We might also call it a cross-fertilization of chance occurrences. Transformations of this kind often lead to freshness and discovery, the very essence of the creative process.

Even if you are a beginner, and certainly if you are experienced, keep drawing until you feel that the paper area looks good to you. We will concern ourselves with organiza-

tion in Chapters 4 and 5. For now, the sooner you allow or even force yourself to persist until you feel a completion, the better. When you draw your line you are cutting the area of the paper into other areas of different sizes. Your goal should be to do so with inspired contrasts of size, texture, and space. Sameness creates unity; differences create interest. For the present let your intuition guide you as you do the following exercises. Anything can serve as your subject.

EXERCISES

Drawing 1. Draw slowly, as though tracing, with a consistent, preferably medium pressure and a continuous line (Figure 2.5).

Draw primarily the outer boundaries of objects and areas, but indicate spatial differences by the way lines connect. A line indicating a forward plane will come in front of the rear plane. Do not erase. The drawing will not be accurate. Continue until the area of the paper feels complete.

Drawing 2. With a similar line and again, as though tracing, keep your line continuous, moving not only along the edge but also along any of the inner structures revealed by light and dark. Keeping your line continuous means that you do not raise your pencil or pen from the paper until you have concluded. The result is more complex than the first exercise. Again, do not become concerned with accuracy of the result; persist with more lines until the drawing feels good to you, or until there's nothing more you can think of to do.

Drawing 3. This time, draw in a similar fashion but much more rapidly. Move freely over inner and outer surfaces, rapidly enough so that there is less control and therefore more chance interplay of line and shape (Figure 2.6).

Fix your eyes upon whatever you are drawing. Without looking at your paper, draw in the same manner as the first and second exercises. This is particularly valuable for those of you who are too tightly concerned with how the drawing looks. It is the *way you*

2.5 ANTHONY TONEY, "Game"; Pen and ink.

Draw slowly as though tracing with a consistent and continuous line.

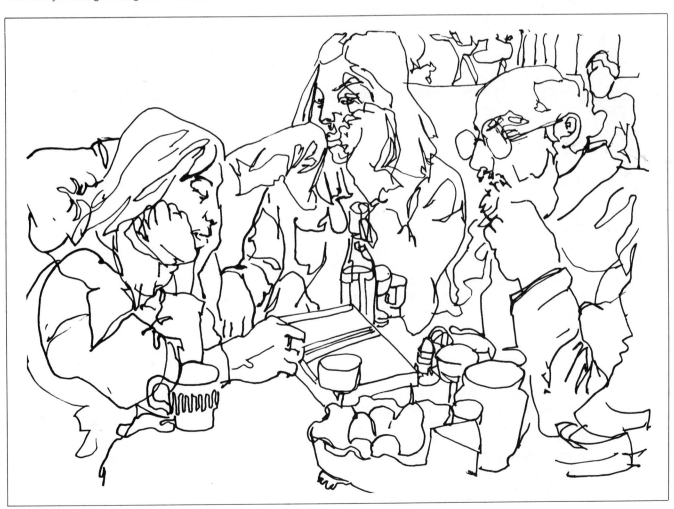

2.6 ANTHONY TONEY, "Study"; Pen and ink.

Draw similarly but much more rapidly so that there is less control.

draw that is more important than what you may want as an end result. In this case, the drawing will be grossly distorted but often of unusual interest (Figure 2.7).

Drawing 4. In this exercise, draw as previously, but be very aware of what your line is doing. Avoid too much similarity of direction, distances, and texture. Ensure that subsequent lines are different from preceding ones (Figure 2.8). Again, do not erase. Stop when your drawing looks good to you.

Drawing 5. While drawing in the same way, consciously distort or exaggerate to get unusual contrasting proportions. Try to express some attitude or mood in the transformations you make. Or dramatize spatial differences, for example, in spectacular foreshortenings.

Drawing 6. Draw a contour drawing and then using Drawing 1 as a point of departure, try to improve it by redrawing on top of it. Now, try to improve this one with still another redrawing. The result illustrates a basic component of trial and error necessary to the creative process. Also the result is full of chance crossings of visual ideas that can stimulate discovery.

Drawing 7. Try the same drawing and redrawing, but use transparent paper overlays for the subsequent drawings. If you wish to end with a clean final drawing, this is one way to approach it.

Drawing 8. If you are beginning to enjoy deliberate transformations, try allowing the image to become even more complex. As you draw something, let the line move over

26

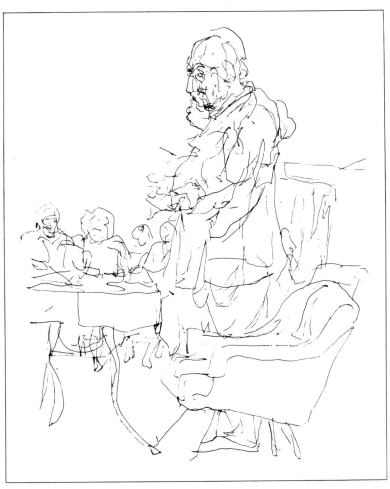

2.7 ANTHONY TONEY, "Study";
Pen and ink.

Without looking at your paper,
draw as in the previous exercises.
The drawing will be grossly distorted
but often interesting.

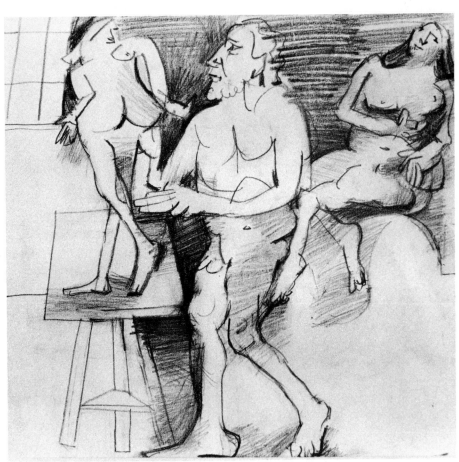

2.8 HERZL EMANUEL, "Sculptor
and Model"; Conte crayon on rag paper.
(Courtesy of the artist)

Ensure that subsequent lines are
different from preceding ones.

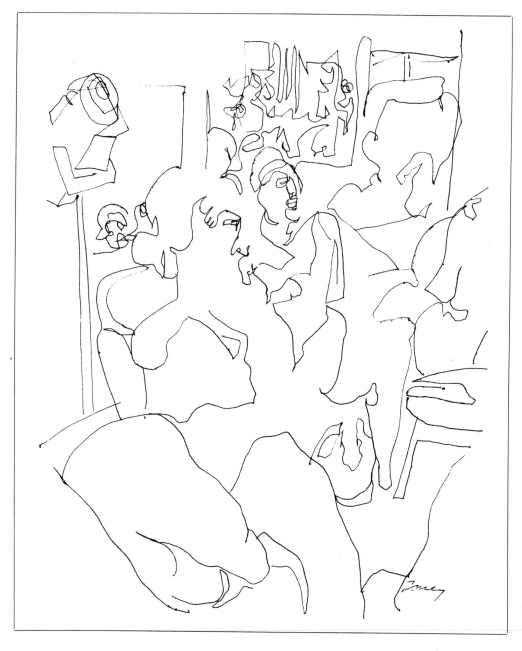

2.9 ANTHONY TONEY,
"Composition"; Pen and ink.

Allow the line to move
from one surface to another,
creating odd juxtapositions.

the surface of something else, joining the sec-
ond to the first and then on to the other forms
as the environment might suggest and back
again, mixing them up so that the resulting
image is a complex montage (Figure 2.9 and
2.10). This can stimulate your imagination and
also lead to exciting visual ideas.

Drawing 9. If your model or models
move, add one aspect of a pose to another so
that the result is a strange mixture of attitudes
and gestures (Figure 2.11). In a classroom,

two-minute poses also lend themselves to this
exercise. Those who worry about accuracy can
benefit from drawings that purposefully dis-
regard it.

Drawing 10. Disregard your main sub-
ject or model and draw everything except that
model. The model will be the empty space.
This exercise is fine for developing awareness
of surrounding or negative areas. Positive
areas are those of your principal subjects,
negative areas are those in between.

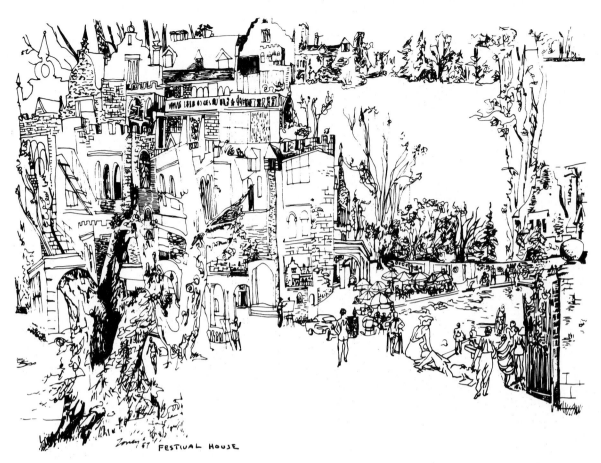

2.10 ANTHONY TONEY, "Festival House"; Pen and ink.

The resulting image is a complex montage.

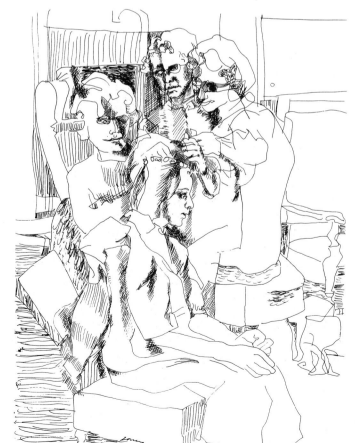

2.11 ANTHONY TONEY, "Anita Doing
Adele's Hair"; Pen and ink on tan paper.

Drawing the model as she moves results in
a mixture of attitudes and gestures.

Drawing 11. To further stimulate your imagination in contour drawing, draw a particular thing or model in one part of your paper. Then draw another version of the same model or thing next to it. Make sure that the drawings are different. Draw another and another. Try to be as inventive as you can in the differences that you include. Keep drawing until you fill the page (Figure 2.12).

Drawing 12. Repeat Drawing 11, but this time be even more inventive. Transform each image completely so that each one is like a metaphor or analogue. These images may become much more abstract (Figure 2.13). Let them.

Drawing 13. Experiment with using a brush in the previous exercises. Use either ink or paint. Try to silhouette the whole shapes of what you draw; then just the areas of dark or light if you are drawing with white on dark paper. Turn each area of dark into a calligraphic stroke of the brush (Figure 2.14). Try to ensure that each stroke contains unusual contrasts. Another time use different values so that you can indicate space differences. These exercises are excellent practice for calligraphic painting.

All of these ways of drawing illustrate the part-by-part approach when you are looking at something. It is also important to make yourself aware of the possibilities of drawing from imagination (Figure 2.15). A few such exercises follow.

Drawing 14. Fill a page with imaginary writing. Just think in terms of letters and words and improvise as you go along (Figure 2.16).

Drawing 15. Fill pages with small imaginary figures. Don't try to draw accurately. Simply think figure as you move your continuous line on the page, letting the form and pose suggest itself. Doodle figures whenever an opportunity arises. Do so with a simple continuous line.

While the foregoing exercises have stressed an even line, you can also draw with

2.12 ANTHONY TONEY, "Repeated Figures"; Pen and ink. Fill a page with varied versions of a pose.

2.13 Transform the figure as much as you can.

2.14 ANTHONY TONEY, "Seated Figure";
Brush and ink.

Turn each area of dark into a
calligraphic stroke of the brush.

2.15 ANTHONY TONEY, "Drop"; Pen and ink on tan paper.

Draw freely from imagination.

2.16 ANTHONY TONEY, "Figure and Writing Doodles"; Pen and ink.

2.17 RAPHAEL, "Madonna and Child Studies"; Pen and ink.
(Courtesy Dover Publications, Inc.)

You can also draw with linear variation of value.

linear variation (Figure 2.17). Your line can get heavy or light, thick or thin. You may want to proceed from part to part, developing each with great fullness of tonal differences as well as line. This is still the part-by-part approach.

As you draw, your skills will develop. Do not become concerned about how well you are doing. Keep at it at every opportunity. You can have confidence in the process.

These exercises develop various skills and are a way of searching out visual ideas. They encourage sensitivity to detail, to pressure of touch, to shape, pattern, and the role of accident in creativity. They foster improvisation and an awareness in building structure part by part.

PAINTING IN THE ADDITION APPROACH

As applied to painting, the addition method is similar to that in contour drawing. The difference lies in the complexity of color.

You can simply start with a part that interests you, finish it, then proceed to the next part, continuing in this way until you have filled the canvas. If at each stage you add what the previously put down areas demanded, everything that is necessary will be there (see Plate 4).

Once you have a total idea down, you can evaluate and change it if necessary.

You can also begin with a contour drawing and simply fill in the areas in the drawing, again satisfying your taste as you go along, until all areas are filled (Figures 2.18 and 2.19). Sometimes you will discover an almost magical orchestration. At other times you will have to search out what is unsatisfactory. How you decide will depend to a great extent upon your aesthetic viewpoint, as we will see in Chapter 7 when we discuss the creative process.

Painting in the addition approach can be complex (with many shapes) or very simple (with the fewest possible shapes). In either case, finding the color or texture or shape necessary to what is already there may require much redoing (Figures 2.20, 2.21). What one

automatically gets is often not quite right, so be prepared for many trials and re-trials until you get the qualities you feel necessary (see Plates 4 to 6).

Repainting areas as you go may sometimes require removal of the area to be changed. Generally, if you paint more thickly than the area replaced, and if your touch is direct and bold, the strokes will be fresh, not intermixing with the layer below. That is one of the reasons why you should start with leaner and thinner strokes.

One way to change an area is by blotting. Place an old newspaper flatly over the area and gently rub the surface. This does not alter the area but merely absorbs the medium, allowing easier repainting. If that is insufficient, with your palette knife you can remove the passage and wipe it out with a lint-free cloth. Then simply allow the canvas to dry. This kind of control of your surface will keep your painting bold and strong.

Painting definite areas, calligraphic strokes, feeling the tension and texture of the pigment as you touch the canvas are basic to controlled technique.

If you want sharp-edged minimal painting, you can use masking tape. The surface must be dry to ensure a sharp edge. Masking tape works somewhat better with quick-drying pigment such as the acrylics, but it can also be used with oils if you are patient enough.

In the part-by-part approach, it is possible to blend as you go along if you are bold and skillful. When you need to repaint, this kind of blending becomes difficult, because the dry and wet areas fail to conform. In this case you will have to repaint the whole. Blending can be more effectively achieved by using definite strokes for the main planes and then smaller strokes for the intermediate and transition planes. When the surface is dry, you can use dry-brush and transparencies to complete subtle modeling without diminishing the solidity of volume relationships.

If you plan to work opaquely and directly, it can be helpful to establish a warm grey ground. As you proceed, either with or without a drawing and with small planes, relationships can be better controlled if you work in more than one area simultaneously.

Stages in
Addition Approach
Painting

ANTHONY TONEY, "Anita's Guests"

2.18 BEGINNING

The addition approach can begin with
a contour drawing over a ground.

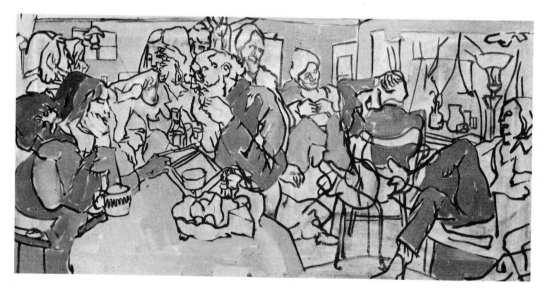

2.19 ELABORATION

Fill in areas as one idea
suggests another.

2.20 FURTHER ELABORATIONS

We may need to change our minds
often as we go along.

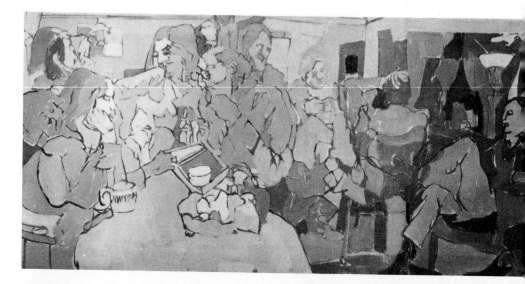

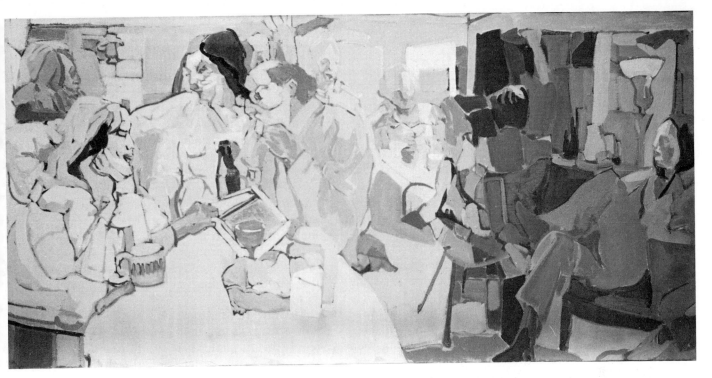

2.21 ANTHONY TONEY, "Anita's Guests"; Oil on canvas.
You will feel when you have the quality of relationships necessary to you.

If you are more interested in transparent color, you should work on white canvas, because its whiteness becomes part of the color value of each stroke.

THE WHOLE APPROACH

In contrast to the part-by-part method, the whole approach begins at once with a rough entity. The paper or canvas is divided and subdivided into the main implied shapes. The limits, the principal thrusts, and the general visual contrasts are broadly stated. Then they are progressively modified until the work is complete. The work thus proceeds through a series of stages, each somewhat complete but becoming more and more complex.

One stage leads to another, moving from the general to the particular, from mass to detail, from simplicity to complexity, and back again. The process remains open until fully realized. Emphasis on movement creates fluidity, enveloping space and the feeling of atmosphere. The method is very flexible and allows for extreme accuracy or any form of transformation.

DRAWING IN THE WHOLE APPROACH

Whether your subject is complex or a single figure, the method is the same. Although one can draw without considering placement on the paper, the whole approach intrinsically demands designing the total area.

Should the main implied shapes or general area of key figures or other subject matter be large or small, placed left or right, or run off the paper? What is the central movement of these shapes? How do they group? The implied shape is geometric and is blocked in for either the whole or part, for the group or for individual figures or things. State the boundaries of what you draw in their simplest terms. Remember, these shapes are just broad guesses and not mechanical prisons within which you draw. They serve as points of departure.

Since flexibility is the essence of this method, keep your lines as light as possible for as long as possible. If you do your preliminary search for placement and general relationships on the actual drawing, don't be concerned by the many lines. They will all become absorbed as the drawing progresses.

We can also explore the possibilities of

35

ideas in thumbnail sketches (described and il-lustrated in Chapter 7) before proceeding to the large paper. Even dark and light patterns can be worked out generally before starting.

The first stage requires concern for the essential movement relationships. What is the key direction of the largest shapes; does it re-flect or contradict the movement of the group? Make at least a preliminary decision as to what is most important. The main movement determines the relationship of the other movements (Figure 2.22).

Once you have the basic movement rela-tionships, establish the main proportions, the center of things. Where are the key parts rela-tive to each other? Are they higher or lower, wider or narrower? These judgments are made easier because you are comparing them to each other and to the whole.

Your first judgments are tentative. Check them by seeing how they line up vertically and horizontally. Don't hesitate to actually draw these reference lines. Make changes un-til the proportions, directions, general widths and lengths check out right or as you wish. Spend as much time as necessary on these large relationships.

Using the same methods, search out sub-divisions and then even smaller relationships. As you proceed, still keeping your touch light, make sure that you are relating parts to each other throughout the paper. The whole image should be brought to the same stage.

At this point you should have an ab-straction, a general statement of directions and proportions. There should be no actual edges or contours. Relative distances but not detail should mark this stage.

The next stage is one of developing the surface movements. This stage simultaneously searches out the complex interplay of surfaces moving in space and begins the dark and light pattern.

These surfaces consist of planes that are revealed by the way light hits them. Some therefore are lighter, others darker. In each object some of the planes that turn from the light, acting as a corner, are darker than the rest of the planes that do not get light. But the rest are affected by indirect light bouncing from other surfaces. These darker planes are called *turning planes.*

To develop the surfaces, these turning planes are stated as gestures, or the move-ment of a sequence of planes in space. State them as a series of lines that caress the sur-face. Keep your pressure light. You should build your values to the actual darks desired very gradually (Figure 2.23).

Move over these surfaces gently, first the larger and then the smaller. Again, work in stages. First, search out all the large move-ments and then the others, ending with the smallest. In the process you will be describing or transforming the interrelationships of all the various anatomical and other material forms in space.

Draw the gestural movement as though you are caressing the surface of the object; feel its every plane or position, each turn and change. Sensitively yet boldly touch the draw-ing where there is darkness, and let up where there is light. As in contour drawing, identify with the movement of the surface in space. The gesture lines at once suggest the appear-ance of volumes and pattern as the dark areas begin to group.

In this stage you can further control your drawing by searching out continuities. These are movements that line up with each other in any direction, and extend throughout the work. For example, as you draw an area in the head, move in the same direction perhaps to the shoulder, and from there perhaps to an arm, and from there to some other area that seems to line up in that direction.

Your gesture lines begin in this way to pull together and recheck the drawing even as they develop it. These continuities are some-times part of your initial blocking in of your proportions and other relationships. But they are as important in this later stage as you check and tie areas together. Such continuities stress purer geometric movements: vertical, horizontal, diagonal, and curvilinear. These extend through the drawing, describing a web of interlocking movement that is general and therefore abstract.

Your gesture lines should seek out the beginnings and ends of the volumes you are relating to each other. Where does this muscle begin and end? What does it line up with? Feel your gesture move all around the volume of the body or tree or whatever. It is as

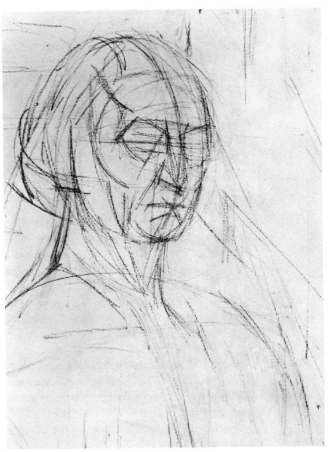

2.22 Beginning a self-portrait in the whole approach.

Place the main implied shapes on the page, then draw the main movements and proportions relative to the whole. How do they line up vertically and horizontally?

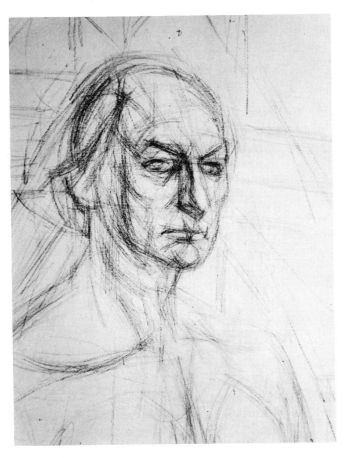

2.23 Second stage.

The turning planes are stated as a series of lines that caress the surface.

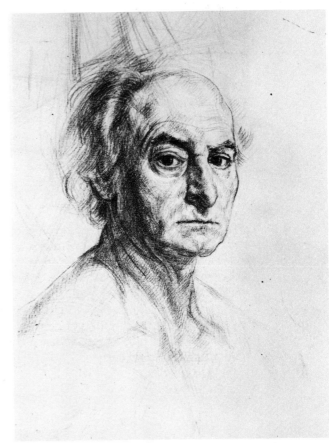

2.24 ANTHONY TONEY, "Self-Portrait"; Charcoal.

As you develop the surface movements, you create the planar relationships and the dark and light pattern. Edges are the consequences of the internal structure. They are done last.

though you are drawing in space, and the objects drawn are transparent.

Take each stage throughout the entire page, gradually getting darker toward whatever value pattern idea that suggests itself. Depending upon your viewpoint, you will stress the values as they appear to you, or as they feel, or according to the needs of transforming discoveries.

You should have been moving from the inside out. The form you have been developing is that of the internal structure. As you proceed, these inner volume interrelationships will sooner or later end. Once you have developed the volume's character, you will know where the edge must be.

The edge will not be a hard, consistent line but rather mysterious, lost and found, hard and soft. It will be determined by what you see or need for your oganizational ideas. The contrast of value of the line will help to bring that edge forward or make it retreat, in relation to the other parts of the composition. Generally, the edge will vary according to its local value and to what is next to it. Where values are very similar, the edge will tend to get lost. Where the contrast is strong, the edge will be firm and dark (Figure 2.24).

Later on we will deal with the complexities of space. At this point, it may be enough to understand that those parts come forward that are darkest, lightest, most defined and detailed, or different from the rest. This is true whether you are copying or making a composition conform to some invention. If you are copying, the darkest parts will be determined by local color and value and position relative to you. If you are creatively transforming your image, light and dark definition is determined by where you establish your center of interest or where you feel something most strongly.

In the whole approach the conclusion is reached as you decide—according to your bent—which are the key repetitions and the lesser ones; where to put your climax, your final details and edges. When the approach is mastered it is thoroughly flexible, allowing any aesthetic direction, whether classical idealization or romantic fervor. It works well for the most faithful copy and for any invention.

You can learn the part-by-part drawing method by yourself because it is a rather natural way to draw. But the whole approach requires instruction. The exercises that follow dramatize its main techniques.

EXERCISES

The following exercises stress particular stages of the whole approach method. Choice of subject or model is up to you.

Drawing 1. Perceive and put down the implied shape of the main object or objects to be drawn. Practice placing the implied shape in different parts of your paper and vary its size. How and where does it feel best? (Figure 2.25.)

Drawing 2. Search out other implied shapes, those that are smaller within the larger whole (Figure 2.26)

Establish the limits of the largest objects or figure. The limits are its top and bottom and its implied shape. Then find its main movement. If it is a thing that is standing, the main movement may simply be a vertical line. All the other movements will then be subordinate, whether horizontal, curved, or diagonal. Again and again, set these limits: the main direction and the subordinate direction relative to it (Figure 2.27).

Drawing 3. State again the limits suggested and map the main proportions. Start with central divisions and proceed from there. Try the same thing with different decisions of proportion. Compare them. Again, make your guesses, and then try to use the first as the basis of better guesses. Judgment of proportion may take time to learn.

Drawing 4. Begin again as above and work with reference lines to see and check what aligns with what vertically and horizontally. Learn to compare angles. Hold a pencil with an outstretched arm and see if one part of whatever you are drawing is higher or lower than another part. Use reference lines to find and state the correct direction (Figure 2.28). Search out the main ways that the parts line up with each other.

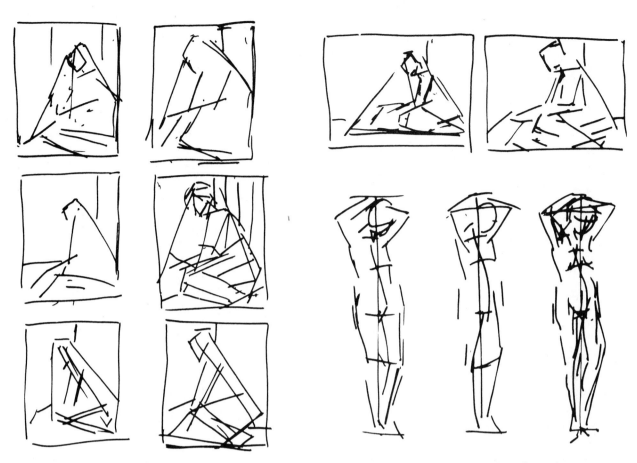

2.25 Implied shape exercise. Perceive and place the implied shapes in varied ways.

2.26 Further implied shapes. Establish the limits, the main movements, and then the subordinate movements.

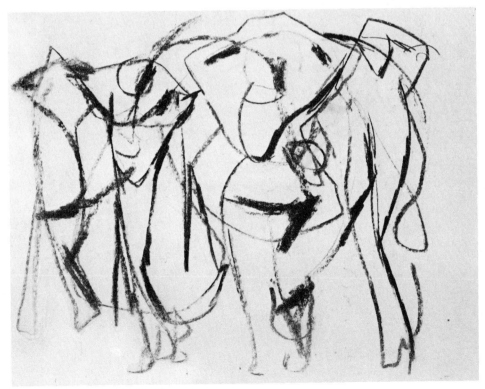

2.27 ANTHONY TONEY, "Surrender" study; Charcoal.

Feel the large implied movement interrelationships.

How do parts line up in diagonal and curvilinear directions? Search for all the main ways that the parts line up. Make a note where one thing is relative to another and another in the same direction. The result will be a map of placement of parts (Figure 2.29). Don't draw the parts themselves, but simply where they are. Do this enough so that you will habitually seek such continuities (Figure 2.30).

Drawing 5. With a quick beginning as above, build rapid gesture drawings that describe the way the darks move. Practice controlling your touch. See how light your gesture lines can be or how dark. Try to skip the light areas, making a line only where the value is dark. Try to feel the movement of the surface. Feel the volume as though you are drawing in space and can move your lines around the volume. Search where a movement begins and ends (Figure 2.31).

Don't become concerned about finishing exercises or with how they look. They serve only to get you used to a way of working, a way of seeing, and a way of helping you develop a selective touch.

Drawing is done for its own sake, as a means of expression. One also draws to explore the structure of things, to record subjects, or to search out compositional ideas. You may draw before painting. In that case you will find either the whole or addition approaches useful, depending upon your goal. You can draw directly with paint, keeping it thin so that it can be wiped off or easily covered or you can draw with charcoal or a sim-

2.28 ANTHONY TONEY, Beginning "Figure Study"; Pen and ink.

Use reference lines to find and state correct directions.

2.29 ANTHONY TONEY, Elaboration.

Line up the parts. The result is a map of where things are.

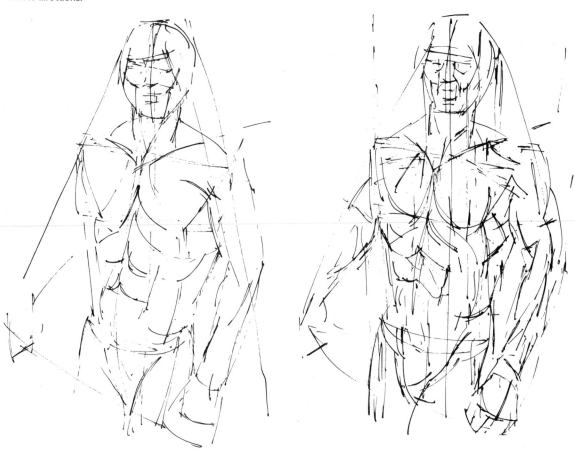

2.30 ANTHONY TONEY, "Figure in Interior";
Pen and ink.

Eventually you will develop the habit of
seeking such continuities.

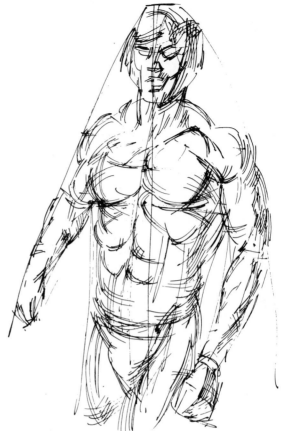

2.31 ANTHONY TONEY, "The Gesture";
Pen and ink.

Feel the volume as though you are drawing in space.

ilar medium (see Plate 7). Although it is pos-
sible to mix approaches, in the beginning it is
preferable to keep them distinct so that you
can clearly see the differences.

PAINTING IN THE WHOLE APPROACH

If you have a drawing as a base, the process
of painting in the whole approach will be dif-
ferent than when you do not start with a
drawing. If the drawing is in charcoal, it
should be solidly fixed before proceeding. If
the drawing is painted, whether it is still in
line or developed in tone, it should be al-
lowed to dry before continuing, unless the
drawing is but a point of departure, and you
intend its destruction.

With a fixed or dry drawing on the can-
vas or paper, simultaneously establish the
largest local values and colors semi-trans-
parently so that the drawing comes through.
Remember that a color, even if it contains
some white, will become somewhat trans-
parent if you include enough medium—water
in acrylic; turpentine, at this stage, in oil.

Next search out and paint the largest
subdivisions of dark and light, still very
transparently and at least thinly (see Plate 8).
Then, using less transparent tones of color,
begin to enrich the larger areas with varia-
tions. Each of the large areas and the smaller
areas are or become planes. Their differences
arise from the fact that light falling on the
surfaces affects each part differently. Some are
darker or lighter, with more blue or yellow or
red.

Mix first the larger areas on your palette and then place that color on the canvas as one or several strokes, guided by your drawing which can still be seen through the previous, washed in, transparent color. When you stroke your canvas, try to do it simply and directly. Put down each stroke boldly yet sensitively, as though you were caressing the surface. Don't fuss with the stroke; put it down and leave it alone. If it is too light, too dark, or too bright and jumps out of the guiding values that you first established, simply remove the offending area with a palette knife, or blot or rub it out. Then replace it. You can continue the procedure until you are able to match value and color.

If the color does not jump (does not seem too different) from the general value upon which it is placed, let it remain even if there seems to be something wrong with it. You will not be able to judge until your canvas has been developed far more fully.

Proceed to paint in all the larger changes until the canvas is covered. This becomes the first stage of actual painting. Subsequently, and better if the paint has somewhat dried, mix and brush in smaller strokes and planes, further modifying the larger again throughout the canvas. This procedure continues until you are satisfied (see Plate 9).

The approach is general, bold, fluid, open. As your painting develops, change your mind as often as necessary. But paint with definiteness of touch from the beginning to the end. The strokes are calligraphic. They follow the contours of the surface as indicated by the way the planes seem to move.

First the largest masses are stated, followed by smaller and smaller areas of value and color, interrupted by changes as they become necessary.

Wholeness means first of all the involvement of the entire canvas. Subsequent relationships are changes within that whole. Begin with an entire situation, modifing it until you gradually reach the necessary detail.

If you prefer to work directly without a drawing on the canvas, you still follow the same method. That is, state the largest contrasts at once so that the canvas is covered quickly. Do not become imprisoned by this first statement. Work spontaneously and automatically, freely changing, adjusting, reacting and readjusting. Your strokes are at the same time drawing and painting strokes. What you get down first becomes the base for a better color, value, direction, etc.

Walk back from your work so that you see it from a distance. It is not easy to see what the relationships are doing as a whole. Sometimes the context will need to be changed. Take the painting into another room, or even turn it upside down. Hang it somewhere in your home or studio where you can see it while doing other things.

Your basic ideas will come from your subject, from the model, from reference material that you have put together, or from your head as one thing suggests another. Once down, the contrasts will affect you, communicating directly and soliciting changes dependent upon your requirements.

Where you wish subtlety of modeling, do not blend the areas. Let them dry strong and definite. These planes can then be modified by transition planes and, if necessary, when they are dry you can put in still smaller planes or, with dry-brush and glazes you can become as subtle as you wish (see Plate 10).

Have confidence in the approach. One stage will make possible a more complex one. Think less of what is represented than of where, how large, dark or light, bright or dull an area is. Compare similar colors to each other and similar areas to each other. Are they different enough? Is the sensation exciting? Do the differences stay within the larger context?

If you wish to copy nature, remember that nature is complex. Your first planes cannot give you that subtlety. You will need the counterpointing sensations of bright and dull, warm and cool, to give you the vibrating life in nature. Try to see the differences in local color. Is this more yellow or blue? Where is the value lightest? What is next lightest? Where is it darkest? and so on. This kind of comparison can help you see the differences necessary to make your planes take the required positions in space.

Compare the values you are looking at, or are trying to get, with purer counterparts. Is this dark, as dark as black? The lightness of an area may or may not be close to white.

Your edges will be the consequence of the work within the larger areas. They come last and will be hard or soft, lost or firm, dark or light, depending upon what is next to them, which edge is in front, which is behind, and how the light affects them.

The whole approach can lead not only to naturalism but to any transformation. It can remain very simple or become very complex. But generally it stresses movement in space and is quite three-dimensional in feeling. The whole approach is represented in the baroque of Rubens or Rembrandt, in the realism of Chardin or Vermeer, as well as in the impressionism of Pissarro and Monet.

The whole approach is clearly evident in the work of the "action" painters. Since sketches are dispensed with or used only as a springboard for improvisation, the whole creative process is exposed on the canvas.

EXERCISES

The essence of painting in the whole approach requires that we be able to see and state the largest mass differences, the central confrontations to which all else is subordinate. The following exercises give practice in the method.

Drawing 1. In a landscape situation, paint, on board or paper, the broad key differences of foreground, middleground, and distance against the sky (see Plate 11). Do one every thirty minutes, trying to catch the differences that arise as the light changes. Keep your strokes broad and large. Do not get involved with detail. State the differences in large flat areas. Try them against white and earth-toned grounds. You will learn to see and state the differences more and more easily.

Drawing 2. Try the same thing with a still life of varied bottles and drapery. Arbitrarily enlarge and make smaller some of the key shapes. Alter the generalized color rela-

tionships. Compare the results. Keep the shapes flat (see Plate 12).

Drawing 3. Set up a white still life with objects that approach white in value and color. Again in flat ways try to state the differences of value and color. Try it again and again. Keep your paint fresh. Paint with strokes that are definite and put down in ways that feel the texture of the paint as it touches the canvas.

Drawing 4. Pose before a mirror so that the light hits your face frontally and clearly defines side and frontal planes. State the large contrasts but go on to state the key differences within the local color. Then on top of these broad areas, paint with calligraphic strokes that do not touch each other (see Plate 13). Leave some of the base areas showing in between. Do not make the planes very small. Just establish the most essential differences that you can perceive. Do not concern yourself with likeness or detail. Since the strokes are separated, there will be no blending. Treat the whole area of the paper.

Drawing 5. In the final exercise, use the same calligraphic stroke to set up relationships of continuity. Your subject can be anything—a still life, landscape, figure in interior, etc. Simply state where one thing is relative to another throughout the entire paper in any particular direction. Keep the strokes separate. Each stroke can be somewhat different, larger or smaller and different in shape. Change the color according to the differences that you see. Keep at it until the paper or board is full of these unevenly distributed calligraphic strokes. Try the same kind of thing against a white ground and an earth-colored ground (see Plate 14).

Although exercises are valuable for stressing a particular aspect, remember that you grow most as you tackle and solve problems that interest you, one after another.

The whole approach can be used in both direct and indirect painting, as we shall see in the next chapter.

CHAPTER

3

Direct And Indirect Painting

Direct and indirect painting are two technical approaches to painting that oppose and interact with each other. Much of today's painting is primarily direct, whether in the whole or part-by-part method. We mix a color and place it on the canvas. Indirect painting separates a painted drawing stage from that of color. It lends itself most easily to the whole way of working, but it can accommodate the addition method as well.

DIRECT PAINTING

The previous chapter dealt with direct painting in connection with the two opposite approaches toward organizing a canvas—the addition approach and the whole approach. In this chapter we will examine opposing ways of applying color.

We paint directly whenever we deal at

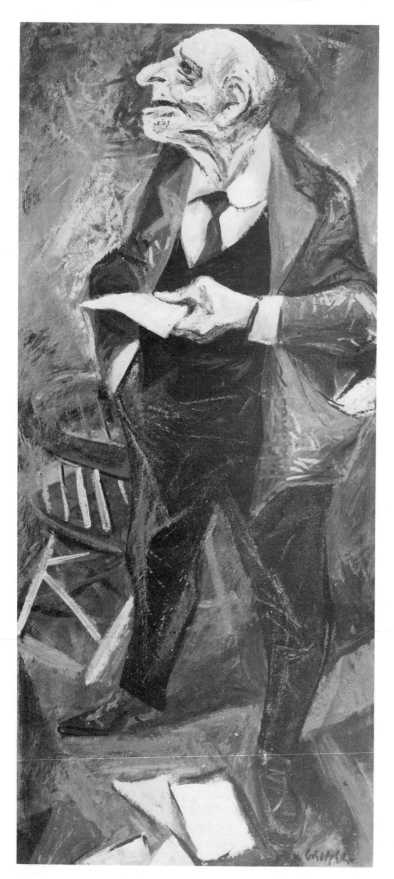

once, or soon, with color oppositions (Figure 3.1). We may make a drawing or not, but in direct painting the drawing is a relatively brief point of departure for painting. In indirect painting, the drawing is put down and more or less fully developed before color is added as a separate adjunct to the value relationship already stated.

Most artists set their color out on a palette. Some work out of containers, mix in jars, and perhaps use a palette as well. Others use spray cans or spray guns. Contemporary experimentation and new media have enlarged the range of ways of mixing and applying color.

I recommend that you mix your color on your palette with your brush and then paint with a calligraphic stroke (Figure 3.2). You can also mix and paint with a painting knife (see Plate 16). When a large surface is to be covered, some painters have used rags, sponges, air brushes, trowels, and even rollers.

Recently, in a large mural, I used rags and a long handled broom for the largest initial areas. But I soon turned to large house painter's brushes to get more control.

Some painters paint by pouring the paint onto the canvas. Some spatter it, attach montage and even collage elements, and paint on top as well. These are all examples of direct painting, since the painters are immediately involved with color.

Some painters try to obliterate the brush stroke and remove all painting texture (Figure 3.3). Air brushes, washes of transparent colors, and sponged surfaces can give that kind of smoothness (Figure 3.4).

Other painters blot, scrape, and dig into thick areas of paint. Some even cut or burn holes in the canvas. There are artists who build special stretchers that have raised and recessed parts. Some stain raw canvas.

I recommend that you mix on a palette and do not blend your strokes, but there are painters who do mix on the canvas, blending their areas or strokes as they work. Still others blend their strokes later with a special butterfly brush.

3.1 WILLIAM GROPPER, "Southern Senator"; Oil on canvas. Courtesy ACA Galleries)

In direct painting we deal at once with color oppositions.

3.2 JOSEPH HIRSCH, "Painted Face";
Oil on canvas.
(Courtesy ACA Galleries)

Each plane becomes a calligraphic stroke.

3.3 ROBERT GWATHMEY, Oil on canvas.
(Courtesy ACA Galleries)

Some painters obliterate the brush stroke.

3.4 PAUL JENKINS, "Phenomena—
High Fork"; Watercolor.
(Courtesy ACA Galleries)

Some artists work with large flat washes of color.

For some years I have gravitated toward keeping each of my strokes separate as part of a mosaic-like structure. But even brush strokes can be used in many ways. We have already described the methodical buildup of flat planes, whether toward the relative flatness and closedness of the part-by-part approach (see Plate 15) or in the fluid openness characteristic of the whole method. But painters also build with dots and dashes of color (Figure 3.5), a method initiated by the impressionists. Some work with layers of dry-brush (Figure 3.6). Others paint with gesture lines of slender strokes of color that move with the surface, seeking out and describing its differences.

Each method makes possible its own kind of relationships, often unachievable in any other way (Figure 3.7). Inevitably you will experiment and discover what seems best for

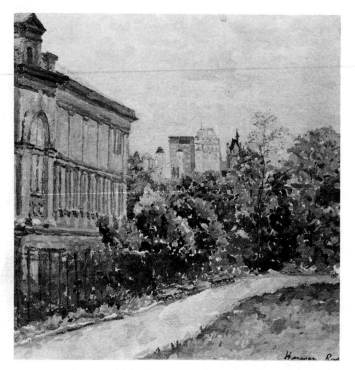

3.5 HERMAN ROSE, "Central Park and Metropolitan Museum"; Oil.
(Courtesy ACA Galleries)

You can build your work with planes of color.

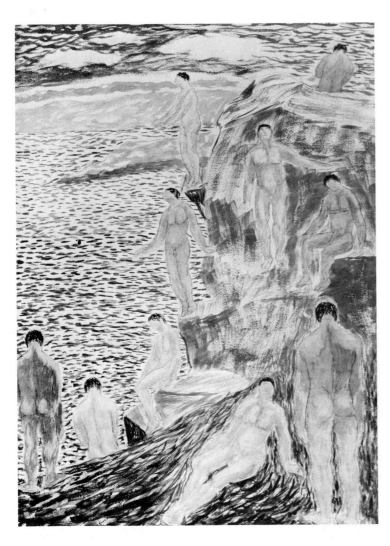

3.6 ABRAHAM WALKOWITZ,
"Bathers, Male"; Watercolor.
(Courtesy ACA Galleries)

Some painters work with dry-brush.

3.7 ZERO MOSTEL, Oil on canvas.
(Courtesy ACA Galleries)

Each way of working makes possible
its own kind of relationships.

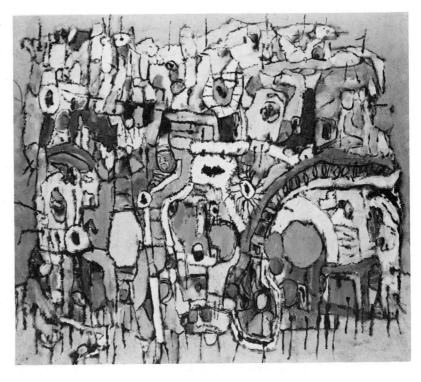

you. In the end it will be the quality of your visual structure that will determine its personal and social value.

CALLIGRAPHIC STROKE IN DIRECT PAINTING

I consider the calligraphic stroke an important technique that can open up the vast range of ways of applying paint and give them more meaning. The calligraphic stroke leads to control and to psychological identification with the structural surfaces.

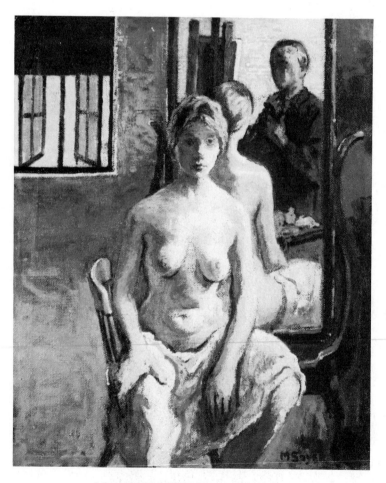

3.8 MOSES SOYER, "Artist and Model"; Oil on canvas. (Courtesy ACA Galleries)

Smaller strokes are superimposed toward defining necessary qualities.

In the addition method, the stroke is related to either a precise drawing or none at all. Like the notes in jazz improvisation, each stroke is determined by those that have gone before.

In the whole approach the strokes may be large, sweeping and usually preliminary, while others are superimposed to define the qualities of form (Figure 3.8).

The brushes used depend on the task. The character of the area may demand a house painter's brush, a one-inch flat bristle brush, or a round red sable for subtleties.

Strokes are called calligraphic when they move like writing or lettering. They are large or small gestures (Figure 3.9). Their shapes can be infinitely varied, depending on the source of the suggestion for each stroke. Psychological identification is achieved as you extract the shape from its reference and place it on the canvas as though placing it on the object that inspired it. You feel the character of the surface, its movements in space, and you identify with it.

You also feel the sensuous quality of the paint itself, its texture, thinness or thickness, as you touch the canvas (Figure 3.10). This involvement makes your stroke at once sensitive, strong, and bold. The definite stroke gives control by providing a clearcut area to change if necessary.

Of special importance is the relation of the palette, the brush, and the palette knife to the painting act. The palette must be kept organized. The color along the edges should be grouped in prismatic sequence, and it should be plentiful. You cannot paint without pigment. Clean the center area of your palette frequently. You must have a clean area on which to mix.

When your mixing area becomes clogged with mixtures, with your palette knife mix similar hues together and put them along the edge. Then rub the surface clean. The greys along the edge will serve as the color you need somewhere or as a base for remixing. Also keep the brush you are working with clean. Dip it in turpentine or in your cleaning solvent and wipe it with a rag. It is essential to clean your brush and palette as frequently as it becomes necessary if you want to be able to control your color.

3.9 ANTON REFREGIER, "The Birds Are Falling"; Oil on canvas. (Courtesy ACA Galleries)

The stroke is a gesture, large or small.

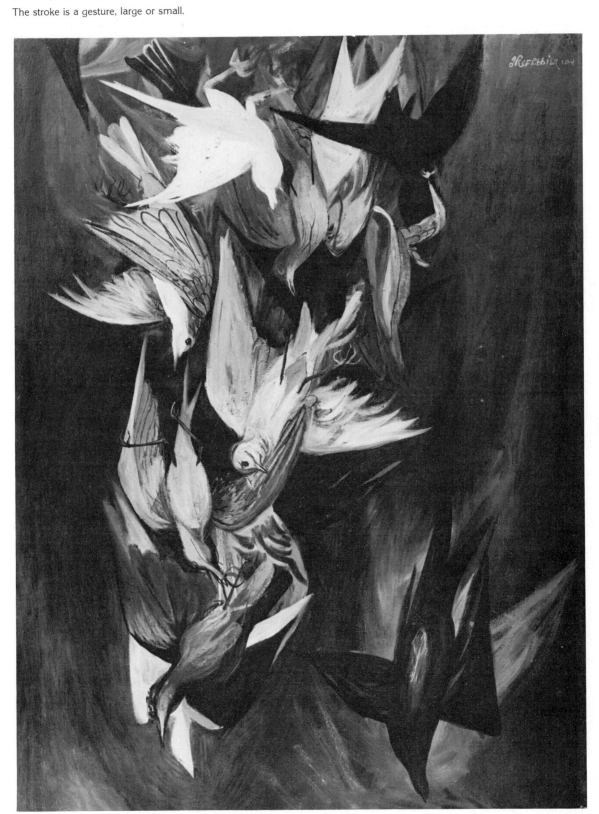

3.10 JOSEPH SOLMAN, "Alison";
Oil on canvas.
(Courtesy ACA Galleries)

Feel the sensuous quality of the paint,
its texture, thinness or thickness.

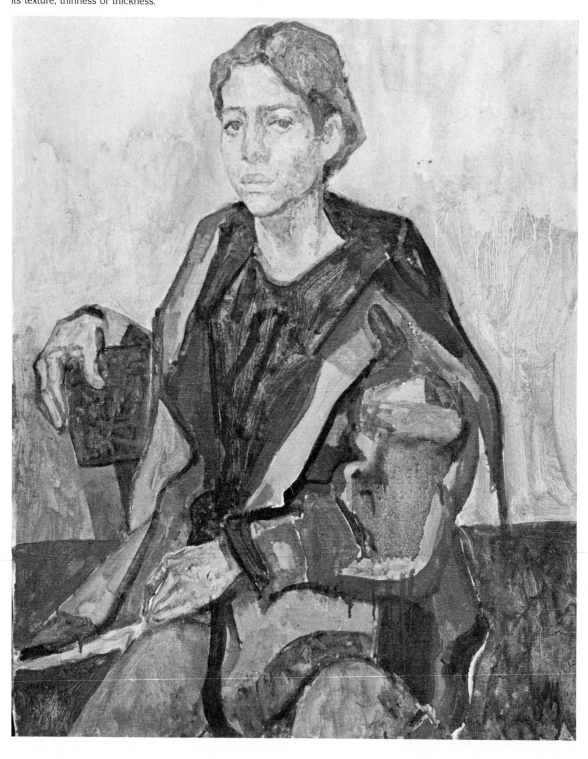

When mixing a light color, begin with white. Add primary hues gingerly until the desired value and color are evident. This will take experience. Too often you will pick up too much of a color to mix with the white. Learn to feel the right amount and develop the habit of dropping off some of the color before mixing it with the white. You can add to it if necessary.

If the hue is to be darker, mix the varying amounts of red, yellow, and blue first and then add white to get the value. Mixing a color is not easy. You will have to try many times before you get accustomed to putting together the right amounts of opposing colors to get the right nuance. If the color you are mixing begins to pile up into a large quantity, just take small amounts to change. Don't keep trying to alter the large amount or it will grow endlessly.

When you are mixing colors that have similar qualities, the same spot of color can be used by simply modifying it with the primary that seems needed. Thus, in a particular area it becomes relatively easy to vary each stroke as you go. It is a way of controlling your value range in that area.

Of course if you need a different hue or an entirely different value, you will have to start fresh. Try to remember that naturalism demands ever-changing hues, because each position in space is inevitably a different value and color. Any nondecorative painting demands at least the appearance of difference between the repetitions employed. Colors will appear different according to their immediate context.

You don't need many brushes, but the brush you are using must be cleaned with your cleaning agent before you mix an opposing color or value. A painter invariably paints with a brush in one hand and a rag in the other. But when the color change is related, it is less necessary for the brush to be clean.

The time taken to keep your palette in order is not wasted. It saves you time in keeping control. Work with passion, but with patience as well.

Direct painting demands that you not only act but also *react* to what you get on the canvas. You try something, change your mind, try again and again in all the stages of the work. Calmness as well as involvement is crucial. Don't hesitate to blot with newspaper or cloth any area to be changed. If the paint surface becomes too thick to change, carefully cut it off with your palette knife before replacing it.

When you have the canvas going well and it's all very wet, let it dry before proceeding. Try for a relative completeness at each stage of your work.

Learn to let your canvas communicate with you. The relationships will reveal themselves if you give them time and receptivity. This may require a fresh emotional context. If some particular area transfixes you, another day may well put it in its place. If you find yourself trapped by some part, and you are no longer seeing the whole, pull yourself away. Let the painting wait for another time. Start or work on something else. It may take some time before you can see what all your painting is doing. Be confident that sooner or later you will see what is necessary.

You will know when your canvas is completed. You set up the problems that you are prepared to solve and with luck you keep going somewhat beyond yourself. Working with patience and persistence you will inevitably, and sometimes suddenly, realize that the structure feels good to you and there is no more to do.

INDIRECT PAINTING

While direct painting involves all of the visual contrasts at once, indirect painting postpones the color stage (see Plates 18 to 21). But indirect painting has its own variations as well.

Separating drawing from color, indirect painting accumulates interacting layers of surfaces that modify one another so that the painting is not completed until the last layer is realized. The layers of opacity and transparency that enter into and change each other achieve a rich range of subtlety. Involved are

various ways of underpainting and methods of painting with transparent color over the underpainting (see Plate 23).

UNDERPAINTING

Underpainting involves some form of monochromatic painting, usually with earth colors such as umber or sienna, although some artists have used black and some have used earth green.

One form of underpainting requires that you use the earth color transparently. Establish your mass contrasts as in the whole approach. Draw as you paint and quickly cover your canvas. Use your weakest medium (with the most turpentine) to thin your umber and sienna. Then take a lint-free rag to wipe out your light areas. As you become accustomed to this technique, you will be able to graduate your light, medium light, and darker values by the pressure of the rag. Also you will be able to control the drawing as you move the rag.

Working this way is typical of the gesture stroke. Your arm movement feels the shape's direction. You will find that you get the action better as you move directly with it rather than concerning yourself with the edges or outline.

The darker tones may be reinforced with gesture strokes of your brush. Draw in a typical calligraphic fashion, feeling for the movement of the planes. Where necessary, you can pull out even whiter whites by wetting a clean brush with turpentine; then make the change with a stroke or two, followed by blotting or wiping with the rag. Finally, you can add semi-transparent darks and lights to complete the smaller plane relationships.

This kind of underpainting is sometimes the base for a direct relatively opaque painting that covers it completely. It also lends itself to scumbling and glazing of transparent and semi-transparent color.

A more traditional underpainting method begins with a dry ground of warm or cool earth color. The umber or sienna is rubbed dry and evenly over the canvas surface to get a middle tone that serves as such for the image to be drawn. Use only turpentine to thin the earth color at this stage. The drawing itself is done with gestural calligraphic strokes of white over the middle tone ground. The light areas are drawn against the darker ground (see Plate 18).

To get the necessary value contrast, you must control the pressure of the brush. Where you wish the white to be most intense, it will have to be opaque. Where the tones are to be darker, allow the brush to barely drag over the surface. This variation of touch in the dry-brush technique must be practiced. It will resemble the use of pastel white. The brush is used in gentle, gestural calligraphic strokes. With less pressure the stroke is darker. With more pressure it is lighter. In general you should aim to get your light tones lighter than you wish to end with, since color glazes will reduce their value, as in watercolor painting (see Plate 19).

If you are working without a pre-established drawing, draw with white, as you would do in the whole or addition approach. When you have stated the light tone relationships you may at once reinforce the darker tones with earth color in the same fashion or you can simply dry brush some white over the whole canvas and allow it to dry. Then you can introduce the darks with umber or sienna and allow that layer to dry. When ready, restate the light tones where necessary and dry-brush a light layer of white over the whole when that layer is dry.

Usually a finished underpainting takes many stages, as in the whole approach. Even an underpainting in the part-by-part approach requires some going over, since this technique separates the dark from the light. Then, too, there's the need for each layer to dry before proceeding.

Working this way lends itself to modifications of every sort, provided you are patient and allow the work to dry between stages. You can introduce darker washes over the white and redraw again and again with white until you get the rendering you wish. Remember that, in this instance, drawing means painting with the brush.

Another basic method is to paint your underpainting with values mixed on your palette. In this method you mix your earth color with white and paint either in the whole or the addition approach until the underpainting is completed.

ADDING COLOR

Color is added to a finished underpainting in transparent and semi-transparent ways such as scumbling, glazing, and dry-brush (see Plate 20). *Scumbling,* in my terms, is brushing a transparent or semi-transparent color on a surface and then wiping off varying amounts with a lint-free rag. Some use the word as meaning the application of semi-opaque color over a darker paint layer. I prefer the former definition and therefore the wiping with a lint-free rag is key to its use.

Glazing is painting with relatively transparent films of color. It too can be controlled by blotting with rag or paper. Dry-brush, as previously described, refers to drying out the brush somewhat before painting with it, using a flat chisel edge. Dry-brush automatically creates a series of thin lines and gives a transparent aspect, whether the paint is fairly thick or thinned with medium. The surface underneath must be dry for glazing, scumbling, or dry-brush.

Scumble your local color for each area first. If you are not sure about your choice of colors you can wipe out the scumble and try again as many times as you wish. The scumble will give you just a general idea of possible color relationships; it is the earliest step in a prolonged process. The painting then must be allowed to dry.

You will usually have to refine your drawing with white dry-brush, as previously described. Each time you do this, ensure that you dry brush some white over the entire canvas. But do it gently.

When the canvas is dry, you may begin to glaze, that is, paint with transparent colors over the underpainting. Since the scumbling should have established a direction for your color scheme, you should now be able to develop the ideas more richly. Glazing is not easy. If the glaze is too liquid, it will run. You will gradually feel the consistency that is most effective for your purposes. Generally the glaze is not wiped or blotted except for control or for some desired change.

A glaze may be applied in many ways. It may be applied as a general wash to establish a local color over an area of the underpainting. The dark and light variations in the underpainting come through, of course, and the color is also affected. Glazes are generally pure or at least prismatic, since the color that comes through will modify them. Generally, successive layers are required to get a particular hue.

A glaze may be applied in calligraphic gestural strokes, each retaining its identity. This can be done as in the whole approach, by working the whole canvas simultaneously, moving to detail gradually. It also applies to the addition approach, in which you try to finish a part before going to the next one.

Glazes can also be applied with a red sable brush in thin linear fashion, using the point of the brush. In this technique you paint with a series of thin lines, as in drawing with colored pencils. The gestural approach is perhaps easiest but it can be done part-by-part. The main difficulty, after learning to control your line, is to keep the lines separate. You will discover the necessary consistency and learn to wait for the glaze to dry before putting on another layer of color.

The glaze can also be applied in dry-brush fashion, using the flat chisel edge of a red sable brush. This is another way of getting a gesture drawing technique into a painting. It is similar to the linear way of working, but it gives a series of thin lines automatically. The same patience and drying intervals are necessary.

Usually, after some glazing and when the canvas is dry, you will need to reassert a subtle redrawing with white, and again sensitively brush some white over the whole canvas. These thin layers of white help to give added brilliance to your color and prevent muddiness. This technique gives you added control.

It is also possible to use semi-transparent glazes. This means that there will be a small percentage of white in the glaze, preferably zinc white since it is already quite transparent. Semi-transparent colors allow for more controlled variation of color.

Often the whole range of techniques may be used in the same canvas. If so, you must balance their use throughout the entire canvas to prevent spottiness. Some opacities might also become necessary before the canvas is completed and their use must also be balanced (see Plate 21).

VARYING PROCEDURES

Some artists approach indirect painting or direct painting through a process of preliminary investigation outside the final canvas. First, general ideas are explored either in thumbnail or somewhat larger sketches (see Figures 7.19 and 7.20). When general placement and pattern have been defined, studies of the parts are developed. Then the composition may be refined and relatively resolved. Color sketches may precede a color rendering. Finally a full-scale drawing or cartoon is completed and transferred to the canvas (see Plate 17). Then an underpainting is done, as described above.

Some artists proceed directly on the canvas and make a resolved underpainting in one of the methods described, and then go into the glazing stage. But I have enjoyed not painting a finished underpainting before going into color. The painting remains more open and the procedure is more complex and typical of the whole approach.

In this procedure the underpainting is begun, as in the whole approach, with the broadest statement of place, size, implied shape, and other relationships. This is done with dry-brushed white on the earth-color ground. With the white, stress is on the light or lighter areas. But darker areas are reinforced, as previously suggested. As soon as the first white development is dry (including the ever-necessary fine layer over the whole

canvas), scumbles are introduced as suggestions of a color possibility. This is allowed to dry as well.

The drawing is reasserted and developed and then allowed to dry. Again scumbles and transparencies are introduced. When dry, the drawing in white is developed further and stated again over the whole. Color is superimposed again when the drawing is dry. This procedure continues until the canvas is completed to one's satisfaction.

In this way of working the complex interacting layers are many and the result is wonderfully rich, resonant, and luminous in color. Remember that in this approach the more general relationships have precedence until you are certain and details are gained last.

Indirect and direct approaches sometimes get enmeshed, either deliberately or of necessity. To extend the range of textural and color qualities, artists find transparencies a gratifying addition to direct painting (see Plate 22). Indirect painters also find direct painting a necessary adjunct to finish a work. When contrasts of value or hue become too severe, a transparent wash may help to bring them together. Subtle differences can often be achieved by the addition of glazes, a scumble or dry-brush. In any case this interaction must be balanced.

When I am in the midst of a work that has become confused, I find it helpful to explore the main movements with transparencies, reasserting them, altering or clarifying the repetitions and the pattern. Since transparencies are thin, they may be wiped out without harm to the foundation, and change after change can be tried. In the process, the work gains another quality of contrast of texture and color subtlety, as well as the hoped for clarity.

The foregoing remarks apply not only to oil painting, but also (with certain differences) to acrylics, casein, and egg tempera. The main difference, aside from medium, is the fast drying of these media. The whole process is expedited in acrylics with some loss of flexibility because the transparencies dry so rapidly.

Those who lack patience may well find acrylics the best way to explore the possibilities of indirect painting. But I suggest that at some time you try it with oil paint as well.

It is important to experiment with the range of possibilities open to you in regard to direct and indirect painting. Certain subjects or situations will demand particular technical solutions. Discovering them is part of the early stage of the creative process. Of course direct painting may be best for certain kinds of sketching and for some kinds of naturalism. Since impressionism, however, naturalism has required some measure of analytical color, and this is sometimes most easily achieved by some indirect means such as dry-brush and glazing.

We have examined the nature of some of our materials and different ways of using them. In the next chapter we turn to the problem of resolution, of organization or structure.

CHAPTER

4

The Language Of Visual Contrasts

Whatever we look at is complex, both visually and psychologically. The components of thought and vision are choked with associated experiences, recognitions, symbolic meanings, and intrinsic visual relationships. It is little wonder that the latter get lost.

Look at a face. We see Jack, Susan, or a stranger. We're aware of eyes, ears, and other features. But we're hardly conscious of the visual contrasts which make them visible (Figure 4.1).

Such psychological recognitions are important to us. But to learn to paint we will need to penetrate psychological responses to the contrasts that allow us to distinguish one thing from another. We have spent years organizing visual components into coherent familiar structures. Now, without destroying their meaning, we must reverse our attention and see differences in light and dark, in shape.

Visual phenomena are complex even if it were possible to separate them from their meanings. To perceive them more clearly, it

4.1 Ranch hand. (Mimi Forsyth photo)

Associated meanings as well as visual contrasts contribute to visual experience.

4.2 PHIL BARD, "Toney"; Pen and ink.

The edges of differences in value and color become line.

may be helpful to separate the various contrasts from each other. We can see the edges of things and dark and light shapes. We call those edges *line* (Figure 4.2). The dark and light differences are called *value.* Homogeneous areas are visible as *shapes.* Where value changes are many, we call the checkerboard effect *texture.* Some of these are nearer, others tend to be behind them or far away. They may be flat or they may have volume, and thus we have *space* (Figure 4.3). They exist in a relationship of *color* differences. Line, shape, value, texture, space and color are our six visual contrasts.

LINE

Line as such can be considered as an invention. We see boundaries as line (Figure 4.4). All edges of shapes, whether determined by local color or dark and light differences, become linear. But not only can line be seen as the separation of one thing from another, more important it can be seen as a series of planes moving in some direction.

As these planes become distinguished from others by colors or value, they form a directional contrast that we translate as line. In each of the visual contrasts there are the pure opposed aspects. In line it is essentially straightness and curvedness (Figure 4.5). But since we live in a world governed by gravity, vertical and horizontal directions are in opposition. Thus the essential base of all complex movement is verticality, horizontality, and circularity. The diagonal or any other direction is some variation or combination.

To move a line as a series of positions in space gives it a three-dimensional quality as well as a psychological identification with that spatial surface. Such a line is *explicit* (Figure 4.6). It is the actual direction perceived, whether complex or simple.

But line can also be *implied.* Such a line is less obvious. It is hidden, revealed only by some similarity of position, as for example, when three points indicate diagonal movements creating a triangle. Implied line is in-

4.3 MAURICE UTRILLO, "Street";
Oil on canvas.
(Courtesy ACA Galleries)

Shapes diminishing toward a vanishing
point on the horizon suggest space.

4.4 ADELE SUSAN TONEY;
Contour drawing; Pen and ink.

We see boundaries as line.

61

variably general or quite pure and simple. It is straight or curved, vertical or horizontal, or a related diagonal.

Implied directions are crucial to drawing in the whole approach. The general movements block out the key samenesses and differences in the situation. It is easier to see or assess and check relationships if they are first stated simply. Complexities are more readily added.

Implied lines play key roles in structural organization. They form the essential repetitions of movement with variation in the thematic visual ideas. In practice, lines are at

4.5 HERZL EMANUEL, "Storage"; Lithograph. (Courtesy of the artist)

Pure linear movement is essentially straight or curved.

4.6 MAY STEVENS, Etching. (Courtesy of the artist)

The actual line is explicit.

once implicit and explicit, having both a main simple direction and some degree of actual complexity (Figure 4.7). The variations in the main movement enrich that movement.

Continuity of direction has the same implied character. It refers to lining up things with each other throughout the image in various general directions. Continuity is implied rather than actual, since the general direction is not a continuous line. Continuity of direction simply notes where one thing is relative to another. Such continuities were creatively exploited in analytical cubism. They are also valuable in searching out and checking proportion, foreshortening, and other spatial positions. They become an integral part of linear structural repetition.

Similarity of direction refers to those directions which are parallel or somewhat so. Such similarities also help us to draw our image and give it structure (Figure 4.8).

Reference lines are simple; they are either circular, vertical, or horizontal. The actual direction can be seen better if compared to its closest pure reference. The angle of any diagonal becomes clearer if it is compared to its vertical or horizontal reference. The whole approach depends on these reference lines.

In the very nature of line exist our two main modes of working—the movement of gesture and the contour of shape.

SHAPE

Line as a boundary forms shapes. Shapes are masses of varying size, value, or color; they are complex or simple, actual or implied. The basic geometric shapes, from which all others are derived, are the triangle, rectangle, and circle.

The *explicit shape* is that area with all its complex contour. *Implicit shapes* are those revealed by implied lines and continuity of movement. They are simpler, more geometric in character, tending toward the triangle, rectangle, and circle or less complex combinations. Each shape has an actual and implied aspect, but implied areas may also override several actual shapes. The image can become

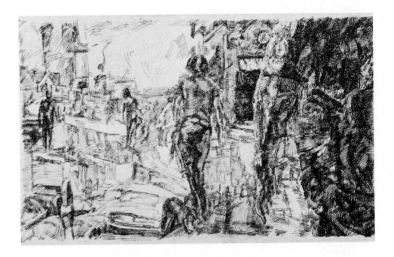

4.7 ANTHONY TONEY, "So Ho"; Pen and ink.

Lines are at once implicit and explicit, having a main simple direction and usually some degree of complexity.

4.8 RUDOLF BARANIK, Etching.
(Courtesy of the artist)

Similarity of direction gives structure to the image.

a three-dimensional web of implied shape relationships within which the actual shapes have another existence (Figure 4.9).

There is, first of all, the actual and implied shape of each building block or plane in the canvas. Second, there is the shape of each group of planes that hang together because of color, value, or textural similarity. This is called *pattern*. Pattern has both actual and im-

4.9 ANTHONY TONEY, "Gallery"; Pen and ink.
Continuities of linear movement create a web of implied shapes.

plied characteristics. Finally, there is the web of implied shape relationships that stem from implicit directions, or the way parts line up with each other.

In the whole approach, implied shapes are as valuable as implied line in developing control of your drawing. Extracting and stating the primary shapes makes it easier to re-

4.10 ANITA KAREN TONEY, "Good Samaritan"; Etching.
Shapes act as planes relative to other shapes.

late the remaining parts. The simple makes the more complex possible even as the complex must again become simple.

A shape usually refers to one or another primary shape, and complex shapes are combinations of primary shapes. Seeing these inner implied shapes is part of the whole approach. Thus we are able to draw more easily and with more control. At the same time these same shape relationships become the basis of main, minor, and opposition shape ideas in the work structure. The interlocking shape ideas involve the actual shape of each plane, each calligraphic stroke, their various groupings or pattern, and their implied shape relationships.

Shapes act as planes relative to other shapes, coming forward, retreating, or moving in one way or another (Figure 4.10). They occupy specific positions within the space context. Changes in size, value, and color alter their place in this context.

VALUE

Although the word *value* can mean many things, as a visual contrast it means the range of differences from dark to light. Each object in nature has an intrinsic *value range* because of its local color or texture. This range varies according to the illumination's intensity and

the way it hits the object. A focused beam of light in a dark room tends to extend the range. In a well-lighted room the range will be less.

The range on white cloth will be narrow and quite light. The range on black cloth will be narrow and dark. If you wish to stay close to nature, compare the value you are matching to its nearest pure value. Compare light objects to white, dark objects to black, and in between values to a middle dark.

Thus differences of value within the range of the local value are caused by the way light reveals the object (Figure 4.11). In nature the sun is the main source. Its direct light shows the object's structure. It causes some planes to be lighter and others to remain relatively darker. These differences cause our awareness of volume.

In your studio if there are several light sources, the illumination can complicate the value structure. If you wish a clear three-dimensional image, have one main source of light.

A painting also has a value range—that between its darkest dark and lightest light. The range can be narrow or extended. Within the painting each value group in the dark and light pattern also has its range (Figure 4.12). Extending beyond that range (either too light or too dark), makes a value jump out of the group (Figure 4.13). Sometimes such pulling away from the group of values becomes part of an interlocking or checkerboard pattern.

The primary aspects of value are extreme dark, middle tones, and extreme light. All values are these or something in between. Obtaining the desired value is sometimes difficult. Accept the fact that you will need a number of trials. Using each as a point of departure will help to get to the desired value. Compare similar values to each other. Which

4.11 JOHN DOBBS, "Motel Room"; Oil. (Courtesy ACA Galleries)

Light reveals the object, causing differences of value.

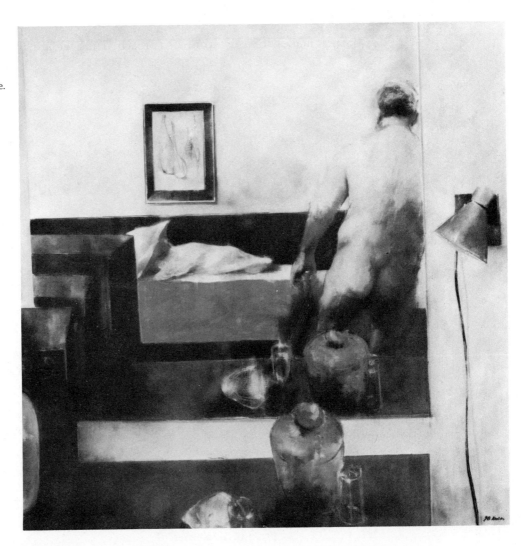

4.12 PHILIP REISMAN, "Cooperage"; Oil.
(Courtesy ACA Galleries)

A medium dark canvas with a range
from white to black.

4.13 MILTON AVERY, "The Painter
Mark Rothke"; Oil.
(Collection of Mrs. Milton Avery)

A dramatic light tone acts as climax in
this medium dark symmetrical composition.

is lightest or darkest? If you look in only one place the value will deceive you. A dark area will grow lighter and a light area will grow darker. Only by reference to the whole, to similar values, and to extremes can you see the actual value.

Contrasts in value create texture as well as pattern and space.

TEXTURE

The element of texture has a threefold role in drawing and painting. In each role it is visually perceived as differences of value. First, there is the *actual texture* of the materials employed, whether these are paint in its various forms or paint adulterated or amplified by other materials. Secondly, there is the *illusion of texture*, as in representation of skin, hair, cloth, and so on. Finally, there is *visual texture*, that is, the dark and light configuration. Visual texture is the essence of the other two, while being able to exist without them. Paint may be applied without contrast of thinness or thickness. Illusion need not be present. But visual contrast must exist or be implied.

The three kinds of texture have the extremes of roughness and smoothness and a medium texture. Any particular texture is at one of the extremes or is some combination of them.

These textures play similar organizational roles as other elements. There are main, minor, and opposition textural progressions in a painting. These textural repetitions, with differences, inevitably form the pattern of the painting.

Actual Texture

In some instances actual texture has become almost high relief, as in some collages which add sizable objects to the work. The use of sand and other materials has had popularity. Plaster or cement gives painting an even more sculptural orientation. Some painters find power and zest in piling pigments high on the canvas.

Artists of all times have been sensitive to the texture of their pigment. It plays a structural role whether within the narrow range of smoothness or roughness or within the wider range of contrasted progressions.

Illusion of Texture

Naturalism relies greatly on the illusion of texture (Figure 4.14). The feeling of a particular surface quality is achieved by superimposing layer upon layer of complexity. You

4.14 HARRY MC CORMICK, "Fruit Market"; Oil. (Courtesy ACA Galleries; Bernard Mack Collection)

The illusion of texture.

begin with the general and work gradually toward finer detail. The detail must hold its place by staying within the value range of that area.

Visual Texture

Value differences, whether large or small, create visual texture. Contrasts of textural progressions move the eye through the work (Figure 4.15). They are important to the organization of the drawing or painting. Inevitably there can be main, minor, and opposition textural ideas.

Some artists have attempted to have all three aspects of texture reinforce one another (Figure 4.16). Actual, illusionistic, and visual textures may thus work together, at once describing and acting structurally. Other artists have used them in contradictory ways, in at least relative opposition.

All three levels of texture are organized. A work may be dominated by one texture or it may be a counterpoint of contrasts.

SPACE

In art as in nature space consists of planes—flat surfaces varying in size that tend to recede, come forward, or stay put within any particular context. Each canvas or drawing will have its own range of spatial oppositions within which each part has its place.

4.15 ANTHONY TONEY, "City Storm"; Oil.

A contrasting visual texture becomes the pattern.

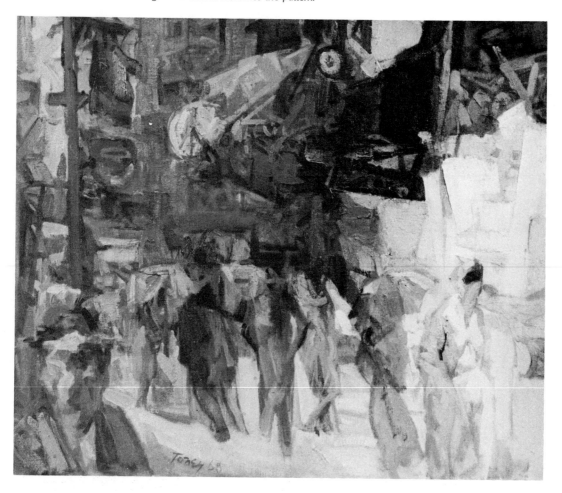

4.16 ANTHONY TONEY, "Levitation"; Oil.
All three aspects of texture may reinforce one another.

4.17 MIMI FORSYTH, "Apple"; Photograph.
Each plane takes its place in reference
to our position.

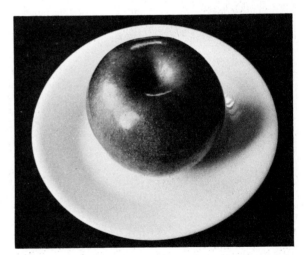

In nature each plane exists in reference to one's particular position (Figure 4.17). Each individual becomes the center of planar positions. Each plane, because of differences in place, atmosphere, direct and reflected light, and color, becomes unique in color and value relative to the individual.

Similarly, in painting, each plane must at least seem to vary somewhat from each other area, if the planes are to move relative to each other (Figure 4.18). Where repetitions of color or value are too similar, the painting becomes too decorative, too static.

Linear and atmospheric perspective explain how we see our world. Near places appear larger, more clearly defined, brighter, lighter, darker, more intense, and more detailed than places farther away (Figure 4.19).

These differences in size and relative strength can be called *force relationships*. The

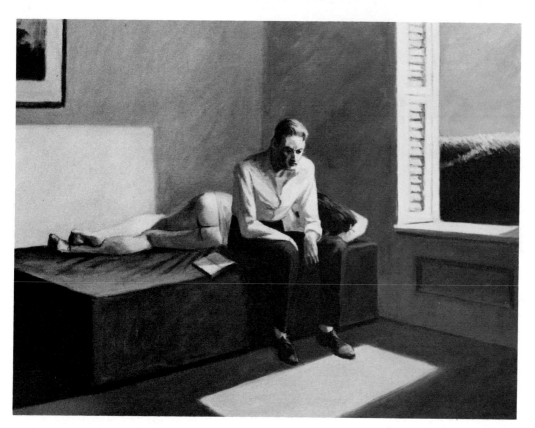

4.18 EDWARD HOPPER, "Excursion into Philosophy"; Oil.
(Courtesy ACA Galleries; Collection Lester Francis Avnet)

Each plane should seem to differ from other planes.

4.19 MIMI FORSYTH, "Elevated";
Photograph.

Example of linear and atmospheric
perspective.

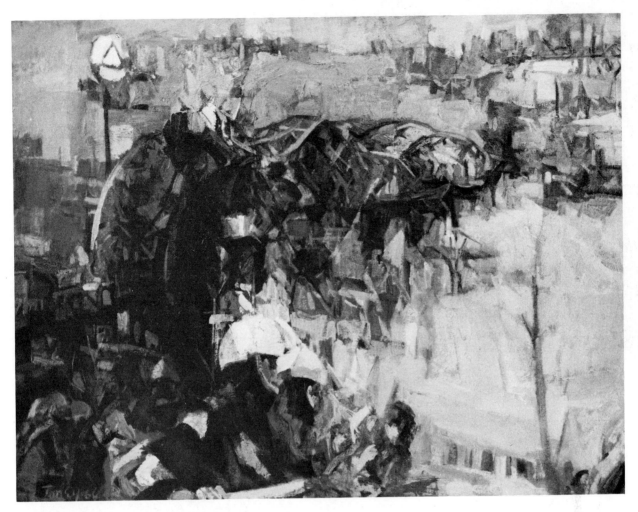

4.20 ANTHONY TONEY, "Chase Near Bridge"; Oil.

The stronger areas dominate.

stronger dominate the others and come forward; the weaker retreat (Figure 4.20). In a particular context, being different gives strength. In a composition full of straight lines for example, a tiny circle will jump forward. The changes in visual differences catch and hold our attention until some more compelling contrast pulls us away.

The extremes of movement in space away from or to the viewer and the middle position are called *primary (or basic) oppositions*. All other positions are variations of these. Primary volumes are the sphere, pyramid, and cube. More complex objects are combinations of these.

The primary volumes have both implied and explicit aspects (Figure 4.21). A head may be generally egg-shaped, but it is actually more complicated. Establishing the primary or simpler aspect of volumes aids in their elaboration into complex detail, as observed in our discussion of the whole approach.

As with the other elements, space is organized into major, minor, and opposition ideas (Figure 4.22). These in turn can be dominated by one of the primary spatial positions or volumes or can be a counterpoint of contrasts.

Since space is an involved visual contrast, we must delve further into its various aspects. This will take us into a discussion of perspective.

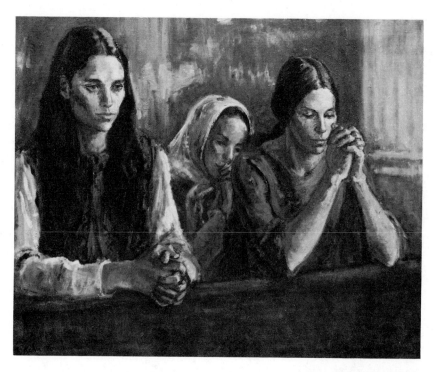

4.21 SUSAN KAHN, "Reverence"; Oil. (Courtesy ACA Galleries)

Volumes have both simpler implied and more complexly explicit aspects.

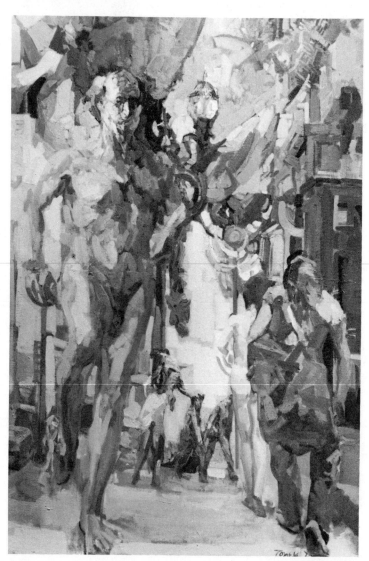

4.22 ANTHONY TONEY, "Jogging"; Oil.

The main idea is the forward plane; the subordinate idea is the middle distance; the opposition is the retained picture plane.

AERIAL PERSPECTIVE

Atmospheric or aerial perspective refers to the effect of the varying thickness of atmosphere upon sight. For that reason things in the distance appear less distinct and also smaller (Figure 4.23). Whatever local color or value they have becomes more neutral, more grey. Viewed closer up, things seem not only larger but also darker, lighter, more detailed, intense, and distinct. Such observations become the basis for creating illusionistic or force relationships of space.

Volumes are best revealed if there is one main source of light, preferably high and frontal (Figure 4.24). Direct light from many sources confuses and flattens space perception. The strongest source is called *direct light*. Planes also receive light indirectly. *Indirect light* is light which is distant or reflected from other surfaces. Place a bright color or white near some dark area and watch the area brighten or take on that hue. Sometimes reflected light may seem brighter than it is. Compare it to the area in direct light. Reflected values must stay within the value range of the larger plane.

Given a main light source, the nearest plane of the darker side of the volume will appear darkest. The dark inner area receiving reflected light will be lighter than the nearer dark planes. The dark turning planes are those which receive least light. These are quite close to the light turning plane, itself closest to the light source. Turning planes are like the corners of cubes (Figure 4.25); they are the inner positions marking the light's main and least impact.

Because shadows are lighter within their edges, this makes their edges appear to be darker (Figure 4.26). Keep comparing values

4.23 MIMI FORSYTH, "Liberty"; Photograph.

Things in the distance appear less distinct.

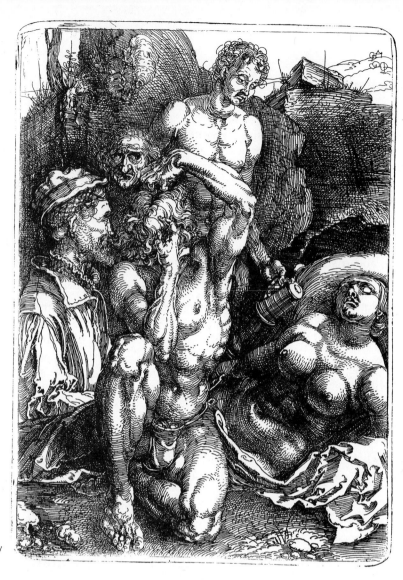

4.24 ALBRECHT DÜRER,
"The Desperate Man"; Engraving.
(Courtesy Dover Publications, Inc.)

Volumes are best revealed if there
is one main source of light, preferably
high and frontal.

4.25 REMBRANDT VAN RIJN, "Study of
Two Women"; Pen and bistre, wash.
(Courtesy Dover Publications, Inc.)

Turning planes are like the corners of cubes, as in
the inner edges of the darks in these figures.

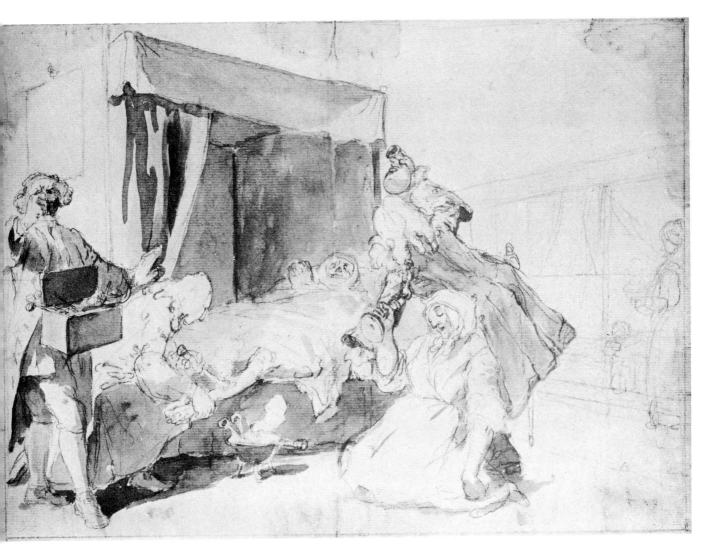

4.26 NICOLAS POUSSIN, "Study"; Brush and wash.
(Courtesy Dover Publications, Inc.)

Shadows are lighter within their edges.

in order to maintain consistency. If you fix your eyes on the dark side without reference to the light area, you will find that you begin to see the dark side lighter and lighter. Similarly the light side seems to get darker as you see more differences in it. I've watched students repeatedly nullify all contrasts because they neglected to keep comparing them.

The volume's edges will be light, dark, or lost, depending upon the value behind the edge (Figure 4.27). The edge will be lost where values are similar. The edge becomes firmer and darker against light, and lighter against dark. Often there is a subtle turning plane along the edge next to the dark. The purpose of these descriptions is to stimulate your own observations.

Although in nature the number of planes in any given surface is infinite, we arbitrarily limit the number according to our varied purposes. Light and dark areas of a volume may be expressed as single planes or they may be complicated. By keeping values similar, a larger plane may be composed of many smaller ones and still retain its simplicity.

Illusion is often arbitrarily controlled ac-

4.27 MICHELANGELO BUONAROTTI, "Study";
Crayon.
(Courtesy Dover Publications, Inc.)

The volume's edges will be light, dark, or lost.

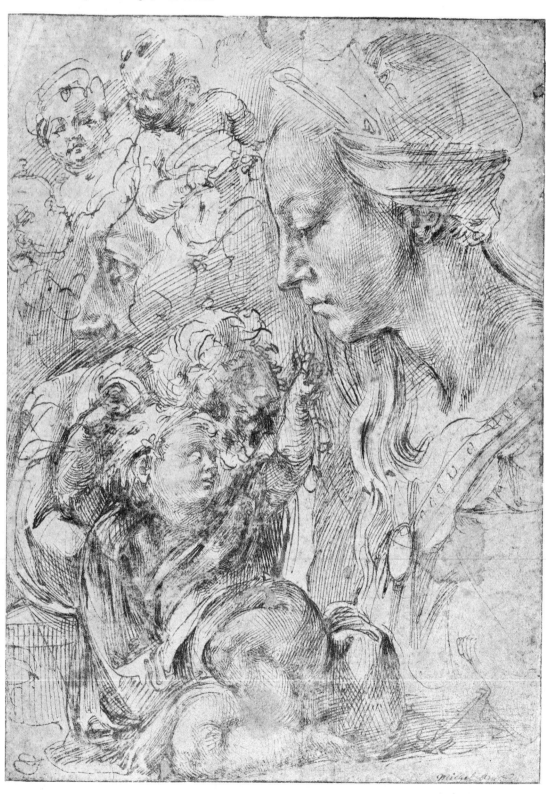

cording to the expressive purposes of the work. Certain planes may be intensified as being more central while others are subdued.

The achievement of atmospheric illusion depends upon the relationships of darkness and lightness of various objects or volumes within the whole space. Therefore you should note the darkest darks and the lightest lights and then proceed within those limits. This process becomes complicated when the value relationships are deliberately altered for organizational and expressive needs. Your extremes of dark, light, and color intensity may then be associated with the climax of the work rather than with areas ostensibly nearest you.

Since lighting conditions are often complex, when you try exercises it is better to work outdoors or near a window if you are working indoors. In any case, control the light so that you have a single source, preferably frontal. Your first exercises should keep the plane structure simple. Stress the more general larger differences in value, trying to see and state the key contrasts in your subject. Later you may want to develop illusion or expressiveness further. You can also experiment with manipulating and contradicting appearance.

Whether working in the whole or addition approach, beginners should stress definiteness of plane and stroke. State the larger simple pattern of contrasts. Find the main turning planes. Paint with strokes that are not worked over, fussed with, or blended. Keep looking at the whole, comparing the values to each other. Developing the habit of being definite will give you control and strength. The larger pattern will guide more subtle variations, which should also be stated so that they do not merge. There will be time enough for transition planes and imperceptible differences.

LINEAR PERSPECTIVE

Linear perspective is an explanation of the appearance of things in space; it projects ways to depict those appearances. There are numer-

ous systems of perspective, each for a particular purpose. Here I will attempt to give you a general understanding. For problems demanding more specific methods, there are books on perspective that can aid you.

We look down a train track and see it become ever narrower until it disappears at some point on the horizon (Figure 4.28). That horizon is the *viewer's eye level,* and will be different for each of us. The position of the viewer is decisive in perspective relationships.

We hold a square box at arm's length in front of us. At eye level the top is a straight line. If the box is moved below eye level, we see into the box; the lower the box is the more we see. When the box is above eye level, at a certain point we begin to see part of the bottom; the higher it is raised the more we see. With the box held at eye level we see neither the bottom part nor into the top. When the box is turned, one side soon appears smaller than another even though we know that both sides are the same size.

In portraiture many of us pose the model on a model stand so that when seated, the model's eyes are at our eye level. The forehead relationships begin to curve downward,

4.28 MIMI FORSYTH, "Track"; Photograph.
We look down the track and see it disappear.

but the nose, cheekbone, mouth, and chin curve upward. With the eyes of the model at our eye level, they are about in the center of the head. If the model's eyes are below our eye level, the distance between eyes and chin diminishes and the distance above the eyes increases (Figure 4.29).

Look down at yourself as you stand. Notice how much you cannot see. Your feet appear to come out of your abdomen. Raise your arm in front of a mirror. Notice that when the arm is raised level, you see the front part of the hand and everything between the finger tips and the shoulder vanishes. This phenomenon is called *foreshortening*.

When we look down from a high building at people below, they appear very small. If we look outward at many houses, those far-ther away appear smaller. If our view is unobstructed and the houses continue to the horizon, they will seem to diminish in size until they get so small that at some point they disappear. We call this the *vanishing point*.

Thus, all planes are vanishing either to points on the horizon or to points directly above and below the eyes of the viewer.

We have three ways to draw these appearances that are often so different from what we know as actuality. Drawing with linear perspective is valuable for accurate renditions of cityscapes, interiors, and some still-life objects. Drawing the figure in perspective becomes more complicated, and here the whole approach to drawing is more successful. Curiously, despite its inaccuracy in specific relationships, the addition method, be-

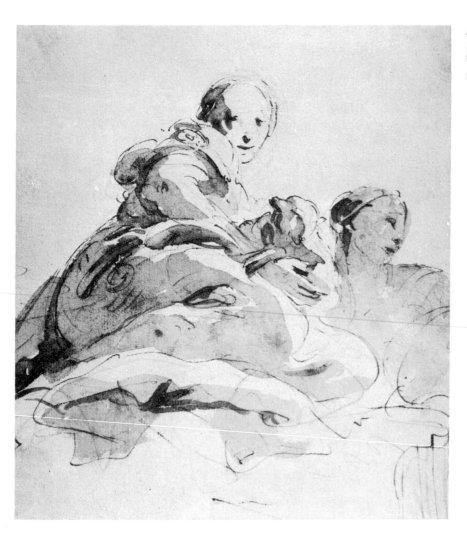

4.29 GIAMBATTISTA TIEPOLO, "Study"; Brush and wash. (Courtesy Dover Publications. Inc.)

Looking up at the models.

cause it identifies with the appearance of the figure, is quite effective in drawing fore-shortened poses.

One-Point Perspective

The simplest form of perspective is one-point perspective. It includes only one vanishing point, and the frontal shape is given. The frontal shape is the actual shape unchanged. If it is the front of a cube, the shape is square, sides parallel and equal. Only the side and top or bottom planes diminish (Figure 4.30).

As an exercise in one-point perspective, draw a horizon line or imaginary eye level well up on the page. Then place three rectangles: one above, one overlapping, and one below the horizon. Establish a point on the horizon to serve as vanishing point. To that point draw faint lines from each corner of the rectangles. Arbitrarily decide where the sides, top, or bottom of the forms should end. Represent those limits with lines parallel to the

original shape. Darken the actual representations and you will note that you have drawn three-dimensional objects as seen above, below, and overlapping your eye level.

Two-Point Perspective

Two-point perspective provides two vanishing points on the horizon line toward which the opposite sides of a given vertical length of line or point recede. In two-point perspective, only vertical lines are parallel; all others get smaller as they approach the horizon (Figure 4.31).

As an exercise, draw the horizon line, as in the previous exercise. Place two vanishing points at opposite ends of the line. Above, below, or overlapping that line draw a vertical line of specific length. That line becomes the corner of your proposed solid. From each end of that line draw light lines to both vanishing points. Decide where the sides of your solid should be and draw parallel lines to the corner. Now draw light lines from those sides to

4.30 One-Point Perspective

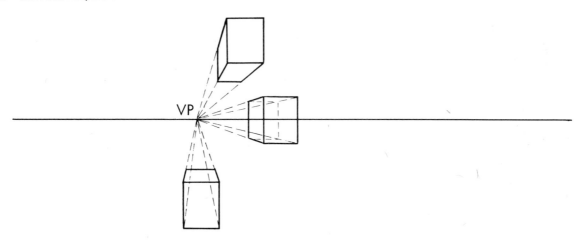

4.31 Two-Point Perspective

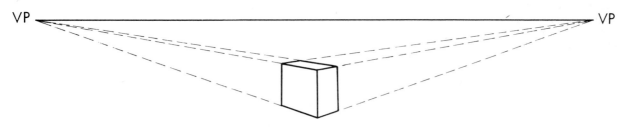

the opposite vanishing points. Again, darkening the key lines will reveal a rectangular volume.

Three-Point Perspective

Three-point perspective involves an additional vanishing point directly below or above the position of the viewer. In this form, no sides are parallel.

As an exercise, place two vanishing points on the horizon as before, then add a third one well below and between the other two. Vertically above the third vanishing point and near the horizon line, place the point that will be the top corner of a rectangular volume. Draw light lines to each of the two vanishing points on the horizon. Determine your volume's widths arbitrarily; from these corners draw light lines to the vanishing point below and then to the opposite points on the horizon line. Decide the bottom point of the corner and again draw light lines to the vanishing points on the horizon.

Darken the form as in the previous exercises. The result is a rectangular volume as seen from above (Figure 4.32).

Four-Point Perspective

Four-point perspective is like three-point except that it adds another vanishing point vertically above or below the third point. This form of perspective applies to objects that overlap the horizon line. As seen in Figure 4.33, the volume is largest at the horizon line, and all sides recede. Three-point and four-point perspective most closely correspond to nature's appearance.

Appying Linear Perspective

When we have only two vanishing points on the horizon, we can infer that all objects in that situation are parallel to each other. If they are not parallel, two more points will be needed for each object. Generally, the distance between points will remain the same.

4.32 Three-Point Perspective

4.33 Four-Point Perspective

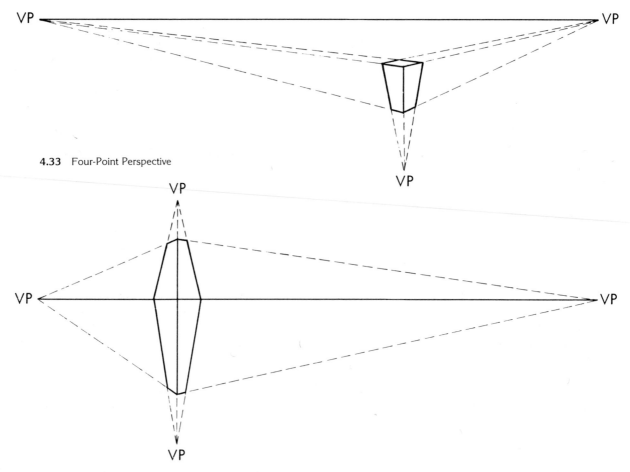

4.34 ANITA KAREN TONEY, "Hierarchy of the Gas Line";
Etching.

More than one viewpoint are combined.

Linear perspective requires a fixed position and one eye level or horizon. It is like a peephole on the world about us. As an exercise, tack paper to a wall. Use string for the horizon lines. Thumb tacks can mark the vanishing points. Attaching string to these tacks will give you a way of establishing lines to the vanishing points. Using this arrangement, experiment with various perspectives. See if they begin to suggest compositions.

One-point perspective has been used as an effective structural tool since it gives a fascinating kind of unity imposed by the single point to which everything must relate.

Many artists prefer to have more than one viewpoint in a canvas, so there may be many or few horizon lines (Figure 4.34). Experiment with several such position changes. They can well be the source of space ideas.

To many of us linear perspective may be too mechanical and far too complicated when dealing with relationships of complex volumes. We insist on a simpler way to draw the appearance of nature or things. This way can

be found in the whole approach discussed in Chapter 2. A brief review may be helpful here.

FORESHORTENING AND THE WHOLE APPROACH

Remember that any angle can be determined by comparing the direction sought with its nearest vertical or horizontal reference line. Based on that principle, the angle of any line or direction can be determined without resorting to linear perspective. In some situations it is easier to apply linear perspective than in others. You will have to choose the method that appears most effective for a particular problem.

Horizontal and vertical reference lines can also determine where one thing is in relation to another. Foreshortening becomes fairly simple to draw if you position the parts in their proper alignment *relative to each other*. Once your general positions are determined, draw those parts nearest you in relation to their rear limits, and the rest must fit in between. Foreshortened views are often unfamiliar and therefore difficult to feel and realize. But blocking out the implied shapes, along with the reference lines, reduces the ambiguity, and assures accuracy and control.

MULTIPLE AND OTHER PERSPECTIVES

Single- or fixed-position perspective is helpful in explaining appearance and can be an effective tool in copying. It does not, however, meet the creative needs of some painters.

In real life we move about a great deal and not only our position but also our eye level or horizon shifts and changes. Our view is thus multiple rather than fixed (Figure 4.35).

This fact has stimulated many adventures in space transformation. Appearances have been disrupted, parts have been recombined, with positions varied analytically, as in

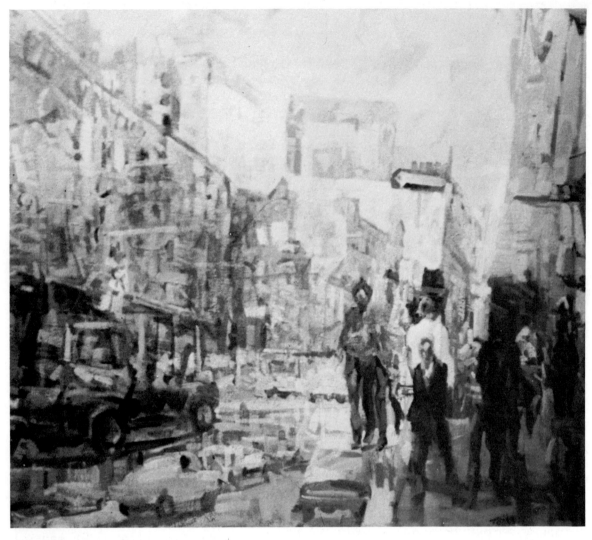

4.35 ANTHONY TONEY, "Center"; Oil.
Multiple perspective.

cubism or synthetically, as in abstraction. Montage, with its possibility of unusual, even fantastic, counterpoint introduces further contradictions in space (Figure 4.36). Photographic investigations in movement have also been a stimulus for space complexity. The use of multiple media has also introduced new ideas for contrapuntal space contrasts. Combined views have also been integrated into single transformed shapes (Figure 4.37), as in some of Picasso's paintings and drawings.

There are traditions of space depiction which involve the simple overlapping of objects, the rear being situated higher in the drawing or painting.

According to psychological space tradition figures or objects of greater importance are made larger as well as more unusual. Space is organized hierarchically. Easily read

views have been combined, as in Egyptian art, where frontal torsos are used with profile heads and legs.

Nonetheless, fixed-position perspective should be understood, even though, and especially if, you intend to transform it.

PICTURE PLANE

Since fixed-position perspective is designed to establish spatial illusion, its use in painting tends to destroy the plane of the picture itself. That plane is like window glass. It is the canvas or paper's surface. Some painters, past and present, who are naturalistically motivated, would like to make the canvas trans-

82

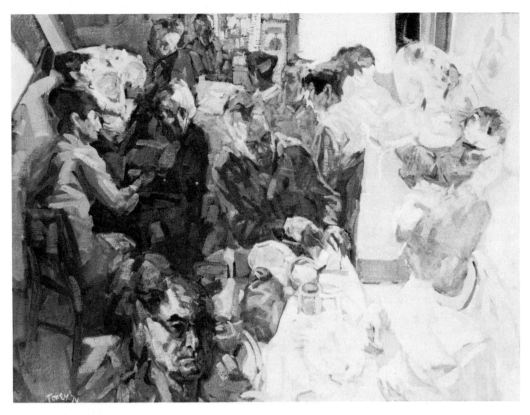

4.36 ANTHONY TONEY, "Supper"; Oil.
Multiple repetitions.

4.37 ANTHONY TONEY, "Great Neck Shore"; Oil.
Combined views have been integrated into single transformed shapes.

parent. The surface would disappear into a peephole on fixed or frozen space. The eye would be fooled.

If contradictions are introduced, they remind us that the work is, after all, an image on paper or canvas, and contradictions are simply violations of appearances. If rear planes come forward rather than retreat, this negates the illusion's naturalness. The picture plane is reaffirmed.

Underpainting superimposed with local color glazes, a line around objects, brusqueness of strokes, stylizations, simplifications, as well as space distortion—these are all ways to consciously retain the picture plane. Where and how such contradictions are introduced depends upon the space orchestration desired. Basically, they establish ambivalences forcing opposite things to occur simultaneously. Certain areas of the canvas may go back and come forward at the same time, thus calling attention to the plane upon which they function.

The naturalist will tend to seek the illusion of transparency. But romantics, classicists, and realists will inevitably be involved with contradictions that reaffirm the picture plane. The very concern for self-expresssion, idealization, or structural synthesis creates space ambiguities (as we shall see in Chapter 6). The opposition of flatness and movement in space is an exciting contrast that intensifies the work's expressiveness.

ACTUAL SPACE

The term *actual space* as used here refers to the active physical force that competing planes possess, regardless of linear perspective. While naturalism does contain force relationships, actual space exists in many forms. It can be completely non-objective, abstract, or whatever. The force aspect springs from each plane's struggle for our attention. The *actuality* of the forces springs from the concept of light as energy affecting the human organism physically. The contrasts are revealed as light variations reflected from light sources.

As noted in our discussion of aerial perspective, areas come forward which are largest, strongest, most intense, sharpest or most distinct, lightest, darkest, more detailed, or simply different. Other areas retreat.

Equalities tend to nullify one another, becoming static as they pull with the same strength and so go nowhere. Differences create interest and attract. Something totally opposite to the main forces in a context becomes very strong and jumps forward. But contrasts function between similarities as well as between opposites.

Elements can thus progress. By *progression* we mean the very differences within similar color or space. A cool crimson will contrast with a hot red light and a grey red. This becomes a progression that moves in space.

Force relationships are not absolute. They are determined by the context. A grey object that might retreat in one context may come forward if bounded by black or associated with an intense color.

The various planes function not only separately but also in conjunction with one another, reinforcing or weakening the other's strength. The assessment of these forces is performed by our sensibility. This assessment determines the orchestration of major, minor, and opposition space themes in our work.

Color is inextricably bound with value as a determinant of space relationships.

COLOR

In discussing materials I recommended particular pigments. We should now look more deeply into the nature of color, the essential characteristic of painting.

The primary colors are red, yellow, and blue. They form the basis for the secondary colors, which are purple or violet, orange, and green. Because pigments have their physical limitations, each primary color must be extended to include warm and cool aspects.

Purple becomes a mixture of purplish ultramarine blue and purplish alizarin crimson. Orange is derived from orangish yellow medium and orangish red light. Green combines

Plate 1 ANTHONY TONEY, "Portrait of a Woman"; Pastel.

Pastel is mixed directly on the paper as one color is laid over another. The counterpoint of lines of color retains the vibration of opposing color. You can begin with soft pastel and finish with pastel pencils.

Plate 2 JOHN MARIN, "Movement Sea and Sky"; Watercolor. (American Library Color Slide Co., Inc.)

In watercolor the binder used is gum arabic; water is the medium for thinning the color. Transparent watercolor uses the white of the paper to lighten the color.

Plate 3 MARY CASSATT, "Maternity"; Oil. (American Library Color Slide Co., Inc.)

Oil painting uses a combination of linseed oil and turpentine as a basic medium. Some artists also add varnish and dryers.

Plate 1

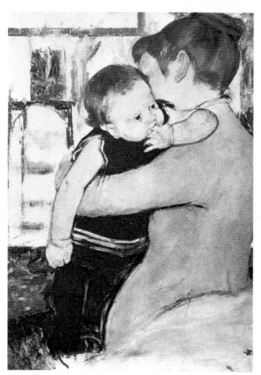

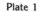

Plate 2

Plate 3

Addition Approach
to Painting

Plate 4 JOSEPH SOLMAN, "Edna";
Oil on board. (Courtesy of the artist)

Put down what the previous areas demand,
until all that is necessary is there.

Plate 5 AKIBA EMANUEL, "Unfurled
Landscape"; Oil on canvas. (American
Library Color Slide Co., Inc.)

The painting can be kept to a few planes
or it can become quite complex. We
can begin with a contour drawing and
fill in areas to satisfy our own taste.

Plate 6 PHILLIP EVERGOOD, "Girl and
Sunflowers"; Oil on canvas. (American
Library Color Slide Co., Inc.)

Finding the color and shape necessary
may require much redoing.

Plate 4

Plate 6

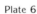

Plate 5

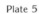

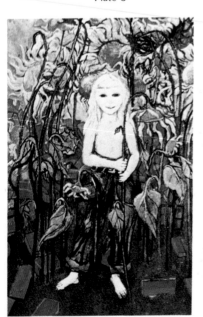

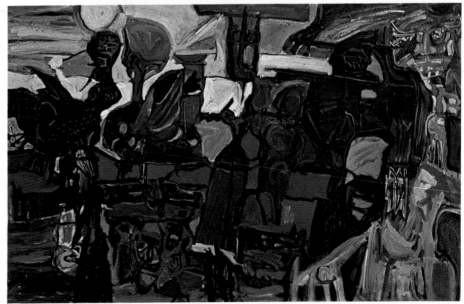

Plate 7

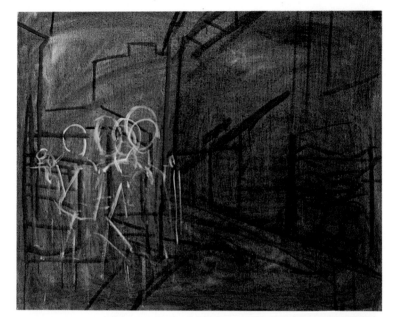

Stages in Whole Approach Direct Painting

ANTHONY TONEY,
"Lower New York";
Oil on canvas.

Plate 7 BEGINNING

You can draw directly with paint on a dry umber or sienna ground.

Plate 8 FIRST STAGE

Search out and paint the largest sub-divisions of dark and light color.

Plate 9 ELABORATION

The approach is bold and open. Change your mind as often as necessary. Paint with definiteness and sensitivity of touch. Smaller strokes or planes may modify the larger.

Plate 10 CONCLUSION

Do not blend areas. Transition planes will keep your relationships strong even as they become subtle. Continue your modifications until the work satisfies you.

Plate 8

Plate 9

Plate 10

Exercises are valuable, but you grow most with whole problems that interest you.

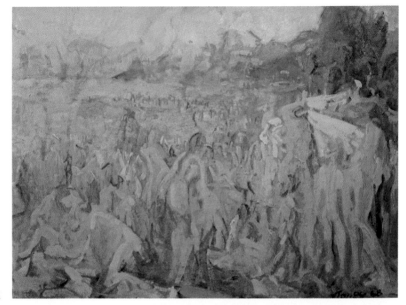

Plate 11

Plate 13

Plate 12

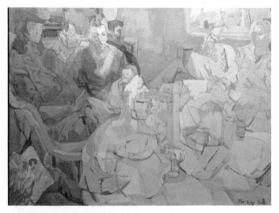

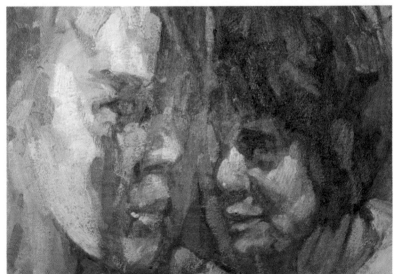

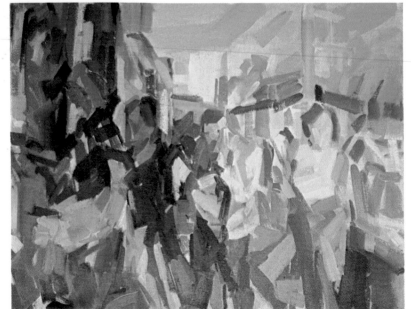

Plate 11 ANTHONY TONEY, "Sun"; Oil.

Paint the broad key differences of foreground, middle, and far distance against the sky. In some exercises try to keep the values very light.

Plate 12 ANTHONY TONEY, "Table"; Oil.

Arbitrarily enlarge and make smaller some of your shapes to see the effect on the design. Set up a white still life; keep the shapes flat and definite.

Plate 13 Detail from the sixth panel of "Aftermath," a mural by Anthony Toney at Syracuse University.

State the large contrasts and main differences within the local color. Paint with calligraphic strokes that do not touch each other.

Plate 14 Early stage of painting of a street in San Francisco.

Use calligraphic strokes to set up relationships of continuity, stating where one thing is relative to another.

Plate 14

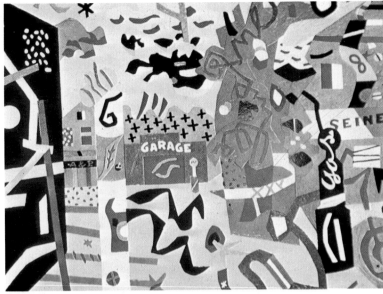

Plate 15

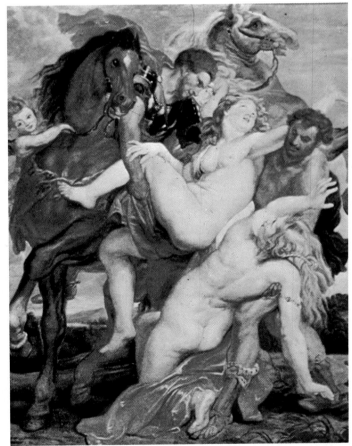

Plate 15 STUART DAVIS, "Report from Rockport"; Oil on canvas. (American Library Color Slide Co., Inc.)

Planes can be built up smoothly in sharply defined shapes.

Plate 16 NAHUM TSCHACBASOV, "The Schochet"; Oil on canvas. (American Library Color Slide Co., Inc.)

You can paint with a painting knife.

Plate 17 PETER PAUL RUBENS, "Abduction of Daughters of Leukippas"; Oil on canvas. (American Library Color Slide Co., Inc.)

Rubens painted indirectly, first planning his work through a series of studies.

Plate 16

Stages in
Indirect Painting

ANTHONY TONEY, "Woman"; Oil on canvas.

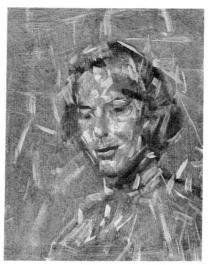

Plate 18

Plate 20

Plate 19

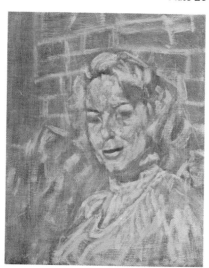

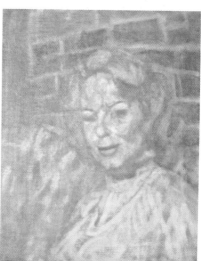

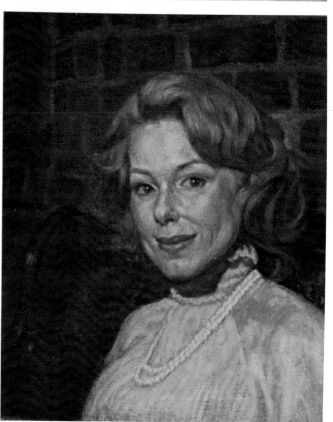

Plate 18 BEGINNING

Indirect painting postpones the color stage and accumulates interacting layers of surfaces. Begin with a dry ground of warm or cool earth color. Draw the underpainting with gestural calligraphic strokes of white.

Control the pressure of your brush so that variations of light are attained through the dry-brush effect that allows the ground to show through and influence the value.

Plate 19 FIRST WHITE DRAWING

Your light tones may be kept lighter than finally desired because the color will darken them. Dry brush a light layer of white over the whole surface when the gestural drawing is complete. Darker tones can be reinforced when the first stage is dry. Then white is again lightly dry brushed over the dark, and allowed to dry.

Plate 20 FIRST COLOR APPLICATION

Color is added in transparent and semi-transparent ways such as scumbling, glazing, and dry-brush. In scumbling, brush color on the surface and wipe off varying amounts. A glaze is a transparent film of color.

Plate 21 CONCLUSION

A sequence of glazing, drying, reworking with white, drying, reglazing, and so on is repeated over and over until you have achieved the desired effect.

Plate 21

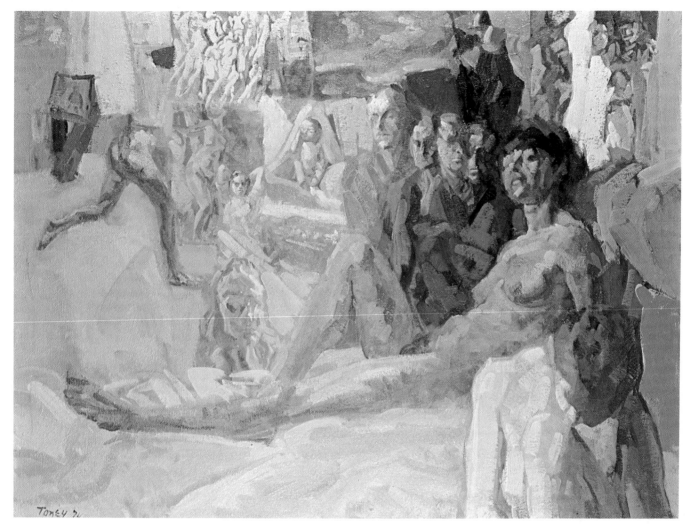

Plate 22

Plate 22 ANTHONY TONEY, "Times and Places"; Oil on canvas.

To extend the range of textural and color qualities, transparency can be a gratifying addition to direct painting.

Plate 23 ISABEL BISHOP, "Ben, Union Square"; Oil. (American Library Color Slide Co., Inc.)

In indirect painting the interacting layers of white opacity and color transparency enter into and change each other to achieve a rich range of subtlety.

Plate 23

Color Separation and Palette

Plate 24 Color separations used in the reproduction process of the painting "Freedom Now" (see Plate 25).

Equal amounts of red, yellow, and blue produce grey. Unequal amounts produce the full range of color. Inevitably we are involved with relative greyness.

Color separations show that yellow, red, and blue play interlocking roles throughout the painting.

Blue green Phthalocyanine green Yellow green Cadmium yellow, light and medium Cadmium orange

Phthalocyanine blue

Ultramarine blue

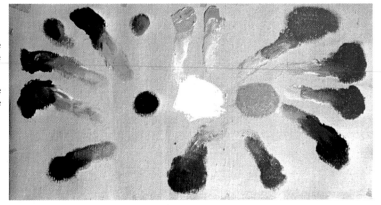

Cadmium red, medium

Cadmium red, light

Blue purple Quinacridone purple Red purple Alizarin crimson

Primary pigments and their secondaries.

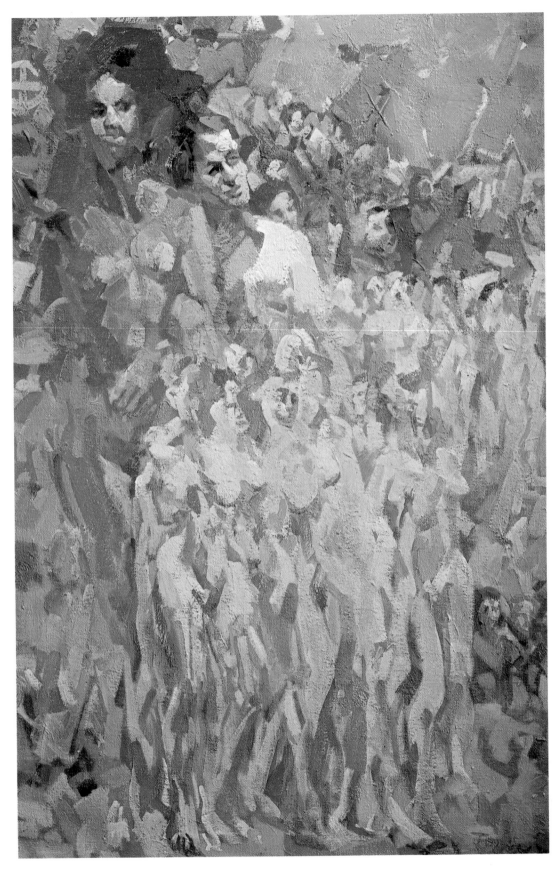

Plate 25 ANTHONY TONEY, "Freedom Now"; Oil on canvas.

Main theme: yellow-orange opposed to white; minor idea: red; opposition: blue to cool greens.

Color patterns create thematic sequences that draw the eye through and around the canvas, culminating in a climax where the color is most intense and/or most contrastive.

Plate 27

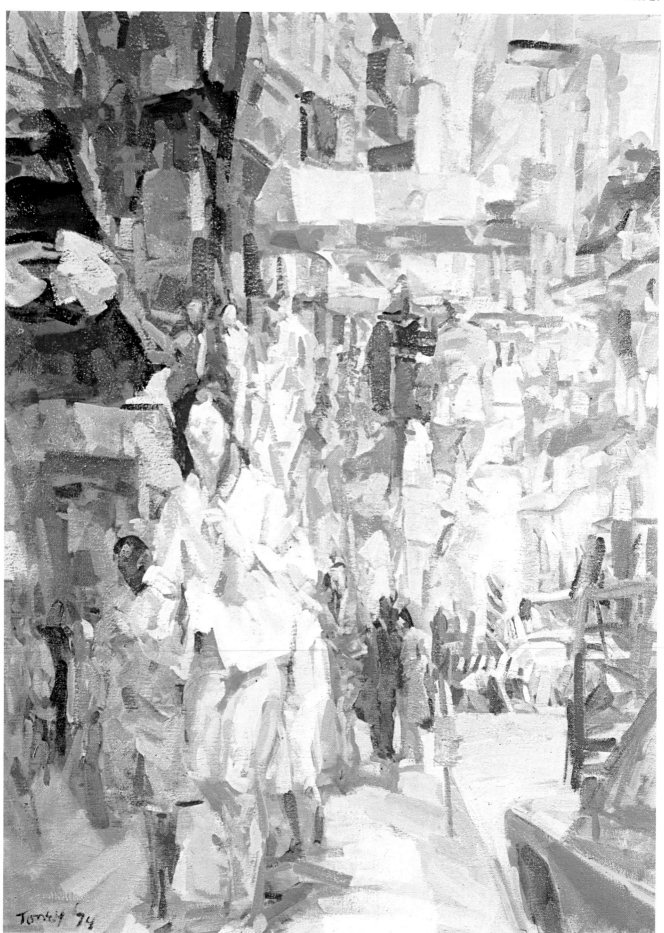

Plate 26

Plate 26 ANTHONY TONEY, "Market"; Oil on canvas.

The dominant is an opposing yellow-white progression, the minor is blue, and the opposition is red. Colors similar to each other tend to be harmonious. Harmonious oppositions include the primaries, other triads, complementaries, near complementaries, and color against black, white, or grey.

Plate 27 ANTHONY TONEY, "Fifth Avenue"; Oil on canvas.

Major idea is blue; minor is yellow-orange; opposition is red. In opposition schemes two or more primaries confront one another with variation throughout the canvas. Color schemes that employ all variations of a particular color are called domination ideas. There is more of a main idea, less of a minor, and least of an opposition theme.

Plate 28 ANTHONY TONEY, "Herzl's Visit"; Oil on canvas.

The main left climax is balanced by the minor light area on the right. Main contrasts are strongly rectangular, shapes quite flat; space is shallow with contradictions; balance is asymmetrical. In dominated schemes the main color is altered by mixtures with other colors and white. Colors that are similar in hue tend to form a pattern, as do similar values. Color progressions include adjacent hues as well as variations of light and dark and other mixtures.

Plate 28

Plate 29

Plate 30

Plate 31

Plate 29 JAN VAN EYCK, "Madonna of Ch. Rolin"; Oil. (American Library Color Slide Co., Inc.)

In the classicism of Jan Van Eyck, the balance is stable, often symmetrical, with tensions reconciled. Line binds clear shapes in defined patterns.

Plate 30 REMBRANDT VAN RIJN, "Hendrickje Stoffels"; Oil. (American Library Color Slide Co., Inc.)

In the romantic strain within Rembrandt, we find an organization of felt sensation, personal reactions, and consequent feelings.

Plate 31 VELAZQUEZ, "Portrait of Innocent X"; Oil. (American Library Color Slide Co., Inc.)

In the naturalism of Velazquez, particular appearances are conditioned by specific time and place.

Plate 32 WINSLOW HOMER, "Herring Net"; Oil. (American Library Color Slide Co., Inc.)

The realism of Homer expresses the richness of reality in a synthesis of thought and sensibility.

Plate 32

cool yellow light and greenish cool phthalocyanine blue. Other mixtures would become quite grey.

Colors can be distributed in a color wheel or circle, the simplest consisting of yellow, orange, red, purple, blue, and green. More extended and in between these hues would be yellow-orange, red-orange, blue-purple, blue-green, and yellow-green. The complement of any particular color is its opposite on the wheel (see Plate 24).

More simply we can think of red, yellow, and blue as basic oppositions. When any two are mixed together, the third one left is in *complementary opposition*. Yellow combined with red gives orange, leaving blue as its opposing complement. Thus purple is the complement of yellow, and green is the complement of red.

Similarly, the complement of red-purple is made up of the complements of its constituents: that of red is green, that of purple is yellow. So the resulting complement of red-purple is yellow-green. By the same procedure we find that blue-purple opposes yellow-orange, blue-green is in complementary opposition to red-orange, and so on.

Colors act as competitive forces, intensifying and bringing each other into being. The highlights of an orange will be influenced by a hint of blue. Although all primaries and secondaries oppose each other, the strongest contrast is between complements.

Adjacent colors tend to share an affinity and so they fight less with each other. The primaries are the purest oppositions, but they are not as strong as the complementary confrontation. In the latter we have all primaries in a single contrast.

When only two primaries are involved, as in the opposition of blue and yellow, there is some contrastive strength. However, the contrast of green to yellow is weaker, because green contains yellow. Having yellow in common, the difference between green and yellow is lessened. The negation of contrast is relative to the quantity of binding color.

Colors are more grey as opposites are mixed with each other. Equal quantities of red, yellow, and blue give us a dark neutral grey. Most of the time we are involved with relative greyness. Obviously, a simple way to grey a color is to introduce its complement.

Neutral grey, white, and black become the negation of color. They possess all colors even as they become no color.

This being so, the opposition of grey, black, and white to any color, particularly to primary colors, is very strong. That fact invariably plays an important role in enhancing contrastive effects in a canvas.

In a neutral context, such as middle grey, a medium red will be stronger than equal areas of yellow or medium blue. In spatial terms the red comes forward, the yellow stays put, and the blue retreats. But these relationships can change if the contextual variables become different. Dark blue might well come forward against a lighter grey if the red is cool. In our use of color the context is decisive.

One's awareness and perception of color is explained in terms of light. Direct light is painful to the eyes and we avoid looking at it, but objects are revealed to us as they absorb and reflect light. We need not go into the physics of light or the physiology of sight, except perhaps to note the fact that light rays differing in wavelength height and complexity determine the hue's intensity and saturation. The important thing to realize is that color and its perception are the result of physical contact. Electromagnetic rays moving at tremendous speeds stimulate the rods and cones of our visual mechanism, activating our nervous system and systems associated with it— emotional, aesthetic, etc.

Working with color involves a continuing action and reaction to color changes as we search for fresh harmonies. It is the physical phenomenon of light-vision-perception, influenced by our previous experiences, that determines our color choices.

The appearances of color are affected by their context, as previously suggested. The same color will seem lighter against a darker ground. Afterimages affect our color perception as colors bring their opposites or near opposites into being. Patches of light colors seem larger than do darker ones. Bright colors appear brighter on a dark ground. Oppositions of relatively equal strength will tend to vibrate because the eyes are unable to focus on both at the same time. These kinds of effects are involved in the color structure of your work. Op art stresses such effects.

Basic color differences are called *hues*. *Tints* are lighter differences. *Shades* are color mixtures that are darker. Hues that range from purple to yellow-green are considered cool; those from yellow to red-purple are warm. But warmth and coolness are relative to specific contrasts and the general context. While colors tending toward blue are cool and those toward red-orange are warm, a red may be cooler than orange, and so on. Greys also contain these cool and warm aspects based on surrounding context and contrasts.

There are many color theories, but it is possible to simplify the key aspects. The basis remains the three variables: yellow, red, and blue, which we will now explore in terms of naturalism.

ILLUSIONISTIC COLOR

Profound naturalism originates in a consciousness of color changes in each plane. This movement of planes must take into account the counterpoint of cold and warm colors, of primaries and their complements, and of color and its negation.

Because of the effects of atmosphere, light, and space, all color is found in an impure state. However brilliant the appearance of any local color, some mixture of all of the primaries will be discovered. The color-reproduction process (used in printing and lithography) which mechanically separates the primaries and then superimposes the separations, is an illustration of this. Once we accustom ourselves to this simple concept, we can assess the relative amounts of red, yellow, and blue in any particular area (see Plate 24).

It was this concept that the impressionists, concerned with the problem of light, attempted to make explicit by juxtaposing contrasting color strokes or touches. These contrasts tend to vibrate as they alternately succeed in gaining attention. And this vibration helps to give the illusion of light.

Every area in nature has not only variations of color and value but a local color and value as well. As light reveals an object or area, part of it becomes brighter and lighter, part of it duller and darker. Parts of the area are more intense; other parts are greyer. The variations are different combinations of the variables red, yellow, and blue. Each complex color plane will be found to be dominated by one or two primaries or will tend to become neutral as the variables become equal. When working with opaque pigments such as oil paint, white is used to lighten colors. But I urge beginners learning to use color to avoid using black to darken colors. Hues will become dark enough by omitting white. Thus atmosphere, spatial position, direct and indirect light transform local color.

Each color plane has an absolute position within a particular context, but our assessment is determined subjectively. Some colors will seem to come forward and others to retreat. Stronger more intense colors tend to come forward, but the actual contest of forces is more complex. Where a color might retreat because of its greyness, an associated sharp or dark line can bring it forward. But in nature colors usually become relatively greyer as the distance between them and our position increases.

As you paint, mix your colors thoroughly and often. Make sure there is some difference each time. Arbitrarily counterpoint warm and cool variations even if you cannot see them. You will learn to distinguish subtle variations through comparison. Use similar hues, particularly the primaries and secondaries, as comparative references. Learn to move your eye over the whole scene, the whole canvas. If the limits of the color situation are stated, the rest will find their place more easily.

COLOR ORCHESTRATION

Naturalistic color sets up the appearance of nature, whereas the romantic, classical, and realistic approaches seek contradictions to appearance, since their goals are emotional, intellectual and structural. (We will go into this further in Chapters 5 and 6.)

Color, then, needs to be organized. Color used for structural reasons is sometimes called *plastic color* (plastic here meaning pliable). Color can be intensified, weakened, and changed in many ways. Much that has been

said about illusionistic color applies to plastic color, but the latter is manipulated more arbitrarily for varying purposes.

Color patterns hold thematic sequences together. They draw the eye through the canvas in a designed color experience, reaching a climax where the color is most intense or most different (see Plate 25).

In deliberate or intuitive orchestration of color you depart from the relative greyness of nature to create arbitrary space. You use pure hues and other extremes, as well as greys, to create a color structure.

PSYCHOLOGICAL COMPONENTS

Psychological tests indicate that most people think they like certain colors best. Blue is a favorite for many, with red, green, purple, orange, and yellow following in order. I know a painter who won't use a bright yellow. Salvador Dali avoids green.

Red and red-orange are considered exciting, blue and blue-purple peaceful, green and yellow-green tranquil, and yellow cheerful. Color associations are part of our language and culture. We "see red," experience "red-letter" days, encounter "red tape," are "in the red," and so on.

Color use inevitably involves psychological associations and often symbolic meanings. Naturalists do not concern themselves with psychology; but classicists, romantics, and realists employ color in psychological as well as structural ways. Van Gogh's letters made specific references to the psychological meanings of his color.

Color is sometimes felt in terms of the other senses. Newton "saw" the sound of C as red, D as orange, E as yellow, F as green, G as blue, A as indigo, and B as violet. Liszt, Beethoven, Schubert, and Wagner also referred to color associations of sound.

We have taste associations such as sour, acidy, and sweet colors. Bright red, orange, soft yellow, and clear green seem appetizing to many; yellow-green far less so. Pale pinks, lavenders, yellows, and greens have pleasant smell associations for some of us. As for touch sensations, red seems hot, orange and yellow warm, green cool, and blue cold; orange and yellow seem dry, and blue seems wet.

These and many other color associations stem from direct or culturally inherited experience. By associating certain colors with specific experiences, we make them subject to recall. Color symbolism is derived from such associations and may be either personal or social. The social becomes personal as it is given individual content. The personal becomes social as others learn the symbolism and begin to use it.

Color played a role in early superstitions, myths, and customs. It was used symbolically in religion, heraldry, for the seasons, and so on. For some, blue stood for love, fidelity, and purity. In religion, blue represented heaven or truth. Green is the symbol for nature, and purple is associated with sorrow. In heraldry, red means bravery and courage, while the red cross of today stands for love and mercy.

The U.S. Coast Guard uses white as a symbol for fair weather, blue for rain and snow. The symbolic uses of color are endless; often contradictory, they can be understood only in particular contexts. Although some symbolic color associations (such as red for valor) may be universal, most are not. All associations are learned (not inborn), and are subject to change, proliferation, and ambiguity.

During certain periods of the past, as in Gothic times, artists worked in precise symbolic color vocabularies. Today most painters prefer more personal color references, but nonetheless they use the color symbols of the cultures of our time. Color associations and symbolism enter a painting as resources, to be used or not, like any other aspect of painting. Both become tools for self-discovery as well as for social discovery and communication.

In many kinds of abstraction, mood is determined by the quality of color. Associations are projected, whether intended or not. Even naturalistic work inevitably if unconsciously contains psychological color meanings.

With color, the key element in painting, we have completed an examination of the six visual contrasts with which we work. While some structural suggestions have been included, it is now important to develop further the nature of organization.

CHAPTER

5

Structuring Visual Discoveries

Each of us has an artistic viewpoint. What we conceive of as our personal idea of reality determines our creative direction. We are a combination of variables stressing either an ideal order, or emotional action and reaction, or appearances, or a synthesis of the factors underlying appearance. Each of us is largely dominated by this or that variable, or is perhaps in a state of conflict. Whatever pull conflicting influences may exert, eventually we gravitate toward one of the following creative mainstreams: *classicism*, dedicated to intellectual idealism; *romanticism*, with its emphasis on the personal and subjective; *naturalism*, devoted to the faithful copying of appearance; and *realism* with its dialectical approach.

These four outlooks explain the creative process in different ways. As we shall see further in Chapter 7, classicism stresses revelation—absolute and codified; romanticism calls it personal intuition; naturalism relies upon observation; and realism sees the creative process as problem-solving.

In this chapter we want to search out the

key components present in all painting and drawing, regardless of one's philosophical bent. At the same time we want to remain mindful that each individual's choices are conditioned (or "colored") by factors that operate from within and from without. In that sense we are structuring as well as being structured by our visual discoveries.

We search out an idea, largely through trial and error. Then we extract generalizations, observations of samenesses and differences. These become the structural themes. We cross-fertilize these observations and make discoveries. Our awareness level sends intermittent intuitive flashes that help us decide when relationships are right for us. In the process a structure embodying discoveries is realized. That object then meets a continuing social test.

Discoveries are made in many ways. Our senses search visual contrasts for gratifying responses. Psychological associations lead to self-discovery. Symbolism cross-fertilizes and invents fresh meanings. Observation of appearances extends our facts and techniques. Finally each creative path leads to its unique structure.

This created structure then is perceived by the senses. Its visual contrasts communicate directly, even when heavy with associations, symbolism, and recognitions. They are the essence of painting and drawing. Thus we must examine and take into consideration all the visual components: line, shape, value, texture, space, and color in order to control their organization.

As already stated, in every work the key is *repetition with variation*. Sameness provides unity; contrast provides interest. A main theme dominates a work. Minor and opposition themes elaborate, contest, and realize the main theme. A climax, rhythm, and pattern enrich and hold the work together in either asymmetrical or symmetrical balance. Let's examine each of these aspects in turn and look at the illustrative examples.

THEMATIC SEQUENCES

The main theme is the dominant varied reiteration in the work. Each element has its main theme. That theme is not necessarily larger, nor the one that attracts your attention. A dissonance can do that. The main theme is quantitatively the central inescapable repetition. Some aspect is selected from each visual contrast to become the one repeated in as many inventive ways as one can bring to it (Figures 5.1–5.4).

The samenesses provide a unifying fabric of threads. The differences draw the eye through this fabric. Explicit and implied triangular shapes become large, small, distorted, elongated, dark, light, textured, and so on. We feel the unity even as we are involved with the contradictions within it.

The thematic motif sequence is thus not a subject sequence. It is not a circus, sorrow, or love idea. But any of these may be the

5.1 ANTHONY TONEY, "Yellow Curtain"; Oil (Collection of Arthur Kahn)

The main linear repetition is a diagonal forming the dominant triangular shape idea. Minor ideas consist of vertical and horizontal directions, hence rectangular shapes with a circular opposition. Space is mainly close, with some middle distance and a suggestion of far distance as opposition.

5.2 Analytical sketch for "Yellow Curtain."
The balance is asymmetrical.

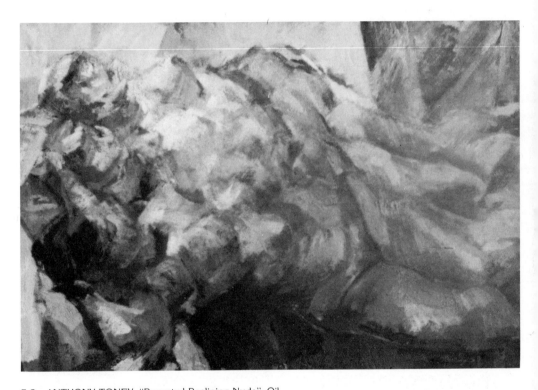

5.3 ANTHONY TONEY, "Repeated Reclining Nude"; Oil.

The main linear theme is a counterpoint of horizontal and diagonal continuities resulting in rectangular and triangular oppositions.

5.4 Analytical sketch for "Repeated Reclining Nude."

The main space theme involves horizontal figure repetition in low relief.

basis for the visual contrasts that do become the theme. Our own lives, our attitudes, as well as the specific problems undertaken constitute our real subject. A painting is a self-portrait. That subject is inseparable from its visual components and these components become the structure. Changes in one transform the other. Your approach, choices, and judgments create and resolve the problem. We are each the subject and the object. But in this discussion we are stressing the central aspect within drawing and painting—their visual components.

Thus, a main linear repetition may be a sequence of explicit and implicit vertical movements pervading the canvas, whether the subject is a nude, still life, or abstraction.

The directional changes within the vertical movement (diagonals, curves, heaviness, lightness, and so on) are contradictions. They are at once different from and subordinate to the main vertical movement. Were they not subordinate, they would displace the vertical idea. The latter would then become subordinate to some other main idea.

These differences within a main idea cause what we call a *progression*. They force you to move from one repetition to another. You progress through the work.

The oppositions within a main theme may remain relatively minor. In that instance the main theme is dominated by the vertical movement. It is a *domination* idea.

But sometimes we prefer a strong challenge to the main movement. The contradiction becomes important enough so that we are aware of a contest. There may be almost as much of a horizontal as vertical movement. This is an opposition idea. It is based on contrast. But since this term might be confused with the opposition to the main and minor themes, we can call it a *contrast idea* (Figures 5.5 and 5.6).

Main and minor themes can each be either domination or contrast ideas. Bear in mind that as your work becomes torn with many contradictions, it can well become confused or static.

As complexities multiply we lose our thematic clarity. Remember that thematic strength and clarity are determined by quan-

tity. There must be more verticality than any other movement if it is to be a main theme based on domination. Verticality and horizontality can be *almost* equal within the main theme in a contrasting idea.

The main themes determine all else in the work. They possess the key differences to which the rest must refer. The vertical direction remains dominant even as it becomes long, short, narrow, wide, black, or white, or as it retreats, comes forward, contains zigzags, curves, and so on. The variations enrich and elaborate the thematic sequence.

Each element must have an organization of its own even as it serves to vary and enrich other visual contrasts. There will be linear, shape, value, textural, spatial, and color elements in all main, minor, and opposition themes.

If you look at the red, yellow, and blue reproduction plates of a good painting, you notice that each separate plate has a completeness. As you examine a good painting, element by element, you will find that each element has main, minor, and opposition assertions. Each element has its own resolution even as it enriches others (see Plate 24).

The main motif has a central relationship to those that are minor or opposition themes. The subordinate themes must oppose or elaborate that main idea in contradictory ways. If the main linear repetition is vertical, the other must be horizontal, for example.

MINOR SEQUENCES

Minor ideas must be subordinate in quantity if they are to remain minor. They act as counterpoint to the main progressions and so strengthen them. They may contest the main themes more or less strongly or subtly (Figure 5.7).

A minor motif contains its own variations. A main linear theme may be vertical but the horizontal subordinate idea may be contrapuntal to it with differences in its own repetitions (Figure 5.8).

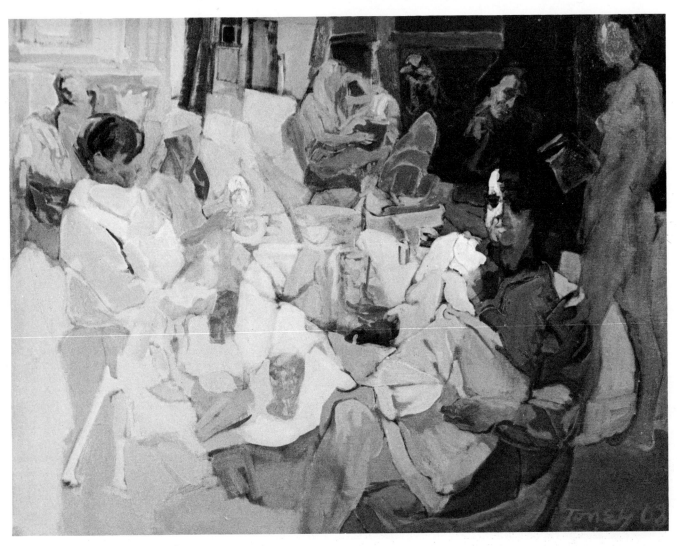

5.5 ANTHONY TONEY, "The Center"; Oil.

The main movement and shape theme is based on contrasting circular and triangular shapes.

5.6 Analytical sketch for "The Center."

An asymmetrical dark pattern reinforces the circular idea. The circular triangular counterpoint determines minor and other ideas.

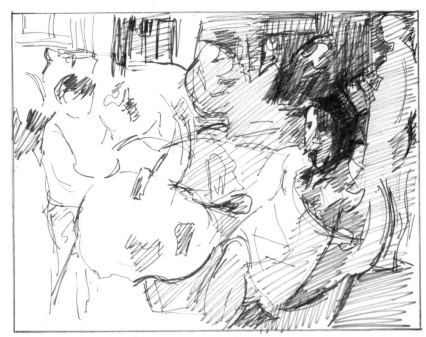

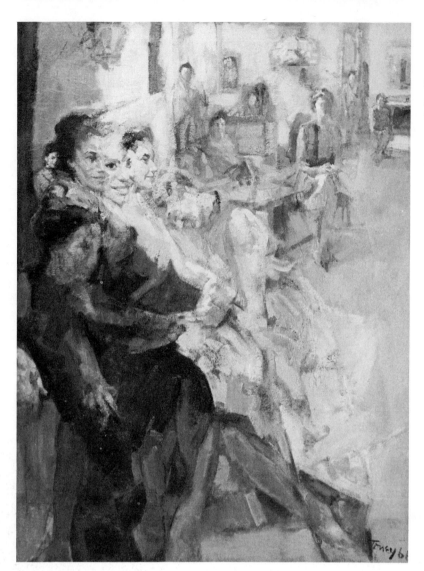

5.7 ANTHONY TONEY, "Repeated Woman"; Oil.
A minor rectangular shape idea stabilizes the main triangular repetition.

5.8 Analytical sketch for "Repeated Woman."
The triangular idea dominates this work.

94

OPPOSITION THEMES

Opposition ideas should contrast strongly against the prevailing concepts in the work. Quantitatively, opposition themes occupy the least space of a work, yet they have impact because they are different. That difference dramatizes the harmony of the rest of the canvas (Figures 5.9 and 5.10).

An opposition motif may possess its own variations and have to be balanced. Since opposition themes by virtue of their sharp contrast attract attention, they usually form part of the center of interest.

Though determined by the main ideas, minor and opposition themes are no less important to the work's realization. Opposing differences at once enliven and, in the climax, become a unifying focus.

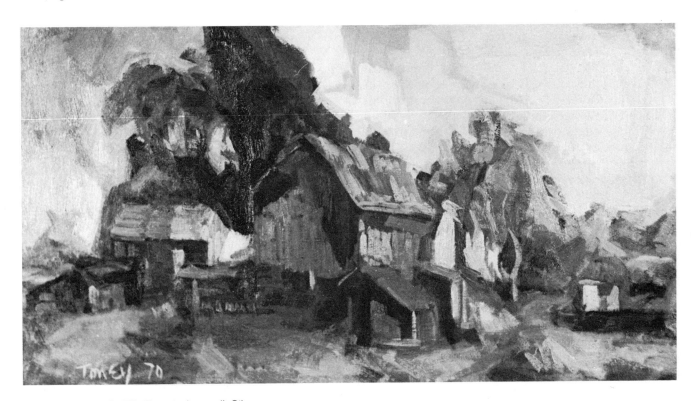

5.9 ANTHONY TONEY, "Farm in Autumn"; Oil.

An implied oval movement forms opposition to the dominant triangular and subordinate rectangular themes.

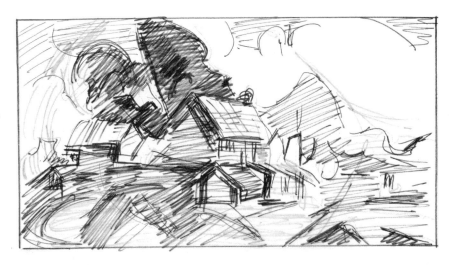

5.10 Analytical sketch for "Farm in Autumn."

Main dark and light patterns reinforce main and minor ideas, but variations within them create an opposition of implied interlocking ovals.

CLIMAX OR CENTER OF INTEREST

Generally, thematic extremes should coalesce to form the center of interest. The climax is thus the thematic highpoint. It is the area that is most involved, most distinct, brightest, lightest, and darkest, and the most unusual in that canvas (Figures 5.11 and 5.12).

The climax is like the highlight on a head smothered in darkness. It is the work's summation—the culmination that holds and integrates the rest. The climax provides at once opposition and unity.

Generally, the climax is not centered in the canvas. It best occurs somewhat off-center to the left or right and either above or below. Corners and any area too near the canvas edges are avoided because they tend to pull us out of the work.

Of course any problem that we set up can be solved. Artists have delighted in doing the impossible. Forces can be compensated, and fresh solutions can be achieved.

A single main climax should suffice. Complex works may also need minor climaxes. Opposition themes and climaxes should not be confused with *surprises* and *dissonances*. Surprises and dissonances may exist within main and minor sequences. They are the possible abrupt and few differences introduced to point up the harmony imposed by the main contradiction.

RHYTHM

Rhythm is an accented repetition within a progression (Figure 5.13). This relatively regular stress within shape, linear, color, spatial, value, and textural progressions can help order the main assertions relative to the lesser ones.

Rhythm provides a secondary level of interest, a unifying beat or bounce, a repetition that strengthens the eye's movement through the painting. In a vertical progression, the movement might be regularly stressed in a way that attracts attention and so catches and moves the eye through the work more strongly than otherwise. The best rhythmic progression is an uneven repetition that asks to be balanced.

PATTERN

Adjoining shapes that are similar in value or color tend to group and form larger shapes. These associated value or color shapes are called *pattern*. Patterns do not exist singly. They counterbalance each other, dark against light, one color against another (Figures 5.14 and 5.15).

Value patterns function within the composition's value range. The darker, medium, and less dark shapes group relative to lightest, medium light, and less light shapes. The pattern is generally interlocking on the level of simply dark and light. But the variations of darker and lighter shapes group subordinately within the larger pattern.

The interweaving patterns take many shapes, sometimes implicitly geometric and often grouping into simple letter or other calligraphic forms. Pattern shapes may be very simple, as in some minimal works. They may be at once complex and simple—simple in implied ways and complex explicitly.

Patterns move against each other, creating implied and actual shape relationships that help pull together the labyrinth of progressions. They make the work more easily readable. Patterns are spatial; their shapes move in space as so many planes toward and away from us.

Pattern tends to assert the picture plane even as its components move back and forth from it. While pattern can be spatially quite flat, it can also be illusionistic with naturalistic volume relationships.

The pattern structure becomes also the visual texture. They co-exist. Yet, generally, pattern relates to the overall counterpoint of values and texture relates to smaller components within it.

Color pattern may contrast boldly or more subtly, depending on the color scheme. The interweaving color groupings may or may not reinforce the value pattern. On the one

hand, a red and green dark idea may be set against a light yellow variation and thus affirm the value pattern. On the other hand, all three colors may counterstate in both the dark and light areas of a canvas and form independent patterns.

The principal device to integrate visual progressions is pattern. Although it is inspired by the contrasting visual movement, pattern has its own shape and space role. Pattern may act as a strong assertion of the main shape progression or it may oppose it. Its counterpoint of value and color may have dominant and subordinate characteristics or it may be relatively equal and need to be balanced.

5.15 Analytical sketch for "Major Deagan Walk".

The large light grouping at lower right penetrates the dark at left and is balanced by the smaller light area at top of canvas. The lightest lights reinforce the oval opposition to the main vertical-diagonal thrusts.

5.11
The clim

BALANCE

Thematic progressions and pattern should be asserted in inventive variation, some aspects stronger, others weaker. To resolve their contradictions and achieve equilibrium, some form of balance is required. Visual forces may be balanced either symmetrically or asymmetrically.

Symmetrical balance develops relative equalities within and to the canvas center. It resolves the tensions of contrasts on all sides of the actual center or those that stem from that center to the surrounding areas. The main motif can be placed in the center, with minor elements to the left and right and above and below. Relatively equal motifs may balance from side to side or from top to bottom or both (Figures 5.16–5.19).

Unless the intention is decorative, symmetrical balance must be destroyed as well as maintained. This is done by embodying severe enough differences within the overall symmetry.

Asymmetrical balance utilizes the principle of leverage. The center becomes the fulcrum, with a large area of tension on one side balanced dynamically on the other by a small weight or tension at an appropriate distance from the center. Our sensibility is the scale that determines this position and relative size.

Paintings can easily be too evenly balanced and thus become static. The tensions cancel each other; and the progression is stopped. Muddiness and confusion result. We need a more precarious balance, one that *seems* to topple but does not.

Each element as it progresses will need varied repetition. Where it needs to be strong will be determined by the main idea. The main thrust is reinforced, elaborated, as well as contested. But the differences created need to be reconciled, balanced symmetrically or asymmetrically, depending on the key idea.

Each visual elemental quality, whether of paint texture, space recession or volume, has to be balanced. You cannot introduce a quality in one area without balanced repetition, unless it is in the climax. If the quality is properly balanced, you may juxtapose the most outrageous contrasts whether of line, color, montage, or collage.

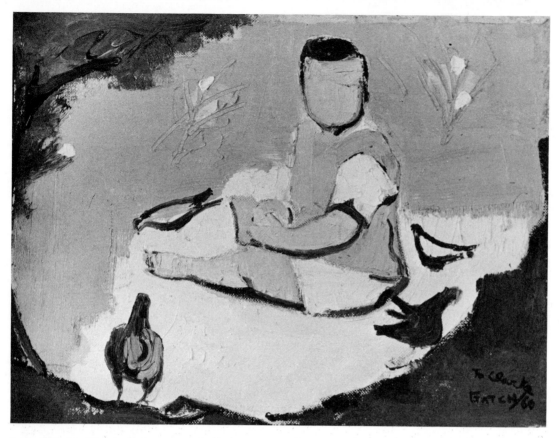

5.16 LEE GATCH, "Clarke and Pigeons in the Snow, Heigh Ho"; Oil.
(Courtesy ACA Galleries; Collection of Philip Bruno)

The main motif can be placed near or in the center if enough differences keep the movement dynamic.

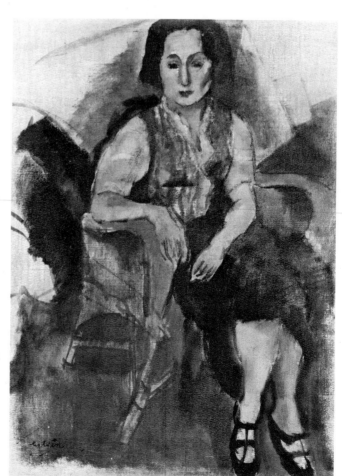

5.17 JULES PASCIN, "Woman in Black Shoes"; Oil.
(Courtesy ACA Galleries)

Diagonals form a spoke-like idea whose symmetry is countered by interruptions and variations.

100

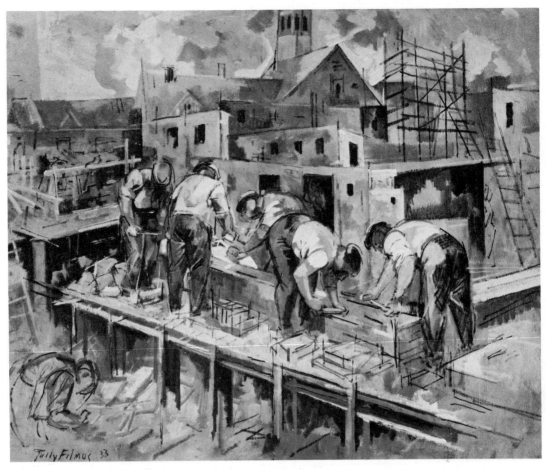

5.18 TULLY FILMUS, "Bricklayers"; Oil. (Courtesy ACA Galleries)
Repeated figures are placed centrally in a diagonal movement repetition.

5.19 ANTHONY TONEY, "Candlewood Interior"; Oil.
Contour line accents the very light value idea in non-symmetrical balance.

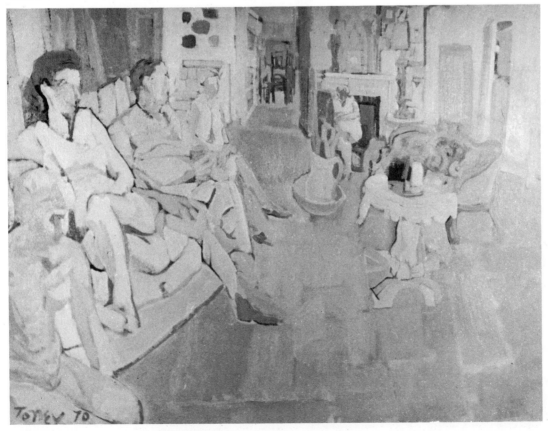

101

The contradictory layers of forces gain resolution in a dynamic equilibrium. Tensions must not become static. Contrasts must remain sufficient to pull the eye freely through the canvas to the climax. They must be retained within the borders in a journey that can resume again and again, nourishing body and mind.

LINEAR THEMES

Linear repetitions are among the most easily perceived. The larger movement relationships are inevitably implied or general. They will tend to be vertical, horizontal, diagonal, or curvilinear. The main thrusts are those that dominate. Repetitions that reinforce the main movements become at least roughly parallel, but with inventive differences (Figure 5.20).

Linear movement sequences may be based on contrast as in a vertical and horizontal idea. Also the motif can be mainly a repetition of a single kind of movement as in a sequence dominantly curvilinear. We must keep clear the nature of our ideas, particularly the main or central repetition which will determine the rest.

A standing figure is a vertical movement that may contain other more or less parallel verticals or diagonals that affirm and enrich the main thrust (Figure 5.21). Variations and contrasts with that key idea are contradictions that add interest. Such a figure may be dominantly a contrast idea of vertical and horizontal movements with circular movements secondary and diagonals in opposition. More likely it may be a counterpoint of diagonals and verticals with a minor idea that is circular and the opposition horizontal.

The placement and attitude of the figure will determine the larger character of negative areas and may or may not require other supporting or opposition developments in those areas. We each decide the differences and their complexity.

Bare lines can have a sharp, clean expression. Contradictions are the more clearly observed and felt. Contour line may be both complex and simple. When it depicts geometrical shapes, its implied and actual characteristics coincide. When it is more varied, it will have a simpler implied direction and be enriched by the minor oppositions within that general movement (Figure 5.22).

Linear movement organization creates the shape structure.

5.20 ANTHONY TONEY, "Musicians"; Oil.

Diagonal continuities establish an asymmetrical pattern with the main weight and center of interest left of center.

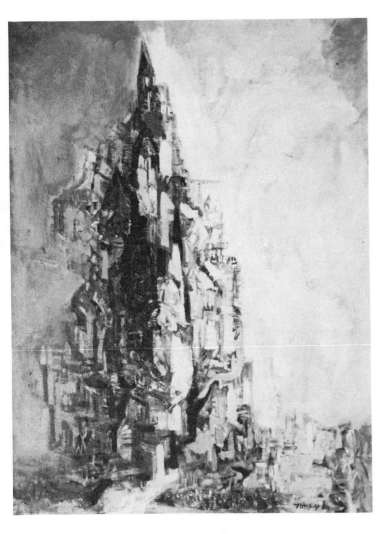

5.21 ANTHONY TONEY, "Pre-Countdown"; Oil.
Vertical movement is the key idea.

5.22 REX CLAWSON,
"Welcome to Fun City"; Oil.
(Courtesy ACA Galleries)

Line can have a sharp, clean
expression. Mainly pure vertical,
horizontal, and circular lines
establish a clear main repetition
with variations of rectangles,
countered by a minor triangular
and circular opposition.

SHAPE THEMES

The main shape ideas derive from the main general linear movements, the larger divisions in the canvas. The minor theme is subordinate and opposed to the dominant theme. The major idea might be a rectangular repetition, the minor idea might be triangular thrusts within it. The opposition might be circular.

Value and color groupings have shapes that may or may not affirm the main shape ideas. However, since the main shape idea is that which is most evident in the work, any pattern shape that too strongly opposes the original idea simply replaces it.

Generally, the pattern shapes affirm the main or minor ideas. But complexities are possible, as when a spoke-like group of shapes may affirm a triangular minor theme while implying an opposition circular shape (Figure 5.23).

Shape organization may become complex as we seek to determine not only the larger actual and implied shape relationships but also each stroke, their groupings, and resulting patterns.

The macrocosmic shape conflict becomes reflected in microcosmic variations within minor forms and details. The photographs of snowflake formations reveal a complex repetition of the larger shape idea within itself in seemingly endless smaller variations.

But of course, shape ideas may become much simpler, as, for example, in some Mondrian works.

5.23 MARCIA MARCUS, "Red, Mimi, Baby"; Acrylic on canvas. (Courtesy ACA Galleries)

Clear, relatively flat shape repetitions move with variation diagonally through the canvas.

VALUE THEMES

Value variations create spatial appearances and differences, form patterns, and textures, and they possess their own thematic statement. Value progressions share the possibility of domination or contrast in major and minor sequences and the other elaborations previously suggested (Figure 5.24).

Drawings and paintings may be very light, very dark or any variation in between, dominantly one or mostly one value. Reinhardt's last dark paintings are an example. An Albers that I saw recently was quite light. Almost every painter has painted his white canvas, filled with white or near white objects. In the 1950's and 1960's a number of artists exhibited works with but one color or value, and the direction persists.

Paintings and drawings may also and more usually have various contrasting light and dark combinations (Figure 5.25). It is generally better to avoid contrastive equalities, but there can be more or less dark or light as you wish.

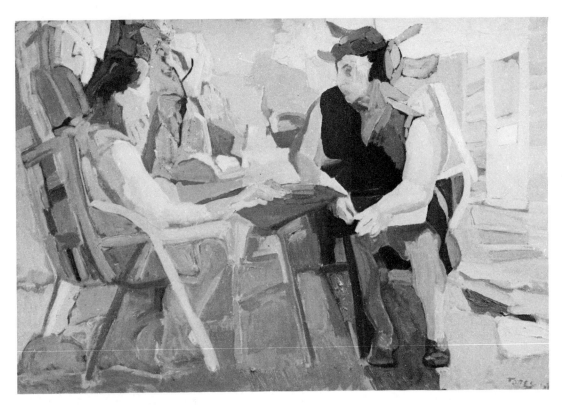

5.24 ANTHONY TONEY, "Summer Game"; Oil.
A medium light value is dominant; darkest dark forms the opposition.

5.25 ANTHONY TONEY, "Spring"; Oil.
The dark and light counterpoint affirms the main rectangular, minor triangular, and circular
opposition themes.

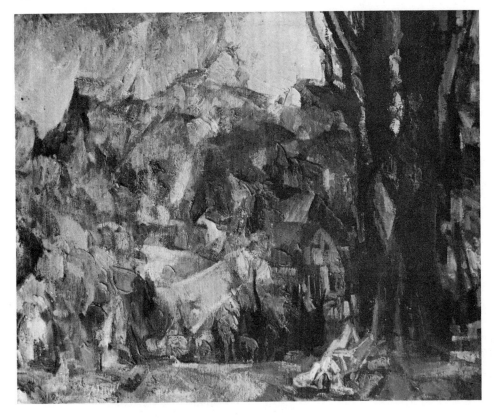

Many painters prefer to use a value range that extends the entire gamut. They wish the darkest black and the lightest white to exist somewhere in their work. Others limit the range variously. The darkest dark may be only a medium dark. The lightest light not really light. The value range is directly related to the value scheme that is selected.

Whatever the value range, most canvases need a central or focal value to which the values progress, becoming as light or as dark as the range allows. In contrasting canvases there is a counterpoint of value repetitions with variation. There may be conflict within the main value theme or between the main and minor value progressions. The opposition theme must be different from both.

Building value schemes is integral with spatial, pattern, and textural development.

TEXTURAL THEMES

Texture is visible only as a value pattern, whether it be hair or a checkerboard or mixed media materials (Figure 5.26).

The main visual textural idea is usually the specific light and dark counterpoint within the large pattern. That idea may be repeated inventively throughout the work to the extent felt necessary. Less rough textures might contrast moderately and the most smooth textures might become the actual opposition.

When the value range is close, as, for example, in a medium tone canvas, the visual texture likewise is limited in its contrast. The actual texture can of course be a counterpoint of varying thicknesses of paint. Thus the visual texture could be a total domination idea and the actual texture contrasting.

If a particular texture pervades a canvas totally, its textural opposition is implied. What is there is implicitly compared to what is not. Some painters, at least in some of their work, prefer to keep the actual texture completely smooth. Paint application is so unobtrusive as to be effectively concealed.

With some impressionists, post-impressionists, and fauvists, both the visual and actual textures played more active roles. Generally, the romantics, such as Van Gogh or Soutine, enjoyed vigorous, even violent textures, both actual and visual.

A complex organization of illusionistic actual and visual textures requires advance preparation such as technical planning, sketches, studies, and so on. If such plans are not made, the canvas must be brought to a finish slowly so as to maintain a flexibility that permits changes.

The abstract expressionist period reveled in contrasting textures. Some painters became quite three-dimensional, with the use of collage and constructed canvases.

Conscious textural control demands the same concern for main, minor, and opposition progressions discussed previously (Figure 5.27). Contrasts must be balanced.

5.26 UMBERTO ROMANO, "Fragment—Pope John Prays"; Mixed media; Glass box series.
(Courtesy ACA Galleries)

An actual pigment texture becomes part of the progression of visual parallel textures.

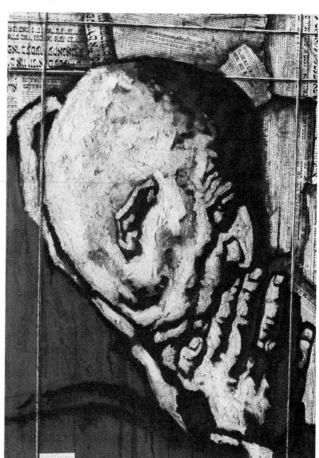

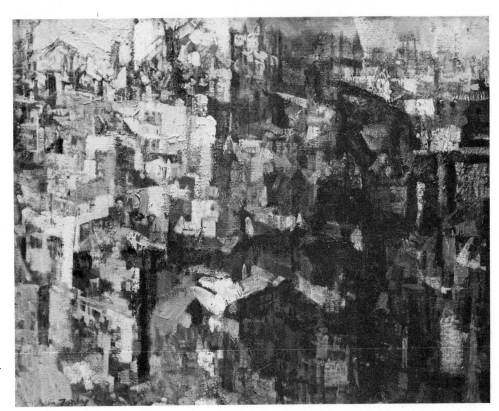

5.27 ANTHONY TONEY,
"Lower East Side"; Oil.

The texture is predominantly rough.
Medium texture plays a very minor
role, and the smoother opposition
barely infiltrates the work.

SPACE THEMES

Space concepts have already been discussed
relative to both naturalistic appearances and
plastic space dependent upon force relation-
ships. Conscious space organization can move
in either direction, but thematic spatial se-
quences involve space pliable to creative
transformation (Figure 5.28).

Ever since cubist analysis tore apart sur-
face unity and bared the structural elements
to experimental possibility, spatial experimen-
tation has multiplied. Spatial movements can
be extracted, assembled, and reassembled in
inventive cross-fertilization. Even the com-
monplace becomes freshly seen.

Technological discoveries in communica-
tion have extended spatial experience. We
move with tremendous speeds; we view our
environment in myriad new ways. We've be-
come spatially involved macrocosmically and
microcosmically. Inner and outer space have
taken on vast dimensions. Transparency and
multiple views are commonplace. It is difficult
to think in terms of fixed positions, when our

5.28 HANANIAH HARARI, "Girl with Flowers"; Oil.
(Courtesy of the artist)

The centered naturalistic figure is opposed by a flat
background. Volumes are fully realized, spatial symmetry
subtly countered.

lives move simultaneously in and out of so many spheres (Figure 5.29). Of course there is action and reaction; we are not all the same.

Space structures may work almost on one plane throughout with subtle differences or they may move with violence with large contrasts of spatial position. Each appreciable difference must take its place within or against the main space idea. Minor and opposition progressions are determined by the major thematic need (Figure 5.30).

Volumes in space may have symmetrical or asymmetrical relationships. They may be up close, in the foreground, or at varying distances. Farness and nearness may counterpoise. The space range in the canvas may be either deep or shallow. The planes may remain relatively flat with little movement or be frequently ruptured by spatial surprise. Whatever the space qualities, assertions, and varied repetitions, there is the need to balance them dynamically (Figure 5.31).

5.29 ANTHONY TONEY, "South Sixth"; Oil.

The larger main spatial movement toward the center of the canvas is countered by a lower weaker movement. The main idea is in the relative foreground, the minor is in the middle ground, and the far distance is in opposition.

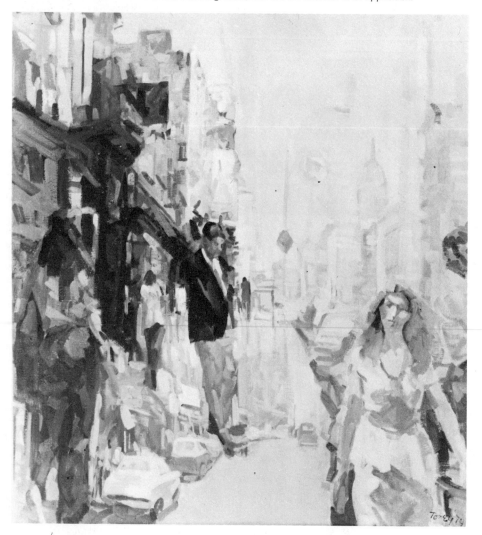

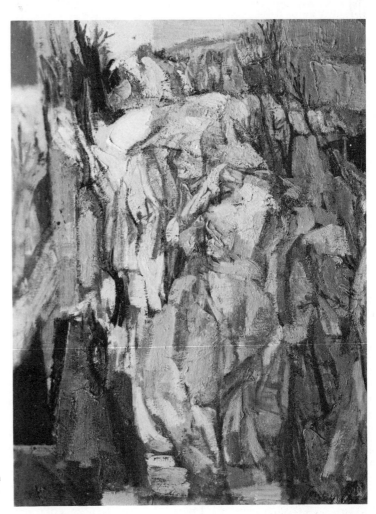

5.30 ANTHONY TONEY, "February"; Oil.

The main spatial idea builds in low relief to and from the picture plane, and is opposed by movement into the middle distance at the top of the canvas.

5.31 SAUL CHASE, "Brooklyn-Queens Expressway"; Acrylic.
(Courtesy ACA Galleries)

The large, open, box-like space is countered by small, dark, tunnel openings.

COLOR THEMES

Color harmonies of various sorts have been taught. Briefly, colors which are similar to each other tend to be harmonious (see Plates 26–28). They can be similar in that they are variations of the same color or are closely related, as are yellow, yellow-orange, and so on. Also we can play off opposing colors. Harmonious oppositions include the primaries themselves, complementaries, other triads, near complementaries, and colors against white, black, or grey. Inevitably, color harmony comes down to domination of a color or some form of opposition.

Since following formulas is not exactly creative, I suggest that you use traditional ideas with great freedom, and that you search out your own reactions and preferences. There are still discoveries to be made in color relationships.

The three primaries are the basis of all color ideas. Any scheme is dominated by one or two of the primaries or else is a counterpoint of them.

Color schemes that employ all tints, shades, and tones of a particular color, of closely related colors, or of colors that are harmonized by the intrusion of a specific color are called *dominated schemes*. In such schemes the main color is altered by mixing in minor amounts of contradictory color and white. The latter enrich and progress the color. The differences in the progression draw our eyes through the work.

In *opposition schemes,* two or more of the primaries confront one another, with variation throughout the canvas. Each progresses through the work by embodying the remaining colors in minor ways.

A progression includes adjacent hues, variations of light and dark, and mixture with minor amounts of other color. Such a progression has a range beyond which there is a break in the chain. Too much of an opposing color can make that color too grey. A red idea with too much yellow mixed into it creates a qualitative change as it becomes yellow-orange, and so jumps out of the progression.

A main color theme is such because there is more of that idea in the canvas. A minor color idea has a lesser role. An opposition idea is there least of all, and often as the climax. The quantitative relationship can vary. In a clear domination by the main theme, the minor and opposition ideas exist far less. Equality of amounts will cause the themes to lose their identity.

In the course of work, one color scheme may change into another as the progressions are strengthened or weakened. Order can become disordered and then reordered in a new way.

Since color ideas often become too complex and equally strong ideas may negate one another and cause confusion, André L'Hote has suggested that only one of the primaries should be brought to full intensity and then contrasted with black, white, or grey.

Colors that are similar in hue tend to form a pattern in a work in the same way that similar values form a value pattern. This related aspect is used to hold the work together and to move us through the canvas.

Base your choices on your own reactions to the color you get. Color discoveries are still being made, and as soon as you learn to feel the relationships, you will make your own discoveries of unique color possibilities.

SEEING WHOLE

A major difficulty when painting or drawing lies in the tendency to subordinate the whole to the part, to the present interest. Our anxiety about a single detail prevents the perspective that could help us place it where it belongs.

We have employed various means, mostly forms of distance, to handle this problem. Simply to have room to walk away from the work is a help. Lacking such space, one can set the work aside periodically or change its environment by taking it into another room.

Time helps. Time permits many trials to occur and current subjectivity to be overcome. The creative process requires time to follow its own logic as influenced by particular cir-

cumstances. Time allows us to see our work in relation to other works in our own and other people's studios, in galleries and museums, in the context of all art.

You can work on several things simultaneously. Hang them where they can be seen while they are in process. Time will help finish them.

Seeing our work through the eyes of others lends another kind of distance. Showing your work to friends and in exhibitions is part of the social test, which is the conclusion of the creative process for a particular work.

Organization is not a static process performed once and for all. Rather, one idea pits itself against another. The relative strength of contradictions is often altered, and minor contradictions become major. Our initial ideas will require considerable alteration before we resolve the work.

The guiding thread of search and discovery is our internal awareness synthesis. We make a work "in our own image," but the discoveries we make while working in turn change us *and* the image. They also determine the works to follow. A work expresses both ordinary and inspired spirit and action. It is or can be whole, but not an absolute ideal whole. One level of complexity or problem leads to another.

Organization is a necessity in art, but it is not everything. The essence of art is the freshness and significance of experience embodied in wholeness. Be yourself. That is the path to freshness. Test your ideas with your own sensibility. Be open but also unafraid to reject what makes no sense to you.

BEAUTY

Is beauty a present concern? Why has it not been mentioned? The word *beauty* is as difficult to define as *talent* or *happiness*. They can mean almost anything.

The classicist envisages beauty as the ideal essence of reality. The romantic feels it as self-will and response. The naturalist relates it to the skillful rendition of appearances. The realist discovers beauty in significant freshness become whole.

Attempts to define beauty involve the fulfillment of purposes derived from one's view of reality. In that sense, the word is unnecessary.

But the word beauty is used even by artists. A specific kind of feeling is attached to it. It is associated with pleasurable sensations, visual but affecting the whole person. The pleasure's source lies in the visual relationships felt whole, particularly as they give the sense of life—not life as appearance but as function toward fulfillment.

This concept of beauty is not form separated from content. Content and form are inseparable. Stress on the pleasurable aspect too often turns beauty into an embellishment or decoration. It often becomes a possession, something to show off, a spot of color to resolve a room, something entertaining.

But art is far more profound. It simultaneously penetrates existence and embodies that penetration within a new existent, a new functioning reality. It radiates the beauty of its life, but the stuff of that life is our own.

CHAPTER
6

Identifying Your Aesthetic Viewpoint

You are the center of your universe. Surrounding and affecting you is a maze of dynamic influences stemming from the past and charging the future. Understanding yourself, knowing your own uniqueness is necessary not only for a healthy existence but also for creative discovery. An old cliché asserts that after art school we need ten years to find ourselves. Today art education may begin the process earlier, and you might emerge from school quite clear as to direction and style. Yet many of us do find ourselves as disoriented as ever.

Schools have always displayed a particular orientation to some aesthetic tendency. It depends upon the attitudes of the administration and the artists that support and make up the school's faculty. Today the stylistic panorama is so vast that schools may differ widely in what is stressed. Some try to reflect aesthetic differences by employing artists with contrasting convictions and methods.

Schools also have grown out of each other, as disaffected students or teachers pull away to form their own centers. Also many individual artists set up their own classes. Schools, art departments, art colleges and art centers have spread and grown in size and influence. In a period when to be "with it" has become important it is inevitable that some of the schools attempt at once to teach or perhaps invent the most recent avant-garde manifestation. This inevitably causes at least some confusion.

The art world reflects all the conflict of merchandising, funding, and manipulation that is characteristic of our society. The difficulties of a competitive marketplace stimulate imaginative efforts to win attention. Artists, teachers, historians, critics, museum and art administrators, and workers—all of us feel these pressures. According to our positions of influence or lack of it, we may or may not prevail. It is a conflict in which convictions and values emerge and retreat relative to each other.

You are in this arena with a point of view, although you may not be aware of it. Many of us are confused by respect for contradictory authority. Our own convictions are most often mixed as well as blurred; but hidden or clear, they are there. When we go into galleries we feel preferences; we tend to know what we like.

Our positions are not pure. They are anything but static. We change as challenges are confronted and as we develop solutions. Our own work will appear different to us at various stages in our life.

We have said that one's creative approach is determined by one's concept of reality. What is our idea of reality? Obviously, for most of us it consists of the things we can touch and otherwise sense as well as our ideas about them and ourselves. Yet is reality so simple? How many contradictions have we absorbed? With little apparent difficulty we believe mutually antagonistic views. Our inner and outer conflicts, intense, turbulent, stalemated, or simply calm with momentary resolution, determine our values and goals, the character of our creative expression.

MAIN CONTRASTING VIEWPOINTS

In art as in life every system requires reevaluation and change both in theory and practice. Throughout history many schools of thought have come to the fore, enjoyed a certain vogue, influenced others, merged, submerged, reappeared in new form, and so on. The most important aesthetic viewpoints that we should focus on are the four most sharply opposed to each other: *classicism, romanticism, naturalism,* and *realism.* These viewpoints are contradictory even as they influence and permeate one another.

These four concepts seem to have been present always in life and art; contemporary art, indeed, is a vast panorama of their action and counteraction. Although in life their manifestations are complex, we can try to understand them as simple oppositions.

The classicist would point out that what we call an object has only a temporary existence while the *idea* of an object is immortal and therefore more real. Our goal should be the perception and expression of this real world of essential ideas.

Some romantics, on the other hand, say that all we know of particular objects is precisely our personal sensations of them. Knowing only complex sensations, we cannot be certain about either the objects or any absolute idea of them.

Naturalists would claim that all ideas, personal or otherwise, are suspect. The material world precedes any idea of it. To understand that world we must observe and measure its relationships, which are physical and mechanical.

Realists, as the term is used here, also believe in a material world. But they consider the mechanical emphasis of other materialists too limited and reductive, in that it accounts neither for the various complexities of levels of reality nor for the transforming role of human ideas or consciousness.

To become aware of how these four concepts relate to us as individuals requires elaboration. We will "step into the shoes" of each to find out.

CLASSICISM

Some of us need to have a very clear absolute understanding of the way things are or should be. We want a system of ideas that will be true always. Inasmuch as our material world comes into being and eventually decays while ideas seem imperishable, matter, our existence, becomes but a shadow, a reflection of the idea of matter or of existence. Theory becomes important. We distrust the chaos of what happens and hold on to eternal truths.

6.1 RAPHAEL, Figure study; Crayon. (Courtesy Dover Publications, Inc.)

Naturalism is transformed into ideal relationships by classical Raphael.

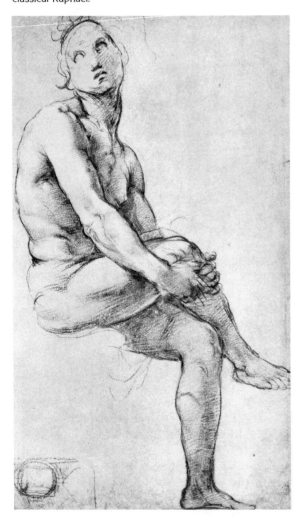

"In the beginning was the word." The idea must precede whatever it becomes. A body, thing, an action is imperfect, but the idea of it can be perfect. Obviously, since the idea of an object is eternal, the idea is more real than the object itself. Classicists are concerned with a hierarchy of pure ideas, which are the essence of reality in eternity, life, and art. Although the source of these ideas is outside of us, we possess them because we are their expression. Like a fragment of a prism, we reflect the whole.

Therefore just as we are born with all knowledge and need only to recall or deduce what is necessary, so to the classicist the painting already exists in ideal form. The artist becomes the agency for giving it material existence.

Every culture has had repeated classical manifestations in art, inventing its own system of ideas and art concepts. Works are produced following such rules as that of the "golden mean." Areas are divided and subdivided in ideal ways to create ideal proportions, whether in relation to the canvas as a whole or to any of the figures within. The golden mean relationship, for example, divides any distance so that one part is to the other as that part is to the entire distance. Derived from classical Greek works, it has had a significant influence. Whether using such formulas or others, as in *dynamic symmetry*, the goal is the eternal ideal, the pure (Figures 6.1 and 6.2).

While past classical cultures relied upon idealized symbolic figures and concern for a hierarchy of ideas, some modern purists stress the removal of all that is extraneous to what is thought necessary. The result is a stress on primary oppositions within the visual contrasts. Minimal painting is an example today.

Classical art possesses a high degree of organization in which each part is fully designed and indispensable to the whole. As such it is a closed art: each fully developed area functions as part of a larger architecture. It is marked by a common vocabulary, social symbolism, and essential simplicity.

In such works the balance is stable, often symmetrical; tensions are reconciled within

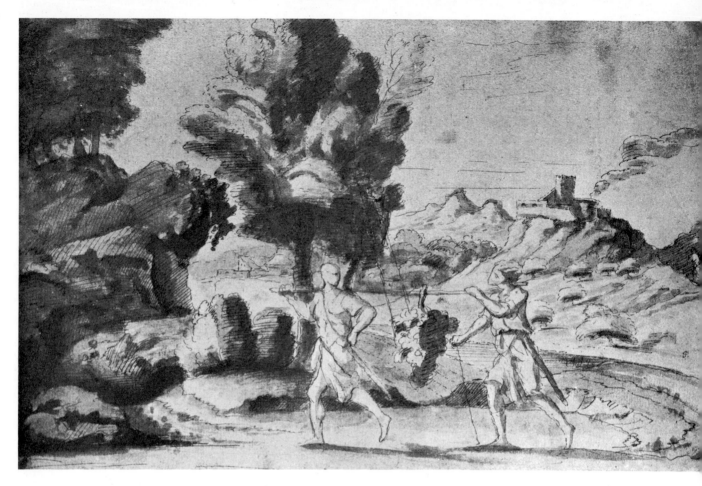

6.2 NICOLAS POUSSIN, Study; Drawing with wash.
(Courtesy Dover Publications, Inc.)

Poussin used mythological subject matter. The tree divides the horizontal distance into golden mean proportions. The distance at left is to that at right as the latter is to the whole distance (A is to B as B is to A + B). The smaller length is a bit more than one-third. A five pointed star automatically possesses such divisions.

and to the frame; line binds clear shapes that exist in defined pattern. Inherent is a synthesis of ideological and plastic elements (see Plate 29).

Outstanding among classicist artists were Poussin and Ingres. Among contemporary exponents striving for the very essence of purity we can name Mondrian, Albers, and other minimalists.

There have been times when our culture was dominated by classicism in art and by objective idealism, its philosophy. Since impressionism, successive periods of action and reaction in art have become briefer with new ideas and overlappings. Our avant-garde now reflects a wide range of contradictory expression.

If you recognize within yourself an affinity for an absolute order as just described,

you may want to supplement this discussion by further reading on classicism. Fortunately Mondrian and others have written considerably about their work and thought.

ROMANTICISM

Many of us react against a theory of absolute ideas. We are certain only of our personal passing present. We are primarily aware of and trust our sensations and feelings. Stressing emotional perception, we regard reality as plural since it is perceived so variously by so many. Reality is so changing that it becomes unknowable. What we consider an object becomes an organization of felt sensations, per-

116

sonal reactions, and consequent feelings (see Plate 30).

Variations of romanticism go by many names. Basically, romanticism is subjective idealism. It shares with classicism the conviction that the material world is secondary to thought. But in romanticism thought is personal; it is derived from sensation and is in no sense absolute.

Elaborate systems, rules, and theories tend to get in our way. We prefer mystery. A stream of intuitions from our innermost being guides us. We need to pin down an inspiration rapidly before the feeling vanishes.

Romantic art runs an emotional gamut that is often highly poetic; it is an art of individual protest, sorrow, or celebration (Figure 6.3). We tend to distort, to use visual contrasts for psychological purposes, to extract images of feeling states and mood. Some of us concretize dream fantasies, pursuing subconscious or unconscious stimuli and the seemingly irrational.

Structure evolves almost accidentally. Order becomes a moment of realization caught on the fly (Figure 6.4). It is held in equilibrium by a climax that dominates a fluid open calligraphic form. The work is marked by mergings, disappearances, sudden surprises, with stress upon unexpected pattern and movement in space.

Through experimentation with materials and techniques, romanticism has stimulated inventiveness and emphasis upon uniqueness. Abstract expressionism dominated the 1950's and it persists along with other forms of romantic art such as social expressionism, pop art, and much of conceptual and environmental art.

In the past, romanticism produced mannerism, the baroque, rococo, and other movements. Its painters range from Rubens and Delacroix to Klee.

Many of us will share the romantic viewpoint since we have been formed by a largely competitive, individualistic society. We may not be aware of it, however, and find this discussion tiresome, irrelevant. But by understanding the changing character of our moods, we may learn to be more patient with our-

6.3 REMBRANDT VAN RIJN, "Woman Seated in an Armchair"; Pen and bistre.
(Courtesy Dover Publications, Inc.)

Sympathy and understanding are expressed with an open, inspired, calligraphic line and form.

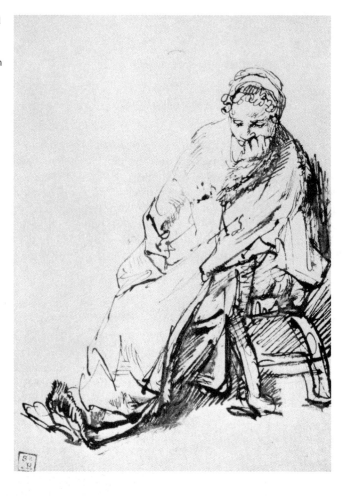

6.4 WILLIAM DE KOONING, "Figure Abstracted";
Pen and ink.
(Courtesy ACA Galleries)

Order becomes a moment of realization caught on the fly.

selves and our work. Romanticism can be destructive and self-deceiving, but it can also be richly personal and alive. Don't allow these theoretical elaborations to discourage you. Paint and draw as you feel like doing. But be more open to what you do. Explore the romantic tradition. It deserves your attention as much as the other approaches.

NATURALISM

Inevitably some artists distrust the moodiness and instability of romantic subjectivity and also reject being imprisoned by the frozen rules of classical organization. We know what we can touch, lift, see, or taste. Our preferences, feelings, ideas (personal or otherwise) are extraneous to what is there to be measured or weighed. When we paint and draw, we want to set down the exact appearance of actuality. What is the effect of the light? Is this longer or shorter? We are naturalists (Figure 6.5).

To us, the idea of something must be *after* the fact, a fallible perception of concept. Matter is primary. To be objective we must freshly and clearly observe and measure natural relationships, which are basically physical and mechanical. Material experience is a labyrinth of cause and effect, of physical action and reaction begun by some first mover who

set the chain of events into motion. Truth disregards feeling or other prejudice. Theory vanishes into practice. Particular appearances conditioned by specific time, place, and skill determine the painting (see Plate 31).

Naturalism has been a potent influence (Figure 6.6). At various times it has corrupted the other tendencies. In impressionism it became a source of renewal, a catalyst to a chain reaction of revolutionary experimentation. At its best naturalism produced Velasquez, Monet, and Pissarro.

If you dislike distortion and idealization, if you prefer to draw and paint things as they appear, you must learn to see. Nature is complex. So often we try to grasp the whole subtle synthesis with a few strokes, and are discouraged that the effect is not the same. As naturalists we may not be interested in designing our work, but we do have to learn nature's design. Nature has structure that we must study and grasp. Perspective, anatomy, and so on become important. Along with learning to see we require the necessary technique.

Drawing and painting are easier if we first establish the larger samenesses and differences and then proceed stage by stage to become more complex.

Some of us may seek all observable differences in detail; others may be more interested in a general impression. Either goal requires faith in the technical process and a calm patience. The texture of skin and hair, for example, becomes inevitable after the basis has been set.

6.5 ANDREW WYETH, "The Captain's House";
Watercolor.
(Courtesy ACA Galleries)

A natural momentary appearance caught with
deft faithfulness.

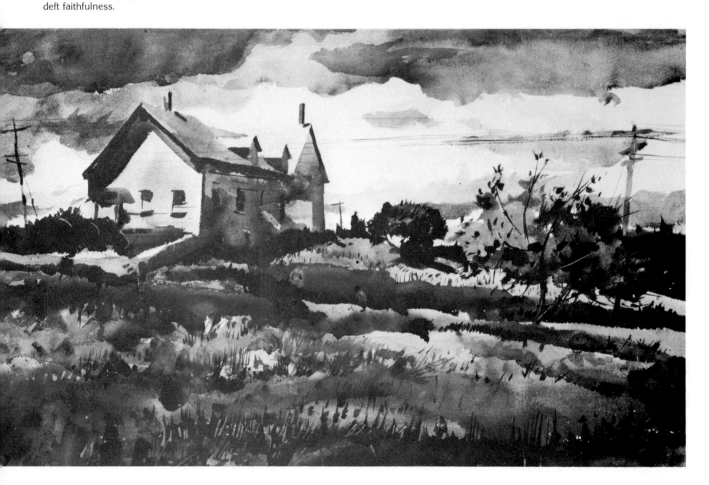

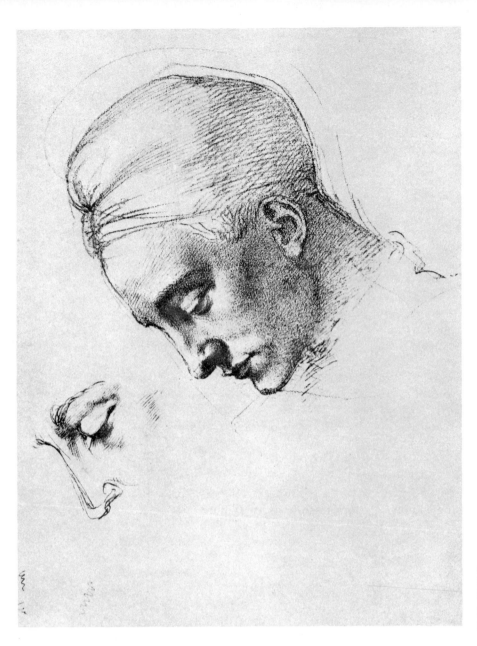

6.6 MICHELANGELO BUONARROTI,
Study of the head; Crayon.
(Courtesy Dover Publications, Inc.)

Naturalism influenced the classicism
of Michelangelo.

REALISM

Certain materialists, while agreeing with the
basic goal of the naturalists, find it too
simple. For the realist, nature has not one but
many appearances, many levels of existence
ranging from nuclear structure to social rela-
tions. The forces of reality need not be set in
motion; they move inevitably as internal op-
positions act upon one another. Reality is
many-sided, consisting of interrelated and in-
terdependent levels of increasing complexity,
all constantly undergoing change. Continuous
small changes eventually result in rapid, more
complete transformations. In art this point of
view seeks to penetrate appearances and to
express the richness of reality in a synthesis
of thought and sensibility (see Plate 32).

For us the naturalistic illusion of appear-
ance is but one facet of a whole that includes
sensation, associations, symbolism, and the
structure of visual contrasts (Figure 6.7). We
are as concerned with truth as the classicists,
but with a truth limited by human perception
and experience. The individualism of the ro-
mantic becomes for us a personal path to so-
cially meaningful experience.

Realists try for objectivity, but they also
understand that we perceive through our
senses, that is, subjectively. There is no way
of escaping the limitations of human in-

120

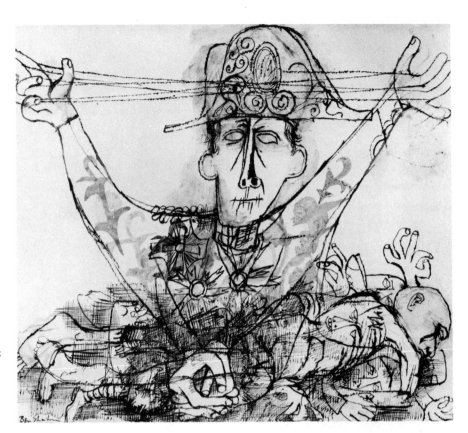

6.7 BEN SHAHN, "Study for the Goyescas"; Watercolor.
(Courtesy ACA Galleries)

Realism includes a synthesis of sensation, associations, symbolism, appearance, and structure.

volvement. We see through the instrumentality of our past experience. Truth remains open. While all is changing, it is a single knowable reality that is changing. Only our awareness of that reality is plural. We each sense the same thing differently, but that difference also becomes part of reality.

To us the painting is real in that it consists of canvas and paint and visual forces that move the viewer's sensibility. It is also real in its reference to the larger reality from which it stems. The parts making up the whole—object or subject, matter or mind, content or form, practice or theory—are inseparable; change in one changes the other.

A painting can be realistic on at least six levels. First, it is material—constructed of canvas, wood, paint, or whatever; we can feel and touch it. Second, the contrasts of linear movement, shape, dark and light, color, space, and texture stimulate our senses. Third, the echoes of past experience are awakened by the configurations. Fourth, calculated symbolic references impress their ideas. Fifth, we recognize the appearances of things: images may imitate those in nature or society, revealing their structure and other qualities. Sixth, all of these levels function within an organization that is an entity as fully and as consciously designed as in classicism; the relationships, however, are not preordained, but torn fresh from life (Figure 6.8).

The climax that often dominates romantic work becomes for the realist the culmination of progressions of thematic visual ideas. The synthesis of these ideas comes out of a social rather than a primarily personal context.

Discoveries are extracted on all levels of experience and thought. The environment sets up the conditions, but the conflict within thought and sensibility provides the forces that move the work. A complex painting will contain many opposing forces, the strongest influencing the others and each having dominant and subordinate aspects. The counterpoint of these forces creates movement as they compete for your attention. The more prevalent contradictions in the work establish its main character.

As realists we are at once alone and of the group; our partisanship is that of alignment with others, based on social awareness, for the good of the whole as conceived at a particular time. Our work expresses our discoveries about ourselves, humanity, nature, and painting. A work of art becomes discovery within wholeness, part of the search and development necessary to our survival.

6.8 PIETER BRUEGEL, "The Alchemist"; Engraving.
(Courtesy Dover Publications, Inc.)

The relationships are not pre-ordained but torn fresh from life.

Realism has produced artists such as Caravaggio, Goya, Chardin, and Eakins. Modern realism embodies the possibilities unearthed within the various directions taken by contemporary art.

ECLECTICISM

Some artists and various art authorities assert that there is only good and bad art. Good art is that which moves them, art they like.

The basis of appreciation is inevitably taste, but that taste is a summation of the contradictions of experience and thought that form a human personality. We have identified some of the crucial differences that are general. But in actuality we each contain conflicting points of view born of the complexity of our lives. In this war of influences within us one tendency becomes stronger. As we change, another tendency may overcome that.

When our convictions reach a relative stalemate, that is, when we have no strong leaning in any particular direction, we have what is called *eclecticism.*

Arnold Hauser has called our time eclectic. Taken as a whole, with the simultaneous confrontations of so many diverse art expressions typical of a period in transition, the characterization can be justified. But I tend to find that the main thrust in our culture is romantic. Others challenge that direction. In that sense our time is not eclectic but simply one of conflict (Figures 6.9–6.13).

Artists and students who lack an overall conviction, who cannot align with any of the four main views, generally reflect in their work a diversity of undigested, unfelt styles. Often they are unable to sustain a work and bring it to its resolution. Although great works of art can be created regardless of one's key attitude, ideas do affect the kind of discoveries we make and the forms they take. Art results whenever a profound experience freshly felt becomes an organic whole.

6.9 HANS HOFMANN, "Lent"; Oil. (Courtesy ACA Galleries)

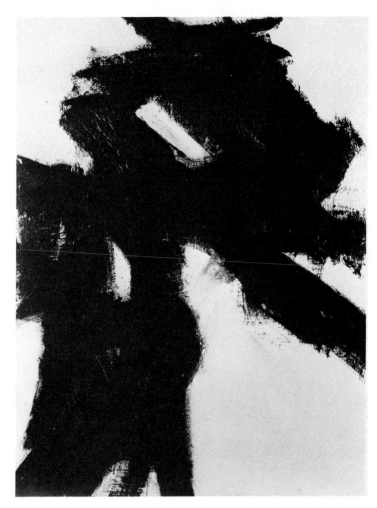

6.10 FRANZ KLINE, "Abstraction"; Oil on board. (Courtesy ACA Galleries)

6.11 RAPHAEL SOYER, Drawing with wash. (Courtesy ACA Galleries)

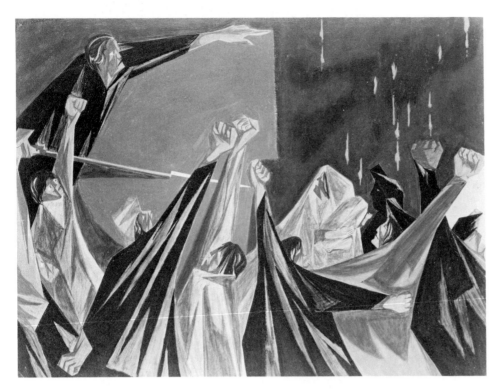

6.12 JACOB LAWRENCE, "Prophecy";
Gouache.
(Courtesy ACA Galleries)

6.13 JOSEPH CORNELL, "Flemish
Princess with Yellow Balls"; Box.
(Courtesy ACA Galleries)

Exploring The Creative Process

Because so many students demand instant success, we must develop some understanding of process in creative work. We do not begin with solutions but rather with problems. Through stages of work we reach the awareness and skill that provide the solution. While we do not all work the same way or the same way at all times, there is always a need for the action and reaction within the creative process.

The various traditions we have examined have their own explanations of the creative process. Both classicism and romanticism center upon the sudden flash of insight—the moment when we seem to get an answer, seemingly out of nowhere, to some enigma. For classicism this is the instant of revelation, its source being some absolute power beyond but containing the human being. For romanticism the insight is personal, one of a stream of inspirations coming from within us.

Naturalism reduces creativity to stages of a technique. Clear observation is preferable to mysterious hunches. Realism broadens the

creative process to include a number of problem-solving stages, each making another possible.

Let's explore each of these interpretations in greater depth, and see what we can learn from all of them about the creative process.

CLASSICISM / REVELATION

Those who seek an absolute order have a unique concept of how discoveries are made. Discoveries are revealed through a process of mental recall. Being ourselves an expression of an encompassing intelligence, we share that intelligence's awareness. As part of it, we reflect the whole. That memory often asserts itself somewhat unexpectedly and is called *revelation*.

In its search for absolute truth, classicism soon erects a firm fabric of ideas with which subsequent findings and deductions must harmonize. To avoid heresy, conformance to fixed traditions is necessary. We must follow the doctrine and the rules in constructing our work.

In a curious sense, the painting already exists; the artist helps to give it its material form. The painting is built monolithically, each part reflecting the closed design of the larger architecture, much as part of a crystal repeats with variation its larger pattern. Our work proceeds logically with an emphasis on ideology and technique.

ROMANTICISM / INTUITION

Adherents to the romantic view tend to be very personal, even proudly heretical. We claim every insight as our own. We are suspicious of authority. Each intuitive flash is one of a stream of inspirations coming perhaps quite mysteriously from our innermost being. To us classicism is too enmeshed with precedent, too intellectual. Its ideas stifle feelings and sensibilities, initiative and freedom. We want no roadblocks to stand in the way of an enigmatic creative process.

We prefer to work spontaneously, automatically, plunging into our work, reacting and changing until it feels good. Because of the destructive character of some feelings and mood, often unrelated to the work, we must learn to have faith in ourselves and patiently to persist until the work conforms to our expectations.

NATURALISM / OBSERVATION

Naturalism shares with classicism a respect for technique, for the stages that make possible the complex synthesis necessary for duplicating the appearance of nature. We want no part of idealization or purist concepts, and have even less confidence in revelation or intuition as a central factor in the creative process.

The naturalist's fundamental base is the close observation of nature. We become interested in its anatomy, in linear and aerial perspective and in the nature of light as it affects appearances. We try to be true to what we see, to develop the methods and stages necessary to simulate it. Creativity turns into a series of stages based on ways of reaching the complexity that meets the eye.

While this process can be one of adding detail upon detail, naturalism is most successful if the parts are established relative to the whole, and if general relationships make possible more complex ones within which detail may finally take its place.

REALISM / SYNTHESIS

Realism respects observation and technique. It is concerned with the search for objectivity, but considers intuition only a part of the process and regards the personal-subjective aspect associated with romanticism as inevitable. Realists tend to agree with Dewey, Whitehead, and others, that the creative process comprises a sequence of steps. These are not simply stages in a particular technique, although technique is involved.

The creative process involves interweaving stages of activity successively making each other possible (Figures 7.1–7.5).

Stages in the Creative Process

ANTHONY TONEY, "Near Houston"

In the creative process, material experiences are transformed into discoveries which become a new reality leading to new discoveries. The completed work is a pause in the continuing transformation.

7.1 THE CONTEXT
Artist's studio (photo by Harari)

7.2 BEGINNING: THE PERCEPTION STAGE

Trial and error exploration of the problem's possibilities: line, shape, value, texture, space, color. Levels of awareness include: sensibility, association, symbolism, illusion, and structure.

7.3 ELABORATION: THE CONCEPTION STAGE

Generalizations are the basis of organization. Cross-fertilization of ideas is the basis of invention and discovery. Flash of insight is the basis of judgment. Thus do we establish the main, minor, and opposition themes, the pattern, rhythm, center of interest, and balance.

7.4 CONCLUSION: OBJECTIFICATION

The material object as canvas and paint; the visual contrasts; the reflection of inner and outer reality.

7.5 SOCIAL TEST

Exhibition at Bridge Gallery
(Courtesy of Westchester County)

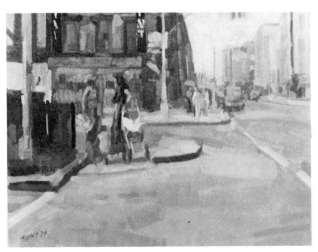

Within a given context, first there comes an awareness of a problem. This leads to its investigation or the perception stage. Exploration by trial and error leads to the conception stage, which involves generalizations and the cross-fertilization of ideas, these in turn stimulating further discovery and invention. At some point there comes the sudden flash of insight that makes possible the judgment needed for final resolution. The work resulting from this process is an art object that ever after meets a social test. Thus the creative process embodies discoveries organized into something that can function as a totality. But since the work itself lives only as it is felt by sensibilities of various orientation, the process remains open ended.

Later on in this chapter we will examine each of these stages in more detail.

MOTIVATION: LEVELS OF SIGNIFICANCE

We may not like to think of painting and drawing as a problem, but what activity does not involve contradictions, difficulties that must be resolved? We may come to painting for relaxation and it can relieve the tensions of fragmentary lives precisely because it asserts wholeness. But any activity closely involving growth, development, the need of discovery and judgment must get its fair share of anguish.

Obviously, no one can start with the end result, the solution or resolution. We do not simply learn a sequence of actions that make us a painter; but rather we must experience one level of expressive achievement after another, each making possible the next. It is this chain of victories that leads to important transformations. We can and must learn to have faith in the creative process.

In the penetration of a visual problem we confront five levels of experience that may have significance for us. First is sensibility, which is physically affected by visual contrasts. Our sensibilities are wedded to a labyrinth of psychological associations and symbols (Figure 7.6). There is also the level of illusion, which involves the study of nature's appearances. Finally the work must have an overall structure or design. We may embody all of these levels or stress one or another in a work.

Sensibility

As painters we must become conscious of the sensuous effects of contrasts. Experiment with simple, limited problems. Can you juxtapose only two colors and establish an exciting relationship? Keep one area larger than the other. Superimpose one choice after another. How do you respond to them?

Psychological Associations

As we work, image relationships serve as cues to arouse buried memories. These associations are not only personal but social as well, since our experiences overlap those of others. We can stimulate this experience by being open to chance, to accident.

Accordingly, put paint on haphazardly, blot it, and then put on another layer. Pour various colors; try any idea that suggests itself; make it a rich accident full of variation (Figure 7.7). Analyze the suggestions, both visual and psychological. Look for the differences and the repetitions. What kind of mood or feeling comes to your mind?

Watch for accidents of nature—its odd suggestive juxtapositions and its weather-beaten materials. Accidental configurations that are pregnant with ideas are all around us (Figure 7.8). Allow yourself to dream, to project.

Doodling is a rich form of accidental drawing (Figure 7.9). Allow your hand to move over the paper while your attention is elsewhere. Keep the results as a source of ideas.

Juxtapose images in unexpected ways (Figure 7.10). Allow them to develop spontaneously as in a stream of consciousness. Combine your drawings together and with other materials as in montage (Figure 7.11). Keep suggestive scraps for use in such contrasts, remembering that unusable ideas may become important another time.

Symbolism

Symbols consist of configurations, illusionistic or otherwise, that stand for various meanings, experiences, or relationships. Sym-

7.6 ANTHONY TONEY, "Four Corners"; Oil on canvas.

The physical effect of visual contrasts within a labyrinth of psychological associations
and symbols is seen and felt in this painting.

Sensibility: The impact of visual experience is controlled
to move the viewer.

Thematic sequences: The main, minor, and opposition
ideas are repeated with variation.

Pattern: The dark pattern resembles a fork; the
light pattern stresses triangular movement into the
background.

Rhythm: Rhythmic repetition of dark rectangular buildings.
Oval and circular shapes are rhythmically stressed, as are
also the lightest areas.

Climax: Minor climaxes lead to the main climax in
upper left center.

Balance: Symmetrical idea is countered by diagonal
thrust to the left.

Line: Main linear idea is diagonal; minor idea is vertical
and horizontal; opposition is circular.

Shape: Main shape repetitions are triangular;
minor are rectangular; opposition are circular.

Value: Darker values dominate. There is a full range
from black to white.

Texture: The textural progression reinforces the
fork-like dark pattern. Light areas are smoother.

Space: Counterpoint of deep and flat space. Linear
and atmospheric perspective are countered by flat
building shapes and figure events in varied space.

Color: Main color progression is blue; minor consists
of warm tans, yellows, and reds; opposition is white.

Associations and Symbolism: Street, buildings, and
figure events are permeated with associations. Many
symbolic references to World War II.

Illusion: Although distorted, symbolic figures and
buildings are recognizable.

7.7 ANTHONY TONEY, Varied paint applications.
Try various ways of working with paint.

7.8 MIMI FORSYTH, ''Rock Wall''; Photograph.
Natural configurations can suggest ideas.

132

7.9 PAUL KLEE, "Rosenzwerg"; Ink drawing.
(Courtesy ACA Galleries)

Doodling can be a source of drawing ideas.

7.9 PAUL KLEE, "Rosenzwerg"; Ink drawing.
(Courtesy ACA Galleries)

Doodling can be a source of drawing ideas.

7.10 ANTHONY TONEY, "Edna"; Oil.
Juxtapose images in unexpected ways.

7.11 ANTHONY TONEY, "Decade of Confrontation"; Oil.
Combine various symbolic images in a montage manner.

bols have to be learned, but they are a decisive part of modern life. With them we can add the broadest kinds of meaning to our work, all kinds of cross-fertilization of ideas.

There are two kinds of symbolic references in art: particular and conceptual. A painting may embody particular symbolism, for example, a picture of Marilyn Monroe or Martin Luther King, in the same way that the name of a person stands for that person. A conceptual symbol stands for a group, category, or class, for example, a dog to represent a faithful friend or a hammer to symbolize labor.

Naturalism lends itself to particular symbolism, wherein the image represents itself alone. Classicism, romanticism, and realism are more likely to use conceptual symbolism or both. Particular symbolism in drawing and painting is involved in any representation of a person, place, or event, contemporary or historical. Conceptual symbolism uses not only figures or things to stand for universal concepts but also geometric signs, shapes, let-

ters, words, color, distortions, and so on, many of them taken from everyday life. The painting's structure itself becomes a conceptual symbol as it reveals the painter's attitude or concept of reality.

The "pop" artists often succeed in giving fresh meanings, usually satirical, to old symbols or clichés by using them in a new context. The individual symbol has a social context and easily becomes a social symbol. We bring new symbols into being even as the old are revised, renewed, or discarded.

To discover the possibilities of symbolism try to think in such terms. As an exercise, combine various symbols culled from magazines or newspapers in a montage manner and see what you can say. Does their combination lead to other than their direct meanings?

Illusion

Another term for illusion is nature or the appearance of nature. Many discoveries have been made in the study of nature and in the

effort to duplicate its appearance in drawings and paintings.

Even those of you who are not naturalists will find working from nature extremely useful. Observe the aspects of natural structure, see the appearances and develop the skills to depict them.

Work from life, from the nude. Study anatomical relationships from life, models, books (Figure 7.12). See the way cloth drapes over the figure. Search out the characteristics of animals and plants. Exercises in linear perspective (see Chapter 4) will help you understand the look of things in space. Atmosphere and light affect all other relationships, particularly color and value. Notice the similarities and differences. Nature is always a fresh source of ideas for your designed structure.

Structure or Design

In Chapters 4 and 5 we discussed structure as being necessary to wholeness. The artist incorporates various resources which pro-

vide the body and spirit of the work, resources that are both contradictory and complex. Design resolves the oppositions.

Design involves the organization of the visual components (line, shape, value, texture, color and space) into main, minor, and opposition ideas that are repeated with variation and so progress to a center of interest or climax within a balanced value and color pattern.

Some of you will have difficulty seeing in terms of visual contrasts. It will require effort to separate and organize the comparative values and colors, directions and shapes.

The psychological component can be so strong that we may miss the obvious visual differences. Exercises such as the following may help you to an awareness of overall structure.

Sketches that separate and stress one or another visual difference can help us to see their roles (Figure 7.13). Extract all the vertical movements that line up with each other. Insure that they differ from each other as well,

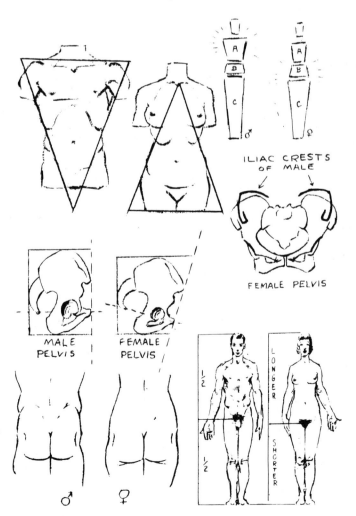

7.12 STEPHEN PECK, Anatomical studies.

7.13 ANTHONY TONEY, "Yonkers"; Pen and ink.

Extract all the vertical movements that line up with each other. Ensure that you have repetitions and variation.

7.14 BENNY ANDREWS, "Study for Circle"; Pen and ink.
(Courtesy ACA Galleries)

Repeat shapes with inventive variation.

7.15 ANITA TONEY, "Lines"; Etching.

Figure shapes are repeated here with unexpected changes in size.

7.16 FRIEDA GREENFIELD, "Village"; Gouache. (Courtesy of the family)

Dramatic contrasts of triangular and rectangular shapes. The heart of structure is sameness, giving unity, and contrast creating interest and movement.

so that you have repetition and variation. Note the way parts of a figure or any somewhat complex object line up with other parts—shoulder to shoulder, side of head to thigh, or foot or ankle, etc. Note these continuities as positions in space with simple marks of pencil or charcoal, but make each mark different. The result is a diagram of place and direction and will look abstract. Let it remain so. This kind of exercise will help you to see directional and proportional relationships as well as abstract possibilities.

Similar exercises that extract and compare particular shapes, stating them with variation, should be tried (Figures 7.14–7.16). Take any shape, such as a star or triangle, and repeat the idea of that shape with as much inventive variation as you can bring to it. The

heart of the concept of structure is sameness, which gives unity and contrast, which creates interest and movement.

THE PERCEPTION STAGE

The first or perception stage of the creative process consists of exploring the possibilities of the problem or situation. This stage is usually marked by a high degree of spontaneity, improvisation, bold constructive and destructive phases. In this, the "fun" period of the creative act, the work is open, free for anything. We may work both automatically and analytically at the same time. We need the freedom to tear the problem apart, to try out all kinds of combinations. Even this freedom is limited by past habits, but we can at least strive for flexibility.

This phase of the creative process requires as much physical freedom as possible, and establishes the basis for the freedom of knowing what is necessary to the problem. In this early period, our goal may not yet be fixed and difficulties can be unforeseen. Within the limitations of our situation, we plunge into the early technical stages, boldly generalizing, trying out one variation after another and their various combinations.

This period of trial and error will be influenced by our previous work, experience, and attitude. Previous painting and drawing will sometimes suggest the direction and even particular ideas for the new work, thus telescoping the process. But usually the path is less clear. The reactions of others to our work, as well as what others whom we respect are doing, also may play a role in what we attempt.

Even when not painting and drawing, we may learn to work almost continuously as we become alive to possible visual ideas wherever we are. But we work as we must, though often we may consciously attempt to contradict past habits in order to discover new ways and meanings. To this end we may willfully create obstacles or court accidents, even failure, in order to force new ideas.

To extend our range of resources it is helpful to gather visual materials for reference. A collection of such materials is usually called a *morgue*. To aid our experimentation in this early investigation, instead of proceeding directly on the canvas or paper we may search out our direction by using thumbnail sketches and studies before proceeding to the final execution.

Morgue

The artist's collection of reference materials, which we call a morgue, may be organized or haphazard. It may consist simply of portfolios or pads of drawings, doodles, studies from life or the model or things about us, or sketches, finished drawings, compositional ideas, photographs, slides, reproductions, and items that caught our eye in newspapers, magazines, etc. In an organized morgue, these materials are kept in files under appropriate headings so that they may easily be retrieved as our work requires (Figure 7.17).

Some artists get a vague idea and proceed to do casual but persistent research, gradually accumulating visual and other facts in folders until the time is right for further development. Various works, for example, murals, may demand much searching for specific facts.

The use of collected or morgue materials has a long tradition. Bruegel depended much upon drawings made on his Alpine journey, and Rubens freely used drawings from antique sculpture. Such research was often based on previous art work. Even today artists often use a work of art or photograph of it as a point of departure for a new work. In this sense, museums and galleries might be considered as glorified morgues—collections of art that are important for technical and visual research.

The growing popularity of montage and collage—putting together disparate two- or three-dimensional bits of visual materials—points to a more direct use of collected items. Some artists combine montage with the use of oil paint or acrylic.

An artist's studio is often filled with objects that caught the artist's eye, or with a general clutter of things that might sometime prove useful in still-life drawing and paintings or in the background of figure compositions (Figure 7.18). Materials of this kind

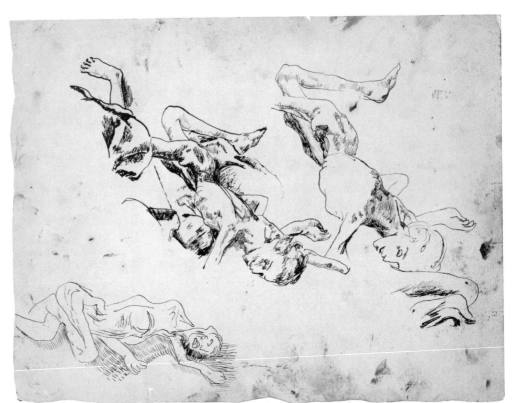

7.17 From the author's morgue, a pen and ink study made in 1946. Your collection of drawings, photographs, slides, etc. can be useful as reference material at some time.

7.18 Author's studio. (Hananiah Harari photo)

The clutter of material may prove stimulating or otherwise useful.

become not only a point of departure for design ideas but also may embody symbolic or associational elements as well.

Thumbnail Sketches

In painting and drawing, the freedom to tear a problem apart often involves drawing a number of thumbnail sketches, elaboration studies, and final sketches before rendering the possible solution. The opposite of this approach is to plunge into the final work directly on the canvas or paper, then proceed either in the whole approach or the part-by-part approach described in Chapter 2.

The following simple device may be helpful to you in making a thumbnail sketch. Take a small piece of paper and cut out an aperture in the shape of your canvas. By holding that opening closer to or farther away from the eye you can make a selected subject—landscape, figure idea, still life, or whatever—appear larger or smaller in the space and thus give yourself a wide range of choices as to how the parts of your subject might cut up the area of your canvas or drawing paper. This aid is very useful when you have already generally designed something. Choosing what to put together to paint and trying out one grouping after another are important during the early period of the creative process.

The thumbnail sketch is an efficient means of seeking out the possibilities of any kind of idea. These drawings should be cursory and very general. They should concern simply size and general shape of parts, the general grouping, the possible patterns of dark and light, and so on (Figure 7.19).

Once you have found some general direction, you can then explore more precise possibilities of approach, the larger main repetitions of direction and shape, and other aspects. Again, after finding a promising path, larger sketches, studies, and final drawings can evolve (Figure 7.20).

Small scale color sketches are also valuable. Try out the main color possibilities in many variations, and when you have found

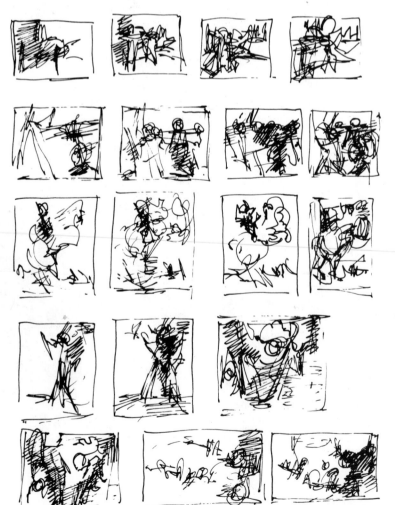

7.19 A sheet of preliminary thumbnail sketches. Thumbnail sketches should be cursory, general, concerned with size, implied shapes, and possible placement and pattern.

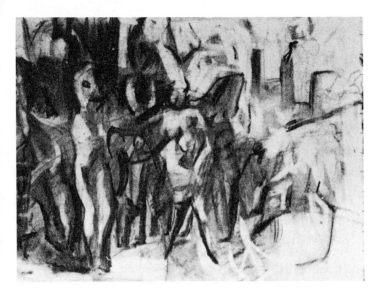
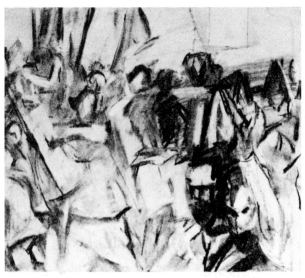

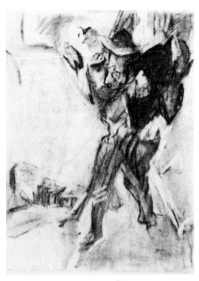
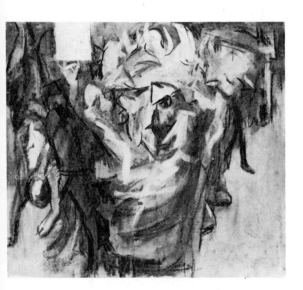
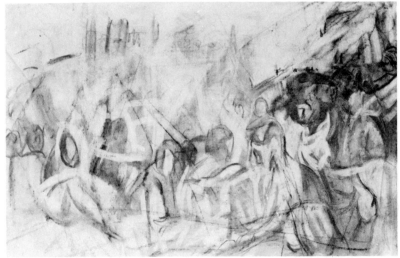

7.20 ANTHONY TONEY, Six charcoal sketches for the mural "Aftermath" at Syracuse University.
After finding a promising idea, larger sketches can evolve.

141

the most promising, elaborate them with minor and counter ideas. Color sketches can also be montages of colored scraps. Pasting together bits of paper sometimes seems easier and often produces exciting suggestions. A collection of color scraps should be included in your morgue. All your explorations should also become part of your morgue, since what is not immediately needed may well prove useful at another time.

THE CONCEPTION STAGE

Discovering what is necessary in the conceptual stage of the creative process involves the following mechanisms: *generalization*, which is the basis of organization; *cross-fertilization of ideas*, which is the source of invention and discovery; and finally the flash of insight by means of which we make the *judgments* that lead to an acceptable resolution of the work. Together these contribute to the work's substance and form. Figures 7.21 to 7.23 show the sequence—beginning, conceptualization, and resolution—in the process of creating my oil painting, "Friend."

Generalization

We make visual generalizations as we become conscious of similarities and differences of visual contrasts and stress one or another. Sameness tends to give us unity; differences develop interest. As we perceive the regularities, we are in a position to pick and choose, to leave out or exaggerate or completely transform them.

Cross-Fertilization of Ideas

Organization without discovery becomes sterile. We transform experience into ideas; such ideas cross-fertilize with one another and lead to new concepts. These, tested in practice, create new experiences that lead to further transformations. The crossing of ideas, whether accidental or contrived, is our opportunity to escape previous habits and make new discoveries.

As we pull apart and reassemble our ideas and interweave our variables, "hybrids" occur which may present fresh insights into reality.

Flexibility, exploration, observation, and the search for many-sided qualities encourage such crossings, even as formalism and academicism tend to restrict them. Imagination and fantasy are the consequences of such coming together of unexpected aspects and, perhaps curiously, lead to realistic discovery.

Works of the dadaists and the surrealists, and such works as magic objects, collages, and montages are among the more obvious examples of the process of cross-fertilization; cubism is perhaps less clear as such. All art, however, depends upon this interaction.

Stimulating Inventiveness

Distortions in the size of body parts or features, exaggerations of texture, and other visual contrasts are paths toward unusual synthesis of idea or form (Figure 7.24). As you enlarge an eye or ear, examine the effect. How does it feel? Making parts of the body expand and contract can intensify feelings of space, power, and movement.

Build your images with montage or collage materials; try figures made of scraps pasted or glued together. If you are painting a figure, paint it as though it were a landscape or a city; if you are painting a landscape, paint it as though it were a group of figures. Encourage associations of all sorts.

In your work try to see the image of mood. What does joy or sorrow look like? What are their colors or textures? Experiment with various configurations. As you make changes, respect your own reactions.

What is the appearance of a sound or a scream? Listen to music. What visual configurations do the sounds suggest? Work freely, spontaneously, with abandon.

Allow your lines to intermesh, contours overlapping (Figure 7.25). Do not erase. If you lose your way, put the drawing aside and work on something else; it will become clearer later. The confusion itself may turn into ideas for exciting mixtures of content and form (Figure 7.26). Try to find what you seem to be saying.

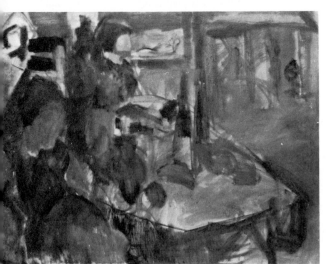

Stages in the Creation of "Friend"

7.21 BEGINNING

Perception of a problem is marked by the freedom of trial and error.

7.22 CONCEPTUALIZATION

The cross-fertilization of ideas allows escape from habit patterns and leads to discovery and invention. Similarities and differences of visual contrasts organize our work as we determine the main, minor, and opposition ideas.

7.23 RESOLUTION

We make judgments as sequences of variables occur, eventually reaching an acceptable result. Often this unexpectedly spurts into our consciousness as inspiration or a flash of insight.

7.24 ADELE SUSAN TONEY, "Interior"; Pen and ink.

Let your line flow as though tracing the objects drawn. Distortions and exaggerations can lead to unusual discoveries and drawing qualities.

7.25 ANTHONY TONEY, "Sketch";
Pen and ink.

Allow your lines to intermesh.

7.26 ANTHONY TONEY, "Girls with Still Life"; Pen and ink.

The cross-fertilization of ideas provides freshness within your visual structure.

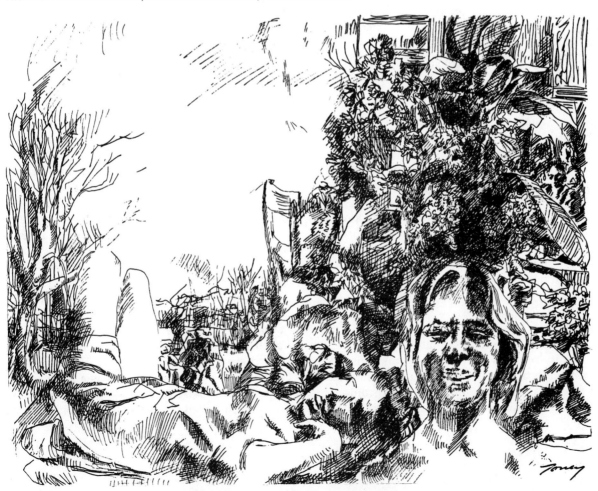

7.27 SALVADOR DALI, "Fantasy Sketches"; Pen and ink. (Courtesy ACA Galleries)

Encourage unexpected associations and juxtapositions.

Combine montage elements with drawing or painting. Encourage unexpected juxtapositions (Figure 7.27). One idea will lead to another. Everything may not be immediately interesting, but it will all help you to become more inventive.

The cross-fertilization of ideas provides freshness within your visual structure, but you still need a way of knowing when you have found your solution. In other words, when have you resolved the work?

Judgment

Everything that happens to a person, the totality of one's experience, forms a matrix of one's particularity or uniqueness. This matrix provides the inner limits of opportunity, order, and disorder in our interactions with the world of which we are a part. Our personal contradictions grow out of and struggle with those about us. Each individual is a dynamic entity, ever changing, sometimes imperceptibly and sometimes radically. Whatever we are at a particular moment determines, together with our outward circumstances, the nature of our artistic problem and the solutions acceptable to us.

Once seized by a problem, our inner self will not relinquish it until we recognize its needs. Sequences of interwoven variables occur, their patterns interlocking, subsuming and being subsumed, and new ones emerging until a synthesis is reached consistent with our present level of awareness. That synthesis spurts into our consciousness as a flash of recognition or insight, providing the necessary resolution to the contradictions with which

we have been coping. That flash of insight, intuition, or inspiration becomes the basis of our judgment.

So long as confusion exists or opposing possibilities seem relevant, decision making involves anguish. It is during the sometimes long, frustrating period of resolving this conflict that we require the utmost patience and belief in ourselves and in the creative process itself. We must persist, knowing that we have at least the answers to the problems that we ourselves create. Sooner or later the synthesis will occur that we are ready to recognize.

Each work extends our experience and thought, changes us and to some degree affects others. It prepares us for further transformation. We live in a complex world with a long past and, hopefully, a future. The more aware we become of its rich substance and conflicts, its science and culture, the more we will participate and the more vital will our particular matrix be. Certainly we can extend our experience in art by absorbing its literature, seeing as much as possible of what has been and is being done. We can become as much a part of the art of our time as circumstances allow.

RESOLUTION

Discoveries are yielded throughout the range of sensibility, association, symbolism, illusion, and structure. Through organization, discovery, and judgment, we evolve a work that becomes a concrete material experience. In the visual arts the work becomes an object, a piece of paper, a stretched canvas, and so on, with organized visual contrasts. This resolution into something material and whole is called *objectification*.

The elaboration of the format of the perceptive investigation of a problem, the subordinate processes of generalization, cross-fertilization of ideas, and intuitive recognition of solutions within conceptions and their objective structure and social test should be used by you as a point of departure for your own thought and action. It achieves its purpose if it makes you somewhat more patient, more persistent, and aware that one level of work makes a more complex one possible and a solution inevitable.

No pattern can approximate the multiplicity of what happens. Few artists work on only one painting at a time. Most people work on many, moving from work to work over an extended period of time. The process may begin and reverse itself many times as the painter gains and loses interest. We may never get beyond the investigative stage; we may work haphazardly or in an organized manner. Much, therefore, depends upon our particular habit structure and situation. The creative process can be frustrated and stunted or it can be nurtured and encouraged. Failure can lead either to more failure or to a more profound success. We must persist in our own endeavors with faith in the creative process and, most of all, in ourselves.

CHAPTER
8

Practical Advice For The Developing Artist

Some of us try to resist the "rat race." We want to exist creatively outside institutionalized competition. This effort to "get off the world" has taken various forms, some religious, others collective in character. But all of us become enmeshed in the web of necessity spun by our inheritance.

In every age, humankind is conditioned by the social forces that dictate a brief life's circumstances, its expression and aesthetics. But today's challenges may well be unprecedented.

Has there ever been such a combination of economic instability, technological promise and trauma, and actual and potential destructiveness? Will we and our planet (even perhaps the solar system) be destroyed by nuclear fusion, fission, pollution, resource depletion, or some natural disaster?

We live at so fast a tempo that our lifetime experiences a revolutionary crescendo in every sphere. Our references are boundless, whether toward promise or horror. When I was in Paris in 1937 (it seems only yesterday),

a French artist spoke to me about the flowers through which he poked his machine gun while on training maneuvers. Where is he today, I wonder.

These are some of the contradictions we live with. Perhaps with micro–macro photography, film, television, radio, the endless stream of printed and spoken words, and so on, painting and drawing have become less dominant as modes of communication. Has art become less important? No. As institutions and corporations turn us into digits, we find our individuality, our humanity in social and individual creative expression. Art becomes a decisive means toward individual and social wholeness and discovery.

It is not that art is ignored or misused in our culture. Art is entwined in some form in all private and public enterprise. In one form or another it serves endless partial purposes and in the process becomes emasculated, its substance stunted, its skills perhaps sharpened but thinned.

Commercialism is not simply employment. Of course artists want (and need) to be paid. But commercialism means the diversion of art to private ends, the loss of art's essential purpose. True art serves the wholeness of life and society.

Artistic freedom begins with the limitations of personal existence in a specific environment, but it expands with each discovery, each solution, each assertion of wholeness.

Serious art has long felt this conflict in roles, and it has long existed outside the mainstream of day-to-day life. But the latter has not been unaffected. Art's discoveries have repeatedly ricocheted through and redesigned practical life.

Courbet's realism, Daumier's humanity and satire, the impressionists' search for light through analytical color began a seemingly endless series of actions and reactions. Artists turned to their own lives and circumstances for subjects. Impressionist dots became post-impressionist dashes that rapidly exploded into massive contrasts.

The resulting problems and opportunities split art's structure into fragments, each of which has since nurtured far-flung experimentation.

This vast panorama of strong influences leads not only to confusion but also to a greater range and richness of experience and possible synthesis.

As artists we face many contradictions. We are both inside and outside our threatened world. Our work, for all its purity, is inevitably a commodity shifting in price with supply and demand. The product of artistic creation suffers the same manipulation as other commodities in the market place. Some works attain major attention and are sold at fantastic prices; others remain unnoticed. Sometimes the unnoticed ones become the sought after and the popular ones decline. But by and large the art market is generally bullish.

Each successive avant-garde manifestation has ultimately become accepted. Regardless of intrinsic contradictions, each, as history, has become valuable and its works correspondingly so. Sometimes artists themselves have benefited from this largess, perhaps now more than at any other time. But their works have a life of their own. Often a single work may eventually bring more financial return than the artist actually saw or used in his whole lifetime.

But our society elevates a few at the expense of many. The succession of those chosen is rapid. There is room at the top, true, but only for a few and not for very long. The fact remains that only the commercial artist, the illustrator, and the designer are integrated within the mainstream culture.

Within the varied circumstantial range, the serious artist persists by doing many things. We try to find ways of earning as much as possible in as little time so that there is some time left to devote to creative art. Our material needs are lessened. That combination plus some good fortune may make it possible to pursue serious art, although many eventually give up.

DEVELOPING OPPORTUNITIES

There has always been some governmental support for art, particularly for public buildings. During the Depression of the 1930's the federal government launched the Works Progress Administration, a large public works

program that put artists to work in a variety of capacities. Many of our well-known contemporary artists worked on WPA projects. The impetus was so great that, although the program was discontinued with the onset of World War II, many art centers continued in operation and new ones were begun and still play important community roles today. These programs employ artists as teachers, hold regular art exhibitions, and provide other activities.

At the same time, government spending for the arts has begun to increase, with the bulk of the funds going to institutionalized art programs such as the various councils of the arts.

After World War II, many artists were enabled to work for varying periods by continuing their art education supported by legislation to help veterans. Various state programs such as the Fulbright enabled some to travel and work in exchange programs. The Korean and Vietnam wars have continued these privileges for veterans, on a lessened basis, to the present.

One of the results of veterans' education assistance was the mushrooming of art departments in the country's colleges and universities. These departments not only employed artists as teachers but also instituted their own art centers and consequent programs.

Internal revenue laws stimulated the growth of private foundations, many with interests in supporting the arts. Furthermore they encouraged the formation of large private art collections and the donation of art works to institutions as well as gifts of art generally to educational and other centers. The result has been a proliferation of public and private art collections.

State Department exchange programs distribute art shows and arrange for artists to visit abroad. State programs have thus served to provide varied aid and encouraged private support of the arts.

Financial and manufacturing concerns and multinational corporations have also begun collecting and using art works in their buildings. Image conscious concerns provide foundation funds for cultural purposes. Art works are also being collected increasingly as financial investments.

As a consequence, the number of galleries has grown enormously in this country, though still largely confined to major cities. New York remains one of the world's major art centers, but Chicago, Los Angeles and San Francisco are competitive. In addition, small communities have not only art centers or some organized art activity but, increasingly, they have private galleries as well.

Major art organizations and art academies have their own programs of exhibitions, grants, and purchases. In addition, artists have repeatedly organized to show their work, begun or promoted art centers, and generally pursued their own interests. Artists have also banded together to form cooperative galleries. More recently, artists who have felt discriminated against, such as women, blacks, and others, have pulled together to form galleries and organizations.

Major museums have grown and have programs in most of our larger cities. These in turn are buttressed by college and university gallery and museum programs. In addition to exhibitions, their catalogues and publications on criticism, aesthetics, art history, and the lives of artists have had considerable influence.

The private arts publishing field has also flourished. There is an enormous stream of art books of every sort coming out each year. The interest and influence are considerable. Libraries often now have not only books on art but also exhibitions and sometimes departments which lend out art reproductions and originals. The loan of original art has been fostered by many museums.

Among the various community activities have been visits to artists studios. Private organizations have been set up to organize such trips, which also are often promoted by art centers. Artists have occasionally set aside certain times for public visits. Such open visits often include a number of neighboring studios.

Outdoor exhibitions have also expanded enormously. Some artists spend considerable time moving from one such show to another throughout the country. Many exhibitions are tied to fund-raising benefits for private philanthropies.

Specialized galleries, in portrait, for example, continue to operate. But there also has

mushroomed a variety of agents and other entrepreneurs or representatives who set out to sell art and promote artists. Some find art that someone wishes. Some are consultants and others take on the responsibility of building collections. There is, moreover, a large number of galleries that rent their space and services to show artists.

A number of magazines promote art and include art criticism, often of current shows. Art criticism of varying levels is included in many newspapers and some topical magazines, but with the attrition of large newspapers, serious criticism has contracted.

With the amazing growth in public art participation, many professional organizations and trade unions include art activities for their members. Various community clubs, associations and religious groups also have art programs. State and local fairs exhibit art. School adult education programs generally include art courses. Many artists also give classes in their own studios.

Thus far we have been concerned largely with art as painting and drawing. To this we must add the many areas of commercial art, including product design and other forms of design, advertising, book and magazine illustration. Art work, broadly speaking, reaches every aspect of contemporary life. How then can we say that the artist is not fully integrated in our culture? Perhaps as we attempt to suggest ways by which you may enter the art scene and, further, become a professional artist, the question can be answered.

WHEN TO START SHOWING

Since the creative process demands a test of reaction to your work, you should show your work at the first opportunity. School shows generally provide your first exposure (Figure 8.1). But other possibilities are community clubs to which you may belong. Of course there is continual exchange with other students, friends, and family. Such showing

8.1 An opening at the New School for Social Research. (Mimi Forsyth photo)

An exhibition helps to elaborate a work, alter our consciousness, and help determine the next problem.

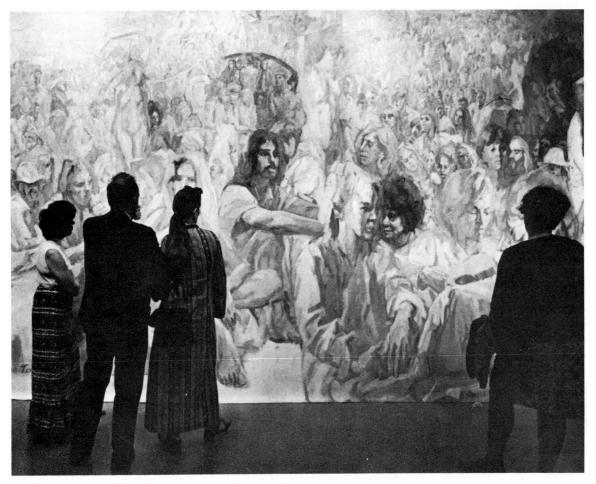

8.2 An audience viewing the sixth panel of the mural "Aftermath." (Mimi Forsyth photo)

A work is deeply understood in its own time by at least some people even if more general appreciation comes later.

should be considered within your special context.

When you exhibit, you are in a competitive situation. This can be constructive or otherwise. The work represents you at a present stage. Reactions can enlarge your view, help to define its direction, suggest limitations and possibilities (Figure 8.2). You should be open to suggestion but must remain aware of fundamental differences in ideas and goals. Not all viewers' reactions will be equally valid. You can also learn much from the work of others, again understanding unevenness of development and varied directions. Try to welcome new ideas. Be open to suggestions within your own identity. Avoid egotistic competitiveness. There is nothing more self-destructive.

Exhibiting is a crucial part of the creative process. It is also the path toward professional recognition. But take your time. Artists today are as skillful as ever, and they are probably more numerous than ever before. A few may seem to win recognition relatively quickly. There are many variables, and chance plays a considerable role. For most of us the journey is a slow one.

Basic development usually requires from four to ten years in and out of schools and working with individual artists. During this period exhibit as often as you can.

Respect your work. Your drawings and canvases record your growth. If someone seems interested in purchasing something, put the price within their reach. Price is determined by supply and demand. Share your work with any who seem truly interested.

As soon as you feel that your work is at least roughly competitive, take it to one or more galleries in your community. They may be willing to take some on consignment. If not, try them again later with different work.

Private galleries in smaller communities usually keep a wider variety of work and are more open to new artists. Commissions are usually one-third to the dealer. Some ask more. If there are a number of galleries, try them all until you find one or more that will handle your work.

Meanwhile take advantage of any and every opportunity to show. Inevitably there will be group shows that you can apply to enter and some to which you may be invited as you become known. In addition, banks, libraries, parks, and shopping centers sometimes offer exhibiting space as a community gesture. If you can have an opening, take advantage of it. The opening is your party, at your expense, but there you are with people who are looking at your work. They are your audience. Generally the opening is a stimulant for purchases and for developing a reputation. Sales occur more readily in private galleries because the dealers are more concerned with selling.

ART ORGANIZATIONS

Join the organizations concerned with art in your community as soon as you are eligible. Help them work more effectively. Cooperate with other artists as soon as the opportunity occurs. As you become known, you will be able to join regional and national groups that serve your professional interests.

Most art organizations are involved either in community art activities or exhibiting. Many exist to provide a single annual exhibition. Others offer many exhibitions and sometimes classes. They may also be involved with performances and programs in many art forms. Often they become art centers, servicing and encouraging many cultural interests.

National organizations also may serve primarily for exhibiting, while promotion of the artist's interests is secondary. Most of these shows are juried and they award prizes. Most of them attract far more than there is room to exhibit. Often their own membership is automatically eligible. Usually a fee is charged regardless of whether or not you pass the jury. The National Academy, National Institute for Arts and Letters, and the American Academy are among those that do not charge fees. Regional and even small community cultural groups have copied these practices and most often they have juries and charge fees. Sometimes they jury their own membership as well.

Large museums, such as the Whitney and the Museum of Modern Art in New York City, have special times for viewing work by new or lesser known artists. Work may then be invited to be shown.

Other organizations carry out programs that concern artists as a group. Often this relates to pertinent legislation and legal and economic interests. A few give artists grants and make purchases. Some have welfare programs with funds for those faced with economic emergencies. Artists Equity Association has such a broad program.

Artists organize with difficulty since they generally work for themselves. But historically, artists have repeatedly joined together as the need arose. During the W.P.A. days of the Great Depression vast numbers did, in fact, work for the government, and they had an artists' union. There are still several organizations (some specialized, others open to all artists) that continue to try to find ways of solving mutual problems. There are also umbrella groups that try to coordinate the efforts of all for particular issues.

These groups are yours not only to join and support but also to improve. Among the issues that concern some is the payment of fees to exhibit. Others are concerned with I.R.S. legislation that would allow artists to deduct gifts of art to special institutions and that would allow more fair treatment in the handling of an artist's estate. Artists generally seek more governmental support, not only for cultural institutions but also for the artist directly. Other programs relate to housing needs, legal protection in relationship to galleries, and so on.

Artists are frequently called upon to give aid and to donate or show their work in benefit shows. In many communities such benefits are now yearly events.

Submissions to shows vary. To some you are invited. To others you may be invited to submit. Then there are the juried open shows. (These are in the majority.) Submission is

now often done with color slides. But you may be asked to deliver or ship your work.

All shows have some importance. The effect is accumulative. Relative importance is dependent on specific relationships between the character of the show and its status with the current art establishment. It is more difficult to get publicity in group shows, but those who do get publicity benefit by it. We must realize that our real purpose is to work as best we can and leave it at that. Show, but do not get overinvolved with reaction or indifference to your work.

GALLERIES

Not all galleries are the same. There are hierarchies related to money, class, and status with the dominant art groups, art magazines, museums, critics, collectors, and so on. These positions of relative importance keep changing. Galleries gain and lose importance as fashions and the other variables are altered.

Galleries that require or are accustomed to dealing with large amounts in sales rarely are interested in new people. Other galleries do add and drop artists. The situation can be fluid. Artists have also combined to form their own galleries. These cooperative galleries are sustained by financial and other efforts of their membership.

Galleries tend to specialize in styles, philosophical attitude, and so on. They generally promote one kind of art. It is to your advantage to get around to every gallery to see where you might fit in. Of course, you might first try to get into the gallery that is currently receiving attention or seems to be the gallery you would prefer.

There are some things to bear in mind. Dealers are selling art for many reasons but, whatever the reason, they are in business. Your work is a commodity. You will generally be treated as a producer of salable or non-salable commodities. There are far more artists than the current art market can handle— probably even very good artists. Also, ideas of what is good vary considerably. But if you persist, you will find a place.

Aside from successful ones, the most de-sirable galleries are those that have a "stable" or group whose members get solo shows regularly and are also handled throughout the year. It is also preferable to have your relationship spelled out in a contract that clearly defines mutual responsibilities.

Customarily, the artist pays for transportation to and from the gallery, framing, photographs for record or publicity, personal mailing costs, and expenses at the opening such as refreshments and service. The gallery takes care of the brochure or catalogue, mailing, advertising, and so on. Exhibitions usually last from three to four weeks. The gallery gets a commission that varies from the preferable one-third to forty percent and even fifty percent.

Invite anyone and everyone who has shown interest in your work or who you think might become interested. You should keep enlarging your list of interested people. The gallery does the same with its own following. The opening or preview is a celebration that is usually held before the show opens to the public and at which refreshments are usually served. Openings are often so crowded that it is difficult to see the work. Some dealers are now trying out all-day openings, mostly without refreshment, so that there is less of a crush.

Single-artist shows at museums and institutional galleries are invitation shows, and generally the institution bears all expenses. These shows are desirable, but sales occur less frequently in such circumstances. Sales seem to require personally concerned intervention.

There are some galleries that purchase work from artists, usually from young or new artists, but they are rare. In some instances galleries have provided weekly support, usually a minimum, for so many canvases yearly (ranging from thirty to all produced in one year). There are also galleries that pay a considerable guarantee yearly for the privilege of showing and representing an artist. And there are artists who prefer not to be affiliated with a particular gallery. They show in various galleries according to circumstances. Gallery representation often involves a percentage to the gallery of sales made elsewhere.

Some galleries rent their space and services. For varying (often considerable) sums you get a single-artist show for a specific pe-

riod. Generally, a contract is drawn up spelling out the services to be given. As a variation of this practice, some galleries are guaranteed a specific sum against sales.

The commercial gallery is important in our society. You have to have someone who is interested in showing, promoting, and selling your work. But much or most of the promotion will be through your own efforts. Your life situation as you manage it will serve to promote your work.

Publicists (public relations people) can be employed, but they may require more of an investment than most artists can afford. There are also collectors who subsidize artists, not only by purchasing their work but also by arranging shows and other promotions. But generally such circumstances are accidental and undependable. You live in a competitive world. Be patient. Work, and in time you will develop and grow in quality and recognition. Even if you remain ignored, if you have managed to work with integrity you have the best of it. This is a difficult attitude to maintain. The numbers of embittered artists continue to grow. We sometimes forget that creative art has its own rewards.

OTHER OPPORTUNITIES

Most professional artists earn their living by combined means. They have jobs, teach, write, are in business, or have another profession or some way to supplement sales or commissions.

Some artists do portrait painting and drawing as well as their own creative work. These paintings and drawings are usually done on commissions obtained through galleries that specialize in such work, or from the recommendations of people whose portraits have been painted.

You can begin with portraits of family and friends. As you become more and more proficient, you will start obtaining commissions. Do them for low fees in the beginning. As you become better known you can raise the prices.

There are usually many opportunities to show portraits locally, not only in the commu-

nity galleries but also in the windows and on some of the walls of local businesses. Your best bet is to get your portraits into the homes of people who like them.

Portraiture has its own problems. Arrangements for sittings may be difficult. Most people do not have time to pose. The expectancies of the sitter may be at variance with your own. Often individuals have so many ideas about how they look or want to appear that an artist can be driven quite mad. Portraiture may require a more conventional studio. Much portraiture must rely on photography for its reference material. But if you enjoy doing portraits, all of these difficulties can be overcome and you will have at least a partial economic solution.

Mural commissions are more difficult to come by, but they are possible. Murals on the outside of buildings have begun to flourish in some of our major cities. The government and private corporations still commission wall decorations. A few organizations promote mural painting. The architect seems to have a decisive voice in the choice of painters and sculptors to work on new or renovated buildings. Often unions are involved in aspects of the work. But murals are being done and some artists actually earn their living by mural painting alone. Many belong to the National Society of Mural Painters.

Allied to mural painting is stained glass decoration, and in recent years more and more creative artists have been finding employment in this field. This is a specialized craft that has been handled by specialized studios. Along with a general resurgence of interest in all crafts, stained glass skills and design are being taught widely. Some artists have worked with the specialized studios for large works.

Mosaics were done by some of the Works Progress Administration painters and are still done today. This art is being taught, but most large mosaic work is done by specialized craft studios. The actual rendering of the Ben Shahn Mosaic Mural at Syracuse Univeristy was done abroad.

Many artists rely on teaching in their own studios. Usually, small classes can be readily secured. Later on the classes can become larger and there can also be more classes. Teaching in your own studio is part

of an old tradition. It is convenient. You remain your own master. It is definitely a thing to try.

But teaching in an institution, art school, college, and so on is more stable. As employment, teaching usually has the advantage of allowing time for one's own work. There may still be some institutions that make creative work outside the classroom almost impossible, but they have diminished considerably.

Many of us teach part time in several places and thus manage to earn an economic base that can be supplemented by sales. Teaching helps us to clarify our own procedures and goals. I have found it a good adjunct to personal creative work.

COMMERCIAL OPPORTUNITIES

In the field of commercial art there are opportunities in illustration, publishing, advertising, promotion, and design.

By and large, design and illustration are such demanding and competitive fields that combining them with our own endeavors is difficult. Some artists (Winslow Homer, for example,) have been able to do both. There are also a few artists today who manage to integrate their creative work with their commercial output.

But the commercial fields are highly specialized and stratified. In advertising art, for example, you have people who do visuals, layout, comprehensives, finishes, mechanicals, or paste ups; some only retouch photographs. Of course, an efficient go-getter may be able to build his or her own studio. Most commercial studios are large, and the artist is an employee at one or another level. The cooperative experience may have healthy aspects that, democratically handled, may be useful in other creative art enterprises. As it is, much of the experience is reduced to repetitive skill.

Much work is farmed out to freelance artists who get commissions, usually through agents who collect 10 percent or more from the artist. The artists work in their own studios, and, when they are out of work, they can paint on their own. However, there is usually pressure to produce fresh samples that can be shown to prospective clients. Nevertheless, some artists have been able to do both.

Commercial art may be an avenue that interests you. To get a job, you will have to present a portfolio of work geared to the specific job. You will have to learn its skills. If you get the chance, many of the skills can be learned on the job. But you are competing with those who have gone through schools that specialize in those techniques.

Book jackets, story illustrations, and "spots" (that is, pen and ink drawings) may be possible ways of entering the commercial field without specialized training. But if you are serious, start an organized morgue of reference materials, clippings, photos, etc., of people, landscapes, of everything from every vantage point. Make a clipping record of illustrations, layouts, and so on. Get to know what is being produced. Answer advertisements. The experience can be instructive. It can teach you how to function in the field.

In commercial art where time is important, mechanical aids of all kinds are used. Learn to use a projector and to trace the images projected. Work from reference material. For finishes work from good photographs. If you can, get the required training or teach yourself. There are books on the aspects of the commercial field and there are published collections of the best illustrations, designs, etc. of the year. If you are interested and motivated, anything is possible.

CONCLUSION

We have merely skimmed over the economic possibilities within the art world. The opportunities are many and varied. What you do depends on your own motivation and abilities.

When you feel that your work is competitive, after you have been in a few exhibitions and have received some recognition, you can apply for the various grants from foundations and public programs. Keep trying. Do the best you can; then relax. Much depends upon variables outside your control.

But the effort you make is part of getting known—and you may be lucky.

Our period has seen a magnificent flourishing of discoveries and abilities. There are promising beginnings to a vital integration of art and society.

As for our own work, we must maintain a long view; the social test is unending. It is subject to many influences, hardly objective.

Yet, as evaluation repeatedly suffers re-evaluation, a relatively objective consensus may be achieved.

We each need faith in our own view. We must be open to the reactions of others, yet accept nothing by fiat. That which becomes clearly meaningful will not be threatening; rather it will contribute to our strength and development as artists and as human beings.

Index